25.00
4

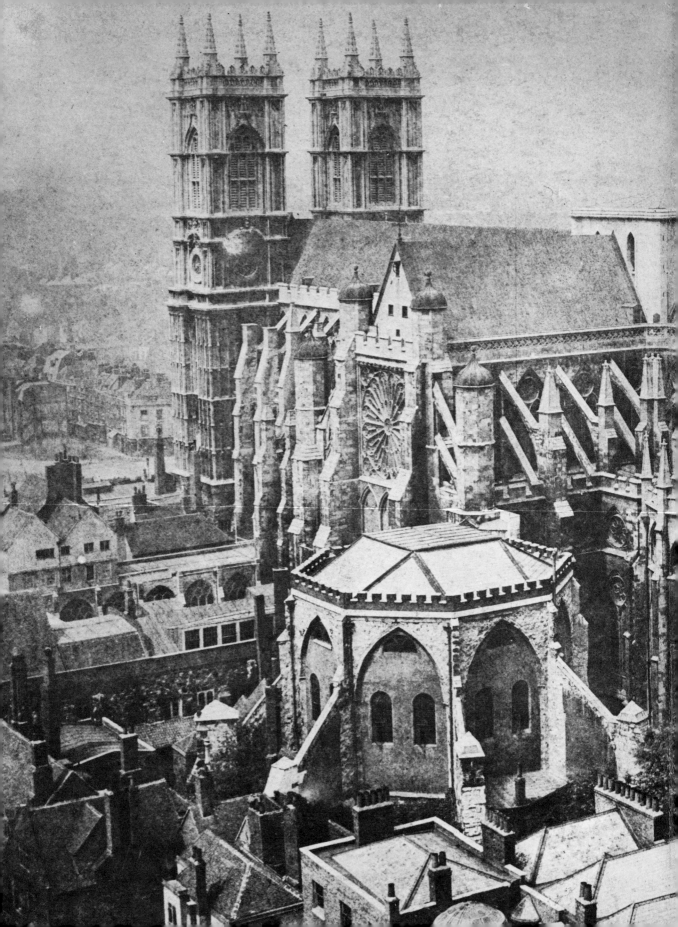

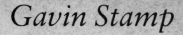

Gavin Stamp

THE CHANGING
METROPOLIS

EARLIEST PHOTOGRAPHS OF LONDON
1839–1879

VIKING

VIKING

Penguin Books Ltd, Harmondsworth, Middlesex, England
Viking Penguin Inc., 40 West 23rd Street, New York,
New York 10010, U.S.A.
Penguin Books Australia Ltd, Ringwood, Victoria, Australia
Penguin Books Canada Ltd, 2801 John Street, Markham, Ontario,
Canada L3R 1B4
Penguin Books (N.Z.) Ltd, 182–190 Wairau Road, Auckland 10,
New Zealand

First published 1984

For
Agnes Mary Stamp

Printed in Great Britain by
Butler & Tanner Ltd, Frome and London

Set in Monophoto Sabon

Designed by Peter Ward

BRITISH LIBRARY CATALOGUING IN PUBLICATION DATA

Stamp, Gavin
Earliest photographs of London, 1839–1879.
1. Photography – Landscapes 2. London
(England) – Photography
I. Title
779'.9'421 TR660

ISBN 0-670-80058-9

CONTENTS

ACKNOWLEDGEMENTS

This book is the product of combined obsessions: with old photographs and with London and its buildings. The books published on London which use Victorian photographs – John Betjeman's *Victorian and Edwardian London in Old Photographs*, Hermione Hobhouse's *Lost London* and Roger Whitehouse's *London Album* – contain comparatively few early photographs, that is, of before the 1870s, yet it seemed to me unlikely that a great capital city should have been less extensively recorded than, say, Bristol, whose history in photographs has been exhaustively illustrated in the admirable series of books by Mr Reece Winstone. The result of my two obsessions was the discovery of many fascinating early photographs of London, of great architectural interest, which had never been published.

A majority of the illustrations in this book derive from libraries, museums and photograph collections. I am most grateful to the librarians and curators who coped with my search for early photographs and requests which often cut across conventional methods of cataloguing. In particular, I should thank two members of the staff at the National Monuments Record, Stephen Croad and Ian Leith, for their enthusiastic help with my project. I am also indebted to John Ward at the Science Museum for dealing with my importunate requests for early calotypes, to Frances Dimond at the Royal Archives in Windsor Castle, to Andrew Saint and Robert Thorne of the Historic Buildings Department of the Greater London Council, to David Allison and Lindsay Stuart of the Photographic Department of Christie's South Kensington, and to Valerie Lloyd for her assistance with the collection of the Royal Photographic Society.

This book would certainly not have been possible without the help of private individuals who most generously allowed me to use photographs in their collections: Gerald Cobb, that unsung pioneer in the appreciation of photographs as historical documents; B.E.C. Howarth-Loomes, with his unrivalled knowledge of stereoscopic photographs; Christopher Gibbs; and Christopher Wood. Several photographs from Prince Albert's own albums are reproduced here by Gracious Permission of Her Majesty the Queen. Other photographs are reproduced by permission of the following: the Bedford Estates; the City of Birmingham Libraries (Sir Benjamin Stone Collection); the British Railways Board; the BBC Hulton Picture Library; the Royal Borough of Kensington and Chelsea Public Libraries and Arts Service; Christie's South Kensington; the Greater

London Council Photograph Library; the Guildhall Library, City of London; the Kodak Museum; the London Transport Executive; the Museum of London; the National Monuments Record; the Lacock Abbey Collection (National Trust); the Mansell Collection; the Royal Photographic Society; the Royal Botanic Gardens, Kew; the Science Museum; Sotheby Parke Bernet & Co.; the University of Texas at Austin (Gernsheim Collection); the Victoria and Albert Museum; Westminster City Libraries; the Dean and Chapter of Westminster. I am also grateful to the following for their advice in finding photographs: Alan Crawford, Professor and Mrs J. Mordaunt Crook, Edward J. Diestelkamp, Michael Robbins and Andrew Sanders.

I hope that this book will satisfy the photographic historians but, as will be evident, the selection of photographs has been determined primarily by an interest in the architecture and topography of London.

King's Cross, GAVIN STAMP
London
October 1983

INTRODUCTION

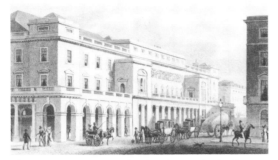

The Opera House, Haymarket, by Thomas Shepherd

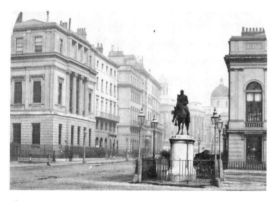

Plate 74

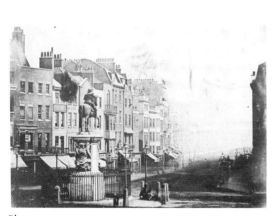

Plate 1

There is a haunting immediacy and a directness about an early photograph not possessed by any print or painting, no matter how accomplished and accurate. In the latter the artist's eye and imagination come between past and present; in the former it is only the camera lens, and that performs with such predictable accuracy that we *know* that what it depicts is there. With an artist's rendering of a building or an event, a wilful act of imagination is required to interpret the image as something concrete; with the photograph no such imaginative leap is necessary. All is real. The photograph is a direct bridge to a distant past; it can be a clear vision of an historical reality across a gap of a hundred and forty years, or more. There is a fascination and a wonder in seeing the reality of long-demolished buildings and long-dead people in rare early images taken when photography was uncommon and in its infancy.

By some miracle, photographs survive which were taken in London in the very year when the secrets of the new invention were announced to the world – 1839. These delicate images, achieved by M. Daguerre's new process, show London in the second year of Victoria's reign, when Lord Melbourne was Prime Minister, when the first railway in the capital had been open for only three years, when London was still as the Georgians had left it. One can only wish that more of the daguerreotypes taken that year were still extant, to show with vivid precision the reality of the smart new London so charmingly depicted by Thomas Shepherd in *Metropolitan Improvements*, published just a decade earlier; for, although individual buildings survive, it was a very different city from the London of today.

It may seem churlish to complain that two of the surviving daguerreotypes taken in London by M. de St Croix in 1839 show buildings which are exactly the same today – if then in a more calm and civilized setting – when we also have a plate so hauntingly and tantalizingly beautiful as his view down Whitehall (Plate 1). This is a photograph taken from Trafalgar Square (then but a decade old), with Charles I standing in the foreground and little buildings stretching away towards the Banqueting House, just visible in the haze so very typical of the London atmosphere of the time. Le Sueur's equestrian statue is still in exactly the same place, but today it stands in a swirling torrent of cars, buses and taxis; in the 1839 photograph, Whitehall is tranquil and empty. The calm beauty of

the street is clear, as are the details of the shops and houses. All is recorded with tantalizing precision. All is so real that, Alice-like, one is tempted to enter the picture in a way that one cannot with the unconsciously idealized London of Shepherd.

London in 1839 was not empty of traffic or of people. The streets are empty in early photographs either because of the long exposure times, which eliminated moving objects, or because the photographer was at work at the best time of the day for his craft, which was the early morning when the atmosphere was clearer. The view of Whitehall in 1839 is not entirely empty, however, for there are cabs parked on the right-hand side of the street, with drivers sitting waiting, and a boy can be seen slumped against one of the William IV bollards which still protect the statue of Charles I today. Who was he, this boy who had the curious distinction of being one of the very first Englishmen recorded in a photograph for posterity? And who were the couple caught walking in the College Garden in Henry Fox Talbot's distant view of Westminster Abbey (Plate 5) taken some six years later? The man is wearing the high stock and peaked cap, the woman the flounced wide skirt, typical of the mid 1840s. Of course they were: it just requires an act of will to believe that people really did wear the clothes normally seen in glass cases or in fashion plates, clothes fashionable before photography became common.

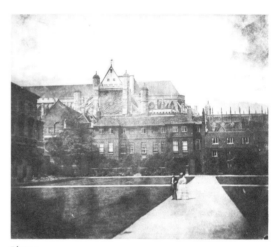

Plate 5

Such is one aspect of the compelling interest of early photographs, yet in Britain comparatively little use was made of them until recently. Architectural historians have almost always relied on drawings and contemporary prints, or on modern photographs, to illustrate buildings rather than on photographs of those buildings when new, which are so much more informative than, say, the coarse woodcuts published in the *Builder*. And photographic historians, it has to be said, often seem interested only in chemical and optical processes and not in what early photographs are actually *of*. Surely the real value of photography is as an accurate and vivid recording device, which has preserved the appearance of streets long altered and buildings long demolished. The character of Nash's London, of Georgian London, and even of London buildings of earlier periods, is evocatively captured in many early photographs which are vital documents of architectural, topographical and photographic history as well as being, so often, beautiful images in themselves. Yet many have never been published: hence this book.

To understand the full import of many of the surviving early photographs of London some technical photographic history is necessary, although a comprehensive account must

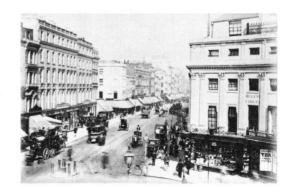

Plate 86

be sought elsewhere.[1] Photography, the fixing of an image obtained by a *camera obscura*, that is, through a lens, was first achieved by the Frenchman Nicéphore Niépce in 1827. However, photography only became a practical proposition in the late 1830s when L.J.M. Daguerre developed Niépce's discoveries. Daguerre (1787–1851) was a French painter who had been responsible for the dramatic topographical canvases in the celebrated Diorama which had opened in Regent's Park in 1823. Daguerre's photographic process was revealed to the world in 1839. Owing to the encouragement of the astronomer François Arago, the French government acquired the *daguerréotype* in July 1839 in order to give the invention to the world in return for state pensions for Daguerre and Niépce's son. However, Daguerre had already taken out a patent on his process in England, a cause of some resentment which, together with Talbot's later patent, inhibited the development of photography in this country.

Daguerre's process took advantage of the sensitivity of silver salts to light. A polished and silvered copper plate was made light-sensitive with iodine vapour and, after exposure in the camera, was developed with mercury vapour and fixed (that is, made permanent when brought into light) with hyposulphite of soda. The daguerreotype had a very beautiful silvery image of a detailed precision which amazed contemporaries, but the process had certain fundamental disadvantages. The resulting image was very delicate and the plate had to be protected under glass from both touch and tarnishing. It was also *unique*, being the plate actually exposed in the camera, and as a result the image was reversed. (The illustrations from daguerreotypes in this book have been re-reversed, for the sake of topographical reality.) Within two decades Daguerre's process had been superseded by more flexible and practical methods.

Arago published the secrets of the daguerreotype at a meeting in Paris on 19 August 1839 – the official birthday of photography. On 13 September 1839, M. de St Croix, a Frenchman, gave the first public demonstration of Daguerre's process in England at 7 Piccadilly, London. *The Times* reported that the plate produced was a street view 'resembling an exquisite mezzotint'.[2] After an interval caused by litigation

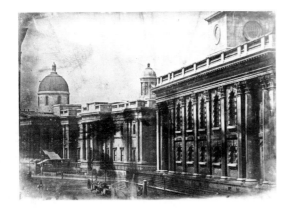

Plate 60

1. For a full account of the technical processes used in early photography, see the works cited in the Bibliography, especially the books by Helmut Gernsheim and Brian Coe.

2. A full account of M. de St Croix's activities in London and the early use of the daguerreotype in England is given in H. Gernsheim, *The Origins of Photography* (1982), page 123, etc. The *Literary Gazette* for 12 October 1839 records that M. de St Croix exhibited views of Regent Street and St Martin's Church.

on behalf of Daguerre, M. de St Croix continued to organize demonstrations and exhibitions of photography throughout October at the Argyll Rooms, No. 218 Regent Street, and at the Royal Adelaide Gallery of Practical Science, West Strand. This gallery was very important in the early history of photography in London. It was at the west end of the Lowther Arcade, on the corner of Adelaide Street just behind St Martin-in-the-Fields. Two years later another Frenchman, A. F. J. Claudet, erected a glazed studio, to take maximum advantage of the light, on the roof of the West Strand building housing the Lowther Arcade, which had been designed by John Nash and built in 1831. It was, presumably, in connection with the Royal Adelaide Gallery that the early daguerreotype views of London attributed to M. de St Croix were taken, for all are of subjects very close at hand (the view of the steeple of St Martin's may well have been taken from the roof). However, although some of the earliest photographs were of outdoor views, early exploiters of the daguerreotype, such as Claudet and Richard Beard, came to specialize in portrait photography which was more advantageous commercially.

It seems that the daguerreotype was at a disadvantage in the London atmosphere, as possibly may be seen in the view of Whitehall. Robert Hunt, F.R.S., the author of the first general treatise on photography, published in 1841, recorded that:

> The *yellow* haze which not unfrequently prevails, even when there is no actual fog over the town itself, is fatal to all chemical change. The haze is, without doubt, an accumulation, at a considerable elevation, of the carbonaceous matter from coal-fires, &c. Although a day may appear moderately clear, if the sun assume a red or orange colour, it will be almost impossible to obtain a good Daguerréotype. Notwithstanding in some of the days of spring our photographers obtain very fine portraits or views, it must be evident to all who examine an extensive series of Daguerréotypes, that those which are obtained in Paris and New York are very much more intense than those which are generally procured in London. This is mainly dependent upon the different amounts and kinds of smoke diffused through the atmosphere respectively of these cities.[3]

However, the chief drawback of the daguerreotype – that it was a unique, reversed image which could not be duplicated – was soon overcome by the Englishman William Henry Fox Talbot (1800-1877), the inventor of the paper *negative* from which an unlimited number of positive prints could be made:

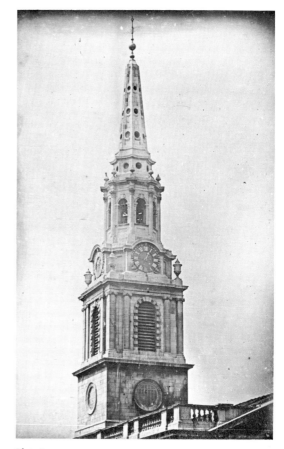

Plate 61

3. Quoted in John Timbs, *Curiosities of London* (1855, 2nd edn 1868), page 306.

the basis of modern photography. Talbot had been experimenting with 'photogenic drawing' and, in 1835, took the first negative image in the world (the light areas dark, and vice versa) at his home, Lacock Abbey in Wiltshire. The public announcement of Daguerre's process in 1839 forced Talbot to publish his own experiments in order to claim precedence in invention, but his process had not then been perfected. Talbot patented his improved process, which he called the 'calotype' (from the Greek, meaning beautiful), on 8 February 1841. Between 1844 and 1846 Talbot published, in a number of parts, a collection of calotypes which became the book entitled *The Pencil of Nature*.

Talbot's process used Whatman's or good-quality writing paper, which was coated with silver nitrate and potassium iodide. After exposure in the camera, dry or slightly moist, the sheet was developed in a solution of gallic acid and silver nitrate and fixed with potassium bromide or hyposulphite of soda. The resulting paper negative was then waxed to make it translucent, and positive prints were made by laying sensitized, salted paper underneath and exposing it to the sun. Later, the negative paper was waxed first, which increased its transparency and sensitivity. The resulting calotype prints – 'sun pictures' – were of a sepia-brownish colour. Owing to the texture and grain of the paper, they did not have the minutely detailed finish of the daguerreotype but were more impressionistic, with great tonal subtlety and beauty. As a result, the calotype was extensively used for landscape and topographical photography in the 1840s and early 1850s by such men as the Reverend Calvert Jones, who took many views in Dublin, and by Hill and Adamson in Edinburgh.

Henry Fox Talbot took most of his early calotypes in and around Lacock Abbey, but in 1843 he set up a photographic establishment in Reading, which was half-way to London on the new Great Western Railway. He also had a house in Sackville Street, Piccadilly, and, as a most fortunate consequence, he photographed many London subjects in the 1840s. The earliest, which must be a print from the first paper negative taken of London, is dated June 1841 and is red in colour. This shows the Thames and Westminster from the Hungerford Market (Plate 2). It is a remarkable view, showing the wharves and jetties which lined the north bank of the Thames before the construction of the Victoria Embankment, and old Westminster Bridge is just visible in the distance. It is even more remarkable for what it does *not* show, for only the Abbey and Westminster Hall are visible on the skyline: the Palace of Westminster had been burned down only seven years before and the new building had not yet risen above ground level. In the mid 1840s, Talbot, or one of his collaborators

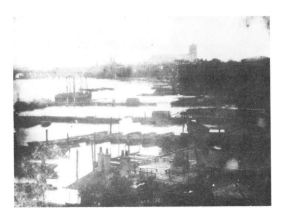

Plate 2

such as Nikolaas Henneman, took a number of views of London subjects, usually of new buildings. The view, often reproduced, of Trafalgar Square with Nelson's Column under construction is one of these (Plate 62).

The next important technical development in photography occurred in 1851 when Frederick Scott Archer (1813–57) introduced the wet collodion negative. Unlike Talbot and Daguerre, Archer did not patent his invention and, although the process became the basis of most Victorian photography, he died in poverty. The wet collodion process was the first practical use of glass for negatives, allowing a much finer definition than was possible with paper. It had been discovered that collodion – gun-cotton dissolved in ether – created a thin, transparent, sticky film over the surface of glass. For photography, a sheet of glass was coated with collodion containing potassium iodide and then sensitized with silver nitrate. It then had to be exposed and developed while still wet. When the resulting glass negative was dry, paper prints could be made from it. (An ambrotype is a wet collodion glass plate specially treated to appear as a positive when placed against a black background.)

At the same time as the wet collodion process was introduced, albumen paper superseded salted paper for prints. Albumen paper, a thin sheet of paper coated with egg-white and salt and sensitized with silver nitrate solution, was invented by L.D. Blanquart-Évrard. The print, which had to be backed with card, reproduced the fine detail possible with a glass negative and was sepia in colour. It could also be further toned with gold, which tended to stop the white areas from yellowing and the whole print from fading.

A majority of the illustrations in this book derive from albumen prints made from wet collodion negatives. No other developments in photography are of immediate concern; the gelatin dry plate, which replaced the somewhat laborious and messy wet collodion plate, was proposed in 1871 but was not in general manufacture until 1878. One optical rather than chemical innovation needs to be mentioned, however: the stereoscopic photograph. By mounting side by side two photographs taken simultaneously of the same subject but from slightly different positions, a three-dimensional effect was obtained when they were viewed through a stereoscopic viewer. Stereoscopic photographs proved to be immensely popular in the 1850s and 1860s. Begun in the era of the daguerreotype, the stereoscope flourished after the introduction of small stereoscopic cameras with a short focal length. The resulting prints, mounted in pairs on card, were small ($3'' \times 3\frac{1}{4}''$) and did not have the precise definition that, say, Roger Fenton achieved with his $15'' \times 15''$ plate camera,

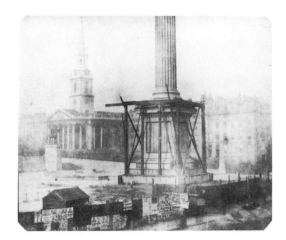

Plate 62

Plate 77

Plate 83

but what they lacked in precision they gained in shortness of exposure.

Stereoscopic cameras were used to obtain 'instantaneous' photographs which gave an impression of movement. By the early 1860s exposure could be reduced to a fraction of a second, whereas the early daguerreotypes and calotypes required an exposure time of over a minute even in sunlight. Such short exposure times changed the type of subject which the photographer could record. Instead of rising early to avoid moving vehicles and pedestrians, photographers like George Washington Wilson (1823-93) and Valentine Blanchard (1831-1901) could record busy street scenes in London (Plates 77, 83). No longer did photographs need to be populated by those ghostly wraiths which were the result of tiresome bystanders moving during the exposure time. Stereoscopic views, taken at home and abroad, became very successful commercially and led to the establishment of such firms as the London Stereoscopic and Photographic Company.

However, the photographer was still limited by the cumbersome nature of his equipment. A large plate camera was a very heavy object which had to be mounted firmly on a tripod (one is visible in Plate 195). Even when using the smaller stereoscopic camera, the photographer had to be very near a dark-room as the wet collodion process required both exposure and developing to be carried out while the glass was wet. Valentine Blanchard mounted his camera on the roof of a cab to take his street scenes. Many other London views were clearly taken from first-floor windows or balconies, a more convenient vantage point and one out of the way of pedestrians. Setting up a camera in the street could be an obstruction to traffic. In 1858, Roger Fenton recalled that:

> Some time back the Commissioners of Police took alarm about the danger of allowing photographs to be taken in the streets of London, and directions were given that all persons armed with cameras should be requested 'to move on', unless provided with special permission to cause an obstruction in the streets. The same was the case in the parks. I took the trouble of getting such permission; but I cannot find that anyone else has done so, nor speaking from my own experience of the pleasure of working in the streets of London, do I think that many are likely to imitate my example.[4]

The vehicle visible in his photograph of Dorchester House (Plate 91) suggests that, in London, Fenton used a horse-

4. Quoted in John Physick, *Photography and the South Kensington Museum* (1975), page 9.

drawn photographic van similar to the one which had pro-
vided such an attractive target for Russian gunners in the
Crimea. This van carried all his equipment as well as acting
as a mobile dark-room. Fenton (1819–69) was the most distin-
guished photographer to have recorded London subjects in
the 1850s and 1860s. Others who took buildings and street
scenes included P.H. Delamotte (1820–89), Francis Frith
(1822–98) and George Washington Wilson (1823–93). By the
1880s the two last had established successful firms issuing
commercial catalogues of topographical views, but London
does not seem to have been as popular a subject as Oxford
and Cambridge or the cathedral cities and most of the pho-
tographs are of familiar scenes. Indeed, it would seem that,
despite its size and importance, London was less well recorded
in the early days of photography than Paris. This may reflect
the commonplace feeling that London is not a *beautiful* city,
like Paris or Florence, or it may be a result of the fact that
Londoners would buy photographs of distant places but not
of the city in which they lived and worked, and knew too well.

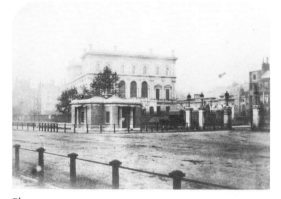

Plate 91

It is interesting to see what metropolitan subjects did inter-
est the independent photographer, that is, the photographer
not specifically commissioned to record a building when new
or under construction, or a particular event. These changed
over the forty-year period covered by the photographs in this
book, and the change in subject-matter is most significant.
Henry Fox Talbot is very revealing in this context; almost all
the photographs taken by him or by his assistants in the mid
1840s were of the new buildings or structures which orna-
mented the smart new London created by Nash and his con-
temporaries after the Napoleonic Wars. Subjects like the
Royal Exchange, the Hungerford Bridge, the Conservative
Club and the Treasury would seem to have been recorded
almost immediately after they were completed and opened.
Talbot also photographed Nelson's Column and a terrace of
houses while they were under construction; he shared the
confidence of his age and delighted in new improvements to
London. When he worked in London, Roger Fenton, too,
made plates of new and impressive public buildings like
Dorchester House and the east wing of Buckingham Palace,
and he took a series of photographs showing the distant New
Palace of Westminster nearing completion.

By the end of the 1870s, however, several photographers
were not so much interested in new London as in the London
which was rapidly disappearing: the London of the seven-
teenth century which was being destroyed by street improve-
ments; the coaching inns and gabled houses which had been
made redundant by commercial redevelopment and the advent
of the railway. Several old London monuments were recorded

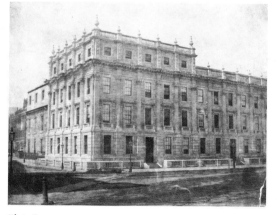

Plate 89

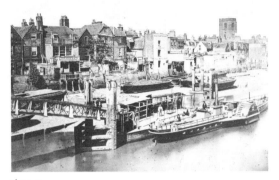

Plate 49

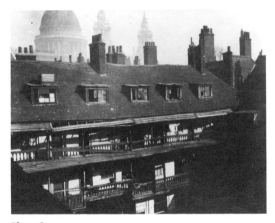

Plate 28

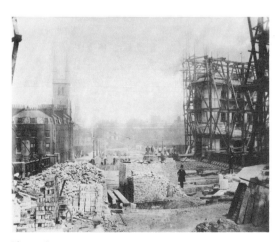

Plate 158

very shortly before they were removed: the Temple Bar, for instance, or the several City churches by Wren sold off by the Bishop of London. Old Chelsea, about to be swept away by the new Embankment, was recorded by James Hedderly (*c.* 1815–85), a rare example of a local photographer who concentrated on one district of London (Plates 48–50). The most significant activity in this respect was the work of the Society for Photographing Relics of Old London. Some of the photographs of threatened inns and houses taken for the Society by Henry Dixon and Alfred and John Bool are among the latest photographs illustrated here. The immediate reason for the foundation of the Society in 1875 was the imminent demolition of the old timbered and galleried Oxford Arms in Warwick Lane near St Paul's (Plate 28). In its aims and in its antiquarian character, the Society was the photographic equivalent of the Society for the Protection of Ancient Buildings, founded by William Morris just two years later in 1877.

There was a very good reason for the cultural pessimism and conservatism represented by the S.P.A.B. and the Society for Photographing Relics of Old London, for since the heyday of Talbot's photography London had been ruthlessly transformed. In the 1850s and, especially, the 1860s London was so altered by the forces of improvement as to make new buildings commonplace and to engender a consciousness that old buildings were precious. This transformation was a product both of population growth and technological change, and it revealed an altered urban sense and a less secure architectural taste. Not only did new suburbs grow up but old parts of London were rebuilt. Much of this transformation is recorded in photographs.

The most radically changed part of London was the City. In the mid century the City of London became depopulated as a result of the advent of commuter railway lines, and the residential urban fabric of Wren and the Georgians - recorded in some of the earliest photographs (Plates 40, 44) - was replaced by purpose-built commercial structures. New streets were created. Cannon Street was widened and extended in the 1850s, while in the late 1860s Queen Victoria Street was ruthlessly cut through from Blackfriars Bridge to the Bank of England. At the same time Holborn Viaduct was being built. This, together with the attendant street improvements which involved a massive destruction of property, was the greatest of works carried out in the City of London and one which was fortunately recorded in a magnificent series of large plate photographs (Plates 156–60).

Major street improvements also took place elsewhere in London in these same years. The creation of Victoria Street, which greatly altered the character of old Westminster and

which opened up Pimlico, was begun in 1845. It was followed by the cutting through of Garrick Street, Southwark Street, Clerkenwell Road, Farringdon Street and, at the end of the 1870s, of Charing Cross Road and Shaftesbury Avenue. All these improvements necessitated the destruction of many old streets and houses and the displacement of many thousands of poor people, but such works were usually welcomed as a means of slum clearance. The building of Northumberland Avenue, however, between Trafalgar Square and the Thames, in 1874-6 required the destruction of Northumberland House, the finest surviving aristocratic town house of the seventeenth century (Plates 64-7). Most of these schemes were carried through by the Metropolitan Board of Works, which had been established in 1855. Perhaps the M.B.W.'s greatest achievement was the construction of the Victoria Embankment between Westminster Bridge and Blackfriars Bridge. Designed by Sir Joseph Bazalgette, the Embankment completely changed the northern aspect of the Thames which, before the 1860s, had been lined with commercial wharves and warehouses. In association with this great improvement, which was as much concerned with London's sewerage as with traffic and urban order, the old eighteenth-century structures of Westminster Bridge and Blackfriars Bridge were rebuilt. The Thames was then further changed by repeated crossings with new lines of railway.

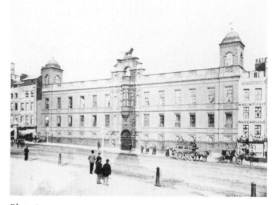

Plate 65

The railways made the most devastating impact on London in the mid nineteenth century. The first main lines had already been built when Talbot was photographing London, although, unfortunately, he seems not to have photographed London Bridge Station, first opened in 1836, nor the impressive Greek propylaeum at Euston, the terminus of the London and Birmingham Railway opened the following year. Waterloo Station was opened in 1848, King's Cross in 1851 and the rebuilt terminus of the Great Western at Paddington in 1854. Victoria was built on the site of a canal basin in 1860. Most of these stations lay on the fringe of central London. It was in the 1860s that the most destructive railway works were carried out, bringing lines into the very centre of the capital.

First, in the early 1860s, the South Eastern Railway extended its lines from London Bridge to Charing Cross, destroying in the process old St Thomas's Hospital and the Hungerford Market and Suspension Bridge, the last two being among the finest public works in London of the first half of the century (Plates 31, 108). The South Eastern Railway also invaded the City, its monster terminus at Cannon Street replacing several old City streets (Plate 203). Meanwhile, the London, Chatham & Dover Railway penetrated across the Thames to Blackfriars and Ludgate Hill, even crossing the

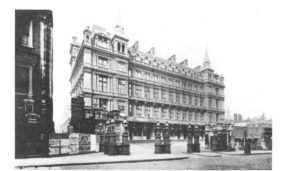

Plate 203

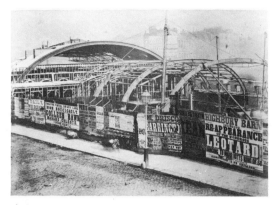

Plate 189

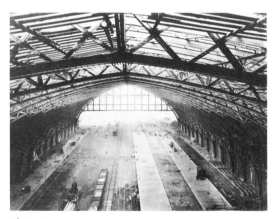

Plate 208

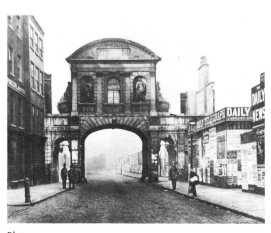

Plate 24

celebrated view of St Paul's from Fleet Street – a sin the railway company scarcely redeemed by facing the railway bridge with vulgar ornament. Such was Victorian private enterprise and self-confidence. In the same decade, the North London Railway arrived in Broad Street and the Midland Railway at St Pancras. During the following decade the Great Eastern Railway executed a most costly and destructive extension from Shoreditch to Liverpool Street.

In addition to all this railway work, the construction of the underground railway in central London added to the chaos. The Metropolitan Railway, the first underground railway in the world, opened from Paddington to Farringdon Street in 1863, having cut a destructive swathe through Clerkenwell. By the end of the decade much of the Metropolitan District Railway was open through Kensington and Westminster, virtually completing what would eventually become the Inner Circle. Even when these sub-surface lines were built under roads and the Embankment on the 'cut and cover' principle, they involved huge and inconvenient building works which, most fortunately, were recorded in a comprehensive series of photographs (Plates 189–200) – as also was the building of the vast new terminus at St Pancras, with its monster Gothic hotel and its train shed which at the time was the widest in the world (Plates 205–11). These photographs, indeed, confirm what seems evident from the building history: that half of London was being rebuilt in the 1860s, and that the city must have been a nightmare of dust, mud, scaffolding and confusion.

In addition to these railway and road works, there were also great numbers of new buildings going up: houses, churches, offices, hotels and public buildings, all varied and eclectic in style. Photographs have survived showing some of the more important public buildings while they were under construction and when they were completed. The great rebuilding of the Palace of Westminster in the 1840s and 1850s was well recorded and resulted in a reasonably comprehensive photographic coverage of Westminster (Plates 112–21), while the creation of the museums and public buildings in South Kensington was extensively photographed owing to the encouragement of photography by Henry Cole, first Secretary of the South Kensington Museum (Plates 173–9). On the other hand, the building of the new Royal Courts of Justice in the Strand in the 1870s seems not to have been recorded in photographs: there are only those showing old Temple Bar with the cleared site for Street's great Gothic pile behind it (Plate 24).

The photographs published in this book are of interest not only as illustrations of long-vanished old buildings and as some indication of the scale of the mid-Victorian rebuilding

of London; they are also full of information about small details of everyday life over a century ago. They reveal methods of building construction – with scaffolding of wooden poles lashed together with rope; methods of road mending, and the types of horse-drawn vehicles on the streets. They show shop fronts, bollards and street lamps; they indicate the nature of the road surface – cobbles or tarmacadam or earth, but always covered with the filth of horse-droppings, necessitating a crossing-sweeper at strategic points along the street. As well as showing the clothes worn in the streets of London, they illustrate the character of the streets, with the canvas awnings (which have now almost completely disappeared) over every shop; they show the practical elegance of the design of railings, lamps and bollards – which contrast so painfully with the ugly metal street furniture and signs which today disfigure London. And perhaps some of the most fascinating details evident in the calm, clear, large-plate photographs are the posters on the hoardings: the advertisements for newspapers and patent products, the theatre bills and railway excursion notices which covered the fencing placed round all building works.

And, of course, there are the human beings themselves. Because of the exposure times, early photographs are less valuable as social documents than late Victorian ones. Unfortunately, the daguerreotypes of street characters, taken by Richard Beard and used as the basis for illustrations in Henry Mayhew's *London Labour and the London Poor* of 1851, are lost, but many photographs of the 1860s survive to show the clothes and aspect of working men on building sites (Plates 169, 193). The 'instantaneous' stereoscopic photographs of the 1860s are full of information about ordinary street life – people on buses, cab ranks, street traders, and so on – while formal group photographs allow a study of everyday respectable clothes and enable one to wonder at their bagginess and untidiness, and at the practical inconvenience of stovepipe hats and crinoline dresses. It is just sad that the names of all the important people in group photographs are seldom recorded; who are all the gentlemen standing on the half-completed Victoria Embankment, and who are all the people celebrating the opening of the Crossness Pumping Station? (Plates 142, 186.)

We can only be grateful for the early photographs which have survived while regretting the disappearance of those whose existence was documented – the series of views from the top of the Duke of York's Column, for instance, which were engraved as a panorama for the *Illustrated London News* in 1851, and M. de St Croix's daguerreotypes of Regent Street. And did nobody take a camera up in the basket of a balloon

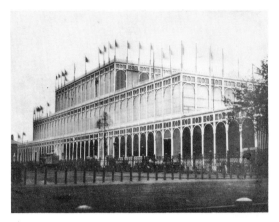

Plate 160

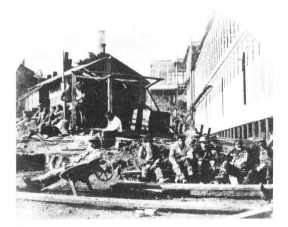

Plate 169

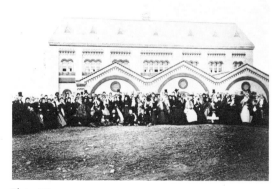

Plate 186

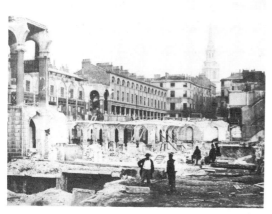

Plate 108

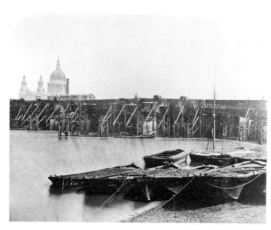

Plate 133

to make aerial photographs of London, as Nadar did of Paris? Furthermore, it seems so frustrating that photographs have not survived of buildings which did survive into the era of photography. Why did Talbot have to choose to photograph Waterloo Bridge, for instance, which stood until 1934, rather than Westminster Bridge or Blackfriars Bridge, both of which were rebuilt around 1860 without being photographed at close quarters? Talbot took several views in Regent Street; did he photograph the Quadrant before Nash's iron colonnade was taken away in 1848? And why could not someone have photographed the beautiful Hungerford Market in its prime? All we have are poignant photographs of it taken when it was being demolished (Plates 108, 110). But more early photographs of London may well be discovered.

Enough early photographs of London do survive to give a convincing and reasonably comprehensive impression of the city in the middle of the nineteenth century; enough to show how fine it was. While the photographs of the mid-Victorian improvements are of great interest, perhaps the most valuable photographs – certainly the most haunting and beautiful – are those which show London just before the transformation wrought by commerce, railways and the Metropolitan Board of Works; just before the Gothic Revival and rampant eclecticism undermined the Classical tradition which gave visual order to London's streets. M. de St Croix, Henry Fox Talbot, Roger Fenton and other anonymous photographers recorded the appearance of London at an ideal time, during a necessarily transient and short-lived phase when the new city of Nash, full of proud, harmonious public buildings in the Classical manner, was still smart, elegant and unaltered, while the older London of earlier centuries, the London of Wren and the Georgians, full of ancient and curious buildings, still survived. By the 1880s, the first London was altered, the second much destroyed.

Just how very interesting, varied and beautiful London was in the 1840s and 1850s is mercifully recorded for us today in some of the rare early photographs preserved largely in public museums and libraries, and illustrated in this book. Sadly, they suggest, in meticulous detail and haunting clarity, that almost every change that has taken place in London since those pioneering days of photography has been a change for the worse.

G.M.S.

A NOTE ON THE
ILLUSTRATIONS

Most of the plates which follow have necessarily been taken
from copy photographs in picture collections rather than from
the original prints. It has therefore not been possible to indi-
cate the dimensions of the original photographs. Where they
are known, the name of the photographer and the nature of
the original photograph is given. When the plate is not cap-
tioned as a 'daguerreotype' or a 'calotype', it may be assumed
that the original is an albumen print from a wet collodion
glass negative. When a precise date is not recorded, the dating
of a photograph is based on internal evidence. All photographs
are reproduced in their original form, without cropping.

The plates are not organized in precise categories but are
placed in a continuous sequence which is intended to be both
chronological and thematically and topographically infor-
mative. The selection begins with the earliest surviving pho-
tographs, which show pre-Victorian London; the later plates
illustrate the mid-Victorian transformation of the city. The
earliest photograph was taken in 1839, the latest in about
1879, by which date photography had become comparatively
commonplace.

SELECT BIBLIOGRAPHY

OLD PHOTOGRAPHS OF LONDON

John Betjeman, *Victorian and Edwardian London in Old Photographs* (Batsford, London, 1969)

Hermione Hobhouse, *Lost London* (Macmillan, London, 1971)

Graham Bush, *Old London: photographed by Henry Dixon and A. & J. Bool for the Society for Photographing Relics of Old London* (Academy Editions, London, 1975)

James L. Howgego, *Victorian and Edwardian City of London from Old Photographs* (Batsford, London, 1980)

Roger Whitehouse, *A London Album* (Secker & Warburg, London, 1980)

HISTORY OF PHOTOGRAPHY

D.B. Thomas, *The First Negatives* (Science Museum, London, 1964)

Helmut and Alison Gernsheim, *A Concise Dictionary of Photography* (Thames & Hudson, London, 1965)

(Exhibition catalogue) *'From today painting is dead'. The Beginnings of Photography* (Arts Council of Great Britain, London, 1972)

Oliver Matthews, *Early Photographs and Early Photographers* (Reedminster Publications, London, 1973)

Brian Coe, *The Birth of Photography* (Ash & Grant, London, 1976)

Helmut Gernsheim, *The Origins of Photography* (Thames & Hudson, London, 1982)

Brian Coe and Mark Haworth-Booth, *A Guide to Early Photographic Processes* (Victoria & Albert Museum, London, 1983)

PARTICULAR PHOTOGRAPHERS

John Hannavy, *Roger Fenton of Crimble Hall* (Gordon Fraser, London, 1975)

John Physick, *Photography and the South Kensington Museum* (Victoria & Albert Museum, London, 1975)

(Exhibition catalogue) *Sun Pictures. The Work of William Henry Fox Talbot, 1800–1877* (Science Museum, London, 1977)

Gail Buckland, *Fox Talbot and the Invention of Photography* (Scolar Press, London, 1980)

LONDON BUILDINGS

As well as the volumes of the *Survey of London* and the two volumes of Nikolaus Pevsner's *Buildings of England* (Penguin Books, Harmondsworth, 1952, 1957, etc.) and the standard architectural histories and biographies, the following were of particular use in identifying buildings in old London photographs:

John Timbs, *Curiosities of London* (London, 1855, 2nd edn 1868)

Harold P. Clunn, *The Face of London* (London, 1932, etc.)

THE PLATES

THE EARLIEST PHOTOGRAPHS OF LONDON

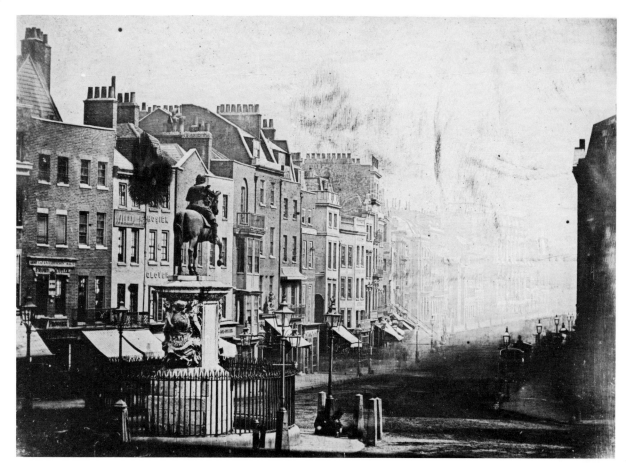

I
WHITEHALL FROM TRAFALGAR SQUARE, 1839
M. de St Croix
(Daguerreotype, image reversed)

This is one of the very first photographs taken in England. The Frenchman M. de St Croix demonstrated Daguerre's process in London in September and October 1839, when presumably this view was taken. The results were exhibited at the nearby Royal Adelaide Gallery of Practical Science in the West Strand in October and all the subjects seem to have been close at hand.

The comparative emptiness of the street is doubtless the result of the long exposure, although small boys by Le Sueur's equestrian statue of Charles I, and a cab driver, are visible. Just apparent in the distant haze is Inigo Jones's Banqueting House. Apart from this and the statue of Charles I, almost every building has since disappeared except the tall stuccoed house with the parapet railings immediately above the right-hand bollards (which also survive today, bearing the cipher of William IV) and the third house along to its left. In the nature of the daguerreotype process, the original image is reversed and has been corrected here.

Compare this view with Plate 68, taken about eighteen years later. See also Plates 60, 61. (*Science Museum, London*)

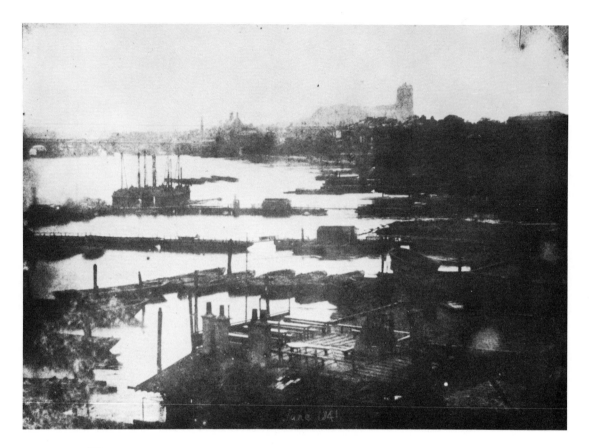

2 WESTMINSTER FROM THE HUNGERFORD MARKET, JUNE 1841
William Henry Fox Talbot
(*Calotype*)

This is probably the first paper photograph taken in London and Talbot wrote the date on the original, which is red in colour.

The view, looking across the wharves and jetties which lined the Thames until the Embankment was constructed in the 1860s, is remarkable for what it does *not* show. There is no Palace of Westminster: the old one was burned down in 1834 and the new one had not yet risen sufficiently to be visible. The only shape on the horizon is the roof of Westminster Hall - which survived the fire - to the left of the bulk of Westminster Abbey. Is the tower to the left of Westminster Hall a crane? To the left of that is the steep slope to the high point of Charles Labelye's Westminster Bridge, opened in 1750 and removed in 1861. To

the extreme right of the photograph is visible the roof of the Banqueting House.

This photograph must have been taken from the upper level of the Hungerford Market (see Plates 108-10), from which Brunel's suspension bridge would cross the Thames four years later. The roof in the foreground, laid out with tables and benches, was presumably a public house or place of entertainment exploiting the magnificent views of the bend in the Thames which at that time could only be seen from bridges and riverside buildings. Hungerford Pier was then the busiest point on the Thames for river traffic.

Compare Plate 130 for a similar view of the river, taken sixteen years later when Hungerford Bridge had been built. (*Science Museum, London*)

3

THE BANQUETING HOUSE, WHITEHALL, 1840S
William Henry Fox Talbot
(*Calotype*)

This is one of a series of calotypes of London buildings by Henry Fox Talbot, mostly taken in the early and mid 1840s.

Inigo Jones's Banqueting House, built in 1619-22 and refaced by Soane in 1829, survives today, together with Gwydyr House of 1772 (then housing the Poor Law Board) to its right on the south side, but the intervening mews building of *c.* 1792, possibly by Henry Holland, was re- placed in 1893 by the Royal United Service Institution, designed by Aston Webb and Ingress Bell. The Georgian building to the left, behind the horse, has also disappeared. This was Gower House, later Carrington House, designed by Chambers, built in 1765-74 and demolished in 1886 to make way for the new War Office. (*Science Museum, London*)

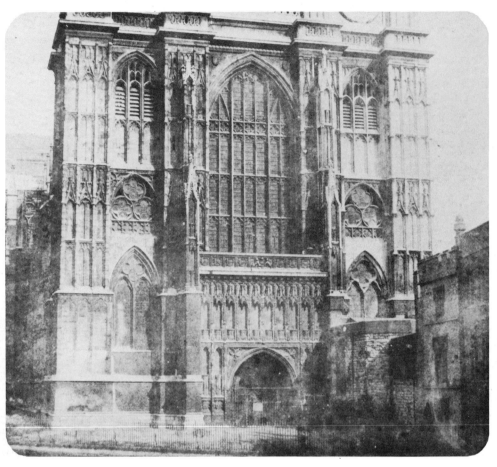

4

WESTMINSTER ABBEY, WEST FRONT, C. 1844
Nikolaas Henneman
(*Calotype*)

This photograph, known to be by Talbot's collaborator, was published as Plate 22 in Henry Fox Talbot's *The Pencil of Nature*, published in 1844-6. Although of so familiar and venerable a building, this view is not unchanged today and is of peculiar interest. In 1845, a year after it was taken, an Act of Parliament was passed to create Victoria Street, running from Westminster to the south-west. Work began on clearing property in 1847. The buildings seen in this photograph immediately to the right of the West Front were demolished and the building line set back (see Plate 125). The Jerusalem Chamber, immediately to the right of the west porch and under the south-west tower of the Abbey, survives today, but the buildings beyond do not. The Gothic Revival façade to the right is that of the Chapter Clerk's House, designed by Edward Blore and built in 1828-9 on part of the ancient site of the Westminster Gatehouse Prison (demolished in 1777). Some time between 1845 and his retirement as Surveyor to the Abbey in 1849, Blore designed the low block of offices which was erected in front of the newly exposed front of the Jerusalem Chamber, and which, in 1954-6, was converted into the Abbey shop by S.E. Dykes-Bower. Compare with Plate 126, taken a decade later. (*Sotheby Parke Bernet & Co., London*)

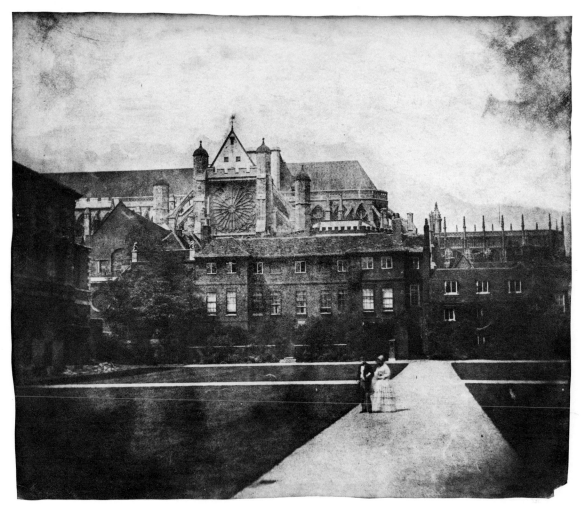

5 WESTMINSTER ABBEY FROM THE COLLEGE GARDEN, c. 1845
William Henry Fox Talbot
(*Calotype*)

As with Plate 4, this very early photograph of the Abbey is of particular interest as the view is different today. In the background, the south transept of the Abbey still has Tudor tops to the buttresses and the Chapter House still has its flat, 'unrestored' roof. Some of the buildings in the foreground are a puzzle as their architectural history seems not to have been investigated. On the far left is the end of the Westminster School Dormitory, or 'College', designed by Lord Burlington and built in 1722–30. To the right of that is the Abbey Dormitory, or 'School'. Next to that again is a seventeenth-century building which looks like Ashburnham House – the other side of the Dormitory – as it is today, having been enlarged. This mystery building had been altered by the twentieth century and was destroyed in the destructive bombing of this part of Westminster in the Second World War. What was it? The next house, in front of Henry VII's Chapel, was rebuilt by Pearson in 1884. Who the people are, dressed so accurately in the fashions of the mid 1840s, is not recorded. (*Science Museum, London*)

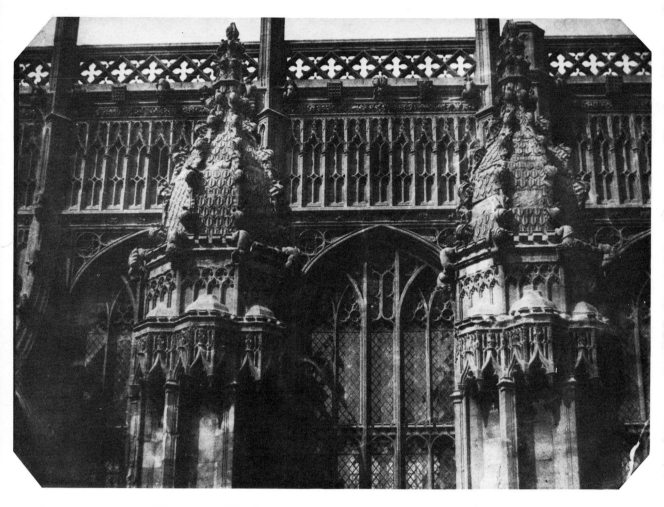

6 HENRY VII's CHAPEL, WESTMINSTER ABBEY, 1840s
William Henry Fox Talbot
(*Calotype*)

The shadows suggest that this close view of the upper part of Henry VII's Chapel is of the south side of the building. Talbot must therefore have set up his camera on the roof of one of the houses in Old Palace Yard, next to the Abbey, which were later demolished. This photograph is of interest as it shows the stonework thirty years after the restoration carried out in 1809-22 by Thomas Gayfere, ostensibly under the direction of James Wyatt. Gayfere had taken plaster models of the mouldings and details of the decaying exterior of the Chapel and had carefully trained masons in the execution of what was then the unfamiliar Gothic style. At the time of writing, all this stonework is being renewed again, an inevitable and continuous process with the exterior of the Abbey. (*Science Museum, London*)

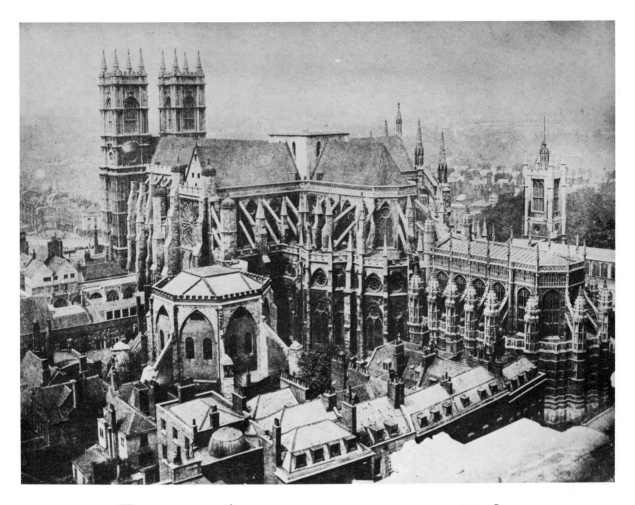

7 WESTMINSTER ABBEY FROM THE SOUTH-EAST, LATE 1850S

Anon.

This photograph was taken from near the top of the newly completed Victoria Tower of the New Palace of Westminster (Plate 119 must have been taken at about the same time, looking in the reverse direction) and superbly conveys the beauty of old Westminster before the clearance of so many houses. The principal feature is the unrestored Chapter House, still visibly in the state described by George Gilbert Scott in *Gleanings from Westminster Abbey* (1863): 'Seldom do we see a noble work of art reduced to such a wreck!' The Chapter House had been made into a public Record Office and, in the early eighteenth century, the vault was taken down and the tracery removed from the windows. The interior was filled with galleries, shelves and record presses. 'Of the external details of the chapter-house scarcely a trace remains; decay and mutilation have brought their work to a final completion' – as can be seen here. On the left of the photograph, above the cloister, are the works for clearing Victoria Street, but the Westminster Palace Hotel (1859–61) on the corner of Tothill Street is not yet built. (*The Dean and Chapter of Westminster*)

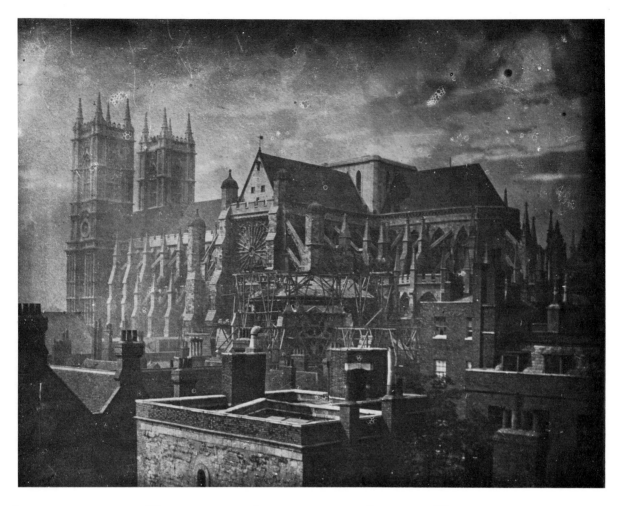

8 WESTMINSTER ABBEY AND THE CHAPTER HOUSE
FROM THE SOUTH-EAST, LATE 1860S

Anon.

This photograph was taken from the roof of one of the houses in Old Palace Yard, which then shielded from public view the remains of Richard II's Jewel House (visible in the foreground of the photograph), whose nakedness, which is of purely antiquarian interest, is today unnecessarily exposed. Behind, work is under way on Scott's great restoration of the Chapter House, begun in 1866. Tracery is being put back in the windows whose mutilated state is visible in Plate 7, and the flying buttresses are being rebuilt. At this stage, the Tudor tops to the buttresses of the Abbey's south transept are still in position. They would not be present for much longer: Scott replaced these by pinnacles in about 1870. (*The Dean and Chapter of Westminster*)

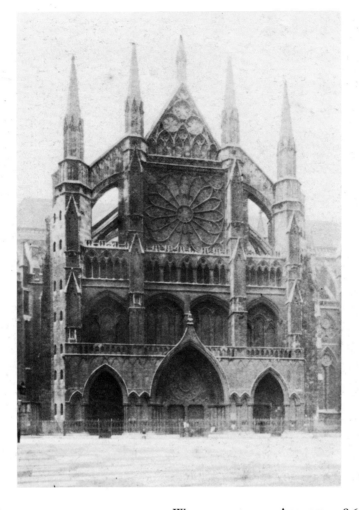

9 THE NORTH TRANSEPT OF WESTMINSTER ABBEY, 1860s
London Stereoscopic Co.

The north transept, the principal entrance to the medieval Abbey with three giant portals in the French manner, no longer looks as it does in this photograph. In the 1860s the transept front was still in the state in which it was left after the restoration of 1719-22, carried out by William Dickinson, Surveyor to the Abbey, under Wren's supervision. In 1875-80 the screen wall across the portals was removed in Scott's restoration of the doors to their original form. In 1884-92 the upper parts of the transept were completely changed in design during J. L. Pearson's 'restoration', although Dickinson's drawing of the transept, signed by Wren, had survived and showed that the form of the rose window had merely been renewed in the early eighteenth century. W.R. Lethaby considered that the blank tracery in the gable, visible in this photograph, was the original work of the thirteenth century; Pearson removed it and redesigned the gable in a different and inauthentic form. (*Science Museum, London*)

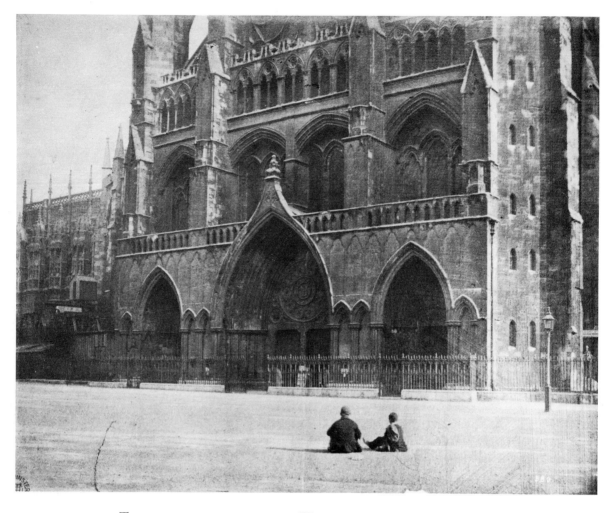

10 THE NORTH TRANSEPT OF WESTMINSTER ABBEY, 1870

Anon.

This photograph shows the three great portals prior to Scott's restoration of 1875-80. The screen wall, gable and tympanum above the central doors are all as they were left after Dickinson's restoration of 1719-22. The railings across the transept front are presumably those 'in the Gothick manner' raised by Dickinson in 1722 and since removed. Scott began investigative work on the portals in 1871. The boarding and gantry to the left of the transepts suggest that work was about to begin. (*Westminster City Libraries*)

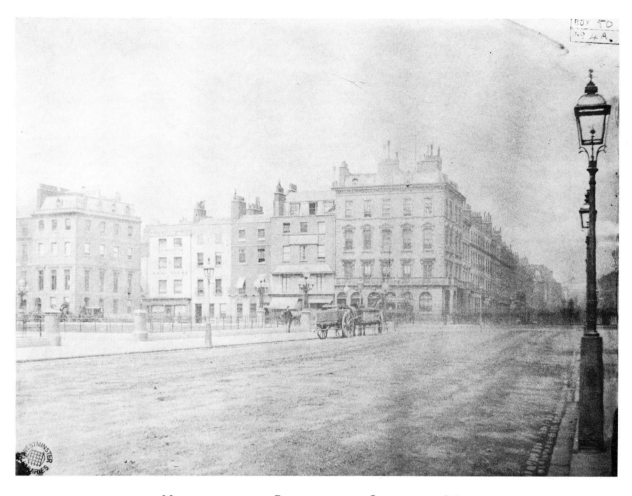

11 NORTH SIDE OF PARLIAMENT SQUARE, 1860S

Anon.

Parliament Square was originally laid out by Sir Charles Barry, using granite bollards similar to those in Trafalgar Square. To the right of the photograph is Parliament Street, running to Whitehall; to the left is the entrance to King Street. All these buildings were removed in 1898 to make way for the building of J.M. Brydon's New Government Offices and for widening Parliament Street to the width of Whitehall. (*Westminster City Libraries*)

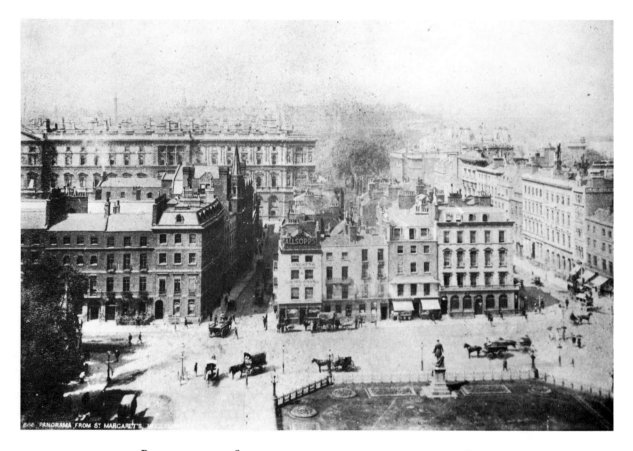

12 PARLIAMENT SQUARE LOOKING NORTH, LATE 1870s

Anon.

This photograph, presumably taken from the roof of St Margaret's, Westminster, shows in the distance the new Home and Colonial Offices, the eastward extension of the new Foreign Office designed by George Gilbert Scott which was completed up to a widened Parliament Street in 1874. King Street, which originally ran through to Whitehall, has now been truncated. It disappeared, along with all the buildings on the north side of the Square, in 1898. Since Plate 11 was taken, Barry's granite bollards have been replaced by Gothic railings. The statue of Peel, by Noble, was erected in 1876. It now stands on the west side of the Square while the Gothic Buxton Memorial Fountain, just visible behind the trees on the left, now stands in Millbank Gardens. (*Westminster City Libraries*)

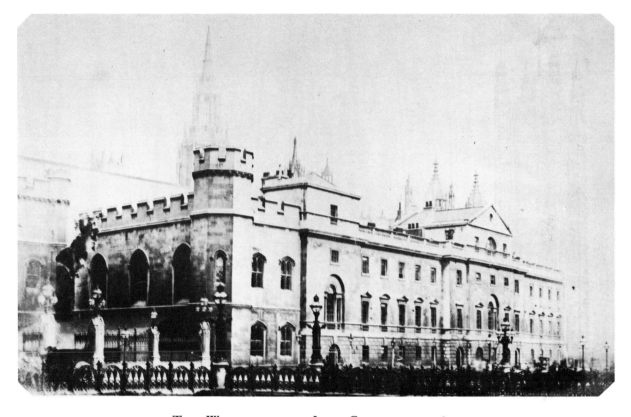

13 THE WESTMINSTER LAW COURTS, c. 1870
Anon.

Although a little out of focus and damaged on the left-hand side, this photograph gives a good impression of the Law Courts in St Margaret's Street (facing Parliament Square) which survived until 1883. Attached to the west side of Westminster Hall, they formed the principal façade to the Palace of Westminster before the fire of 1834. Most photographers, concentrating on the Gothic splendour of the rebuilt New Palace of Westminster, managed to avoid this Classical survival. The central pedimented section and south wing was built by John Vardy after Kent's design in 1755-8. The northern part was faithfully continued by Soane in 1822-4, reproducing the typically Kentian tower at the south end which is missing here as it was gutted by fire in 1834 and not replaced. However, in 1825 the growing neo-Gothic sentiment in Parliament demanded that Soane's return front be taken down and something in the style of Westminster Hall built instead. This, seen on the left, was disowned by Soane. See also Plates 123, 124. (*Christopher Wood, Esq.*)

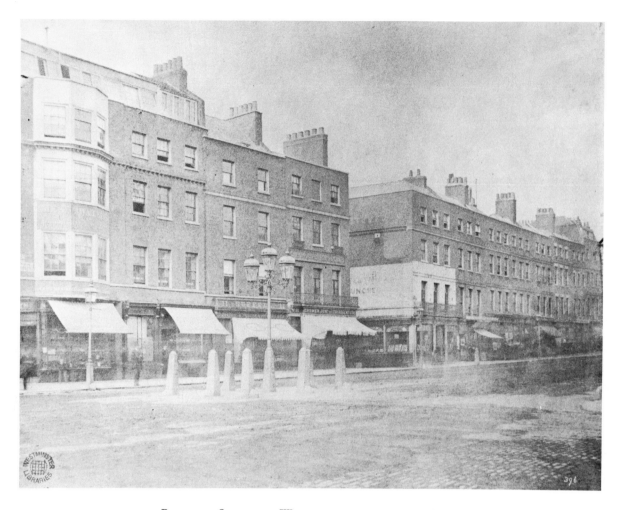

14 BRIDGE STREET, WESTMINSTER, MID 1860S

Anon.

These Georgian houses on the north side of Bridge Street, facing the Palace of Westminster, were progressively demolished in the late 1860s and early 1870s. The turning off the street is Cannon Row, which today leads to Norman Shaw's Scotland Yard building. This photograph shows the same houses as in Plate 15 For the houses on the south side of Bridge Street, demolished in 1860, see Plate 121. (*Westminster City Libraries*)

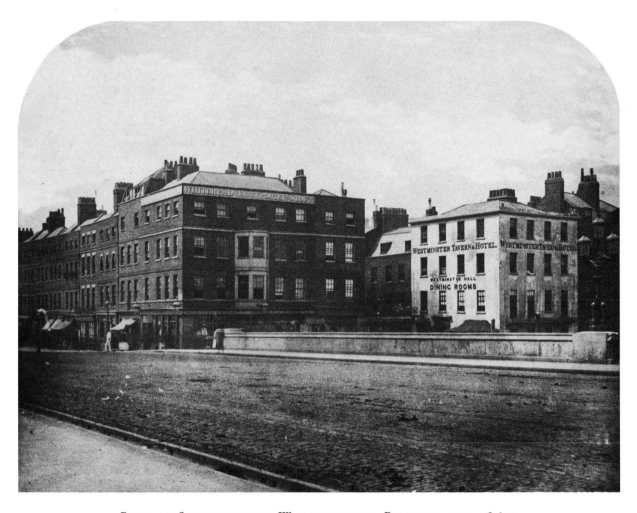

15 BRIDGE STREET FROM WESTMINSTER BRIDGE, MID 1860S

Anon.

This photograph was taken after the completion of the new Westminster Bridge with its triple Gothic lamps, designed by Thomas Page and built in 1859–62, but before the building of the Victoria Embankment and the Metropolitan District Railway. All these buildings were demolished in the late 1860s and early 1870s. In 1868 the Metropolitan District Railway was opened from South Kensington to a new station on the north side of Bridge Street between Cannon Row and the Thames. The buildings on the corner which housed Ginger's Hotel and a wine merchant, together with the Westminster Tavern and Hotel, were replaced by a block in the French Second Empire manner containing the St Stephen's Club, opened in 1875. Work on the Victoria Embankment itself, from Westminster Bridge to the Temple Gardens, began in 1865 and was open for pedestrians in 1868. The new stretch of parapet wall along the bridge visible in the photograph had to be removed when the Embankment was finally completed in 1870. See also Plates 51, 123. (*Westminster City Libraries*)

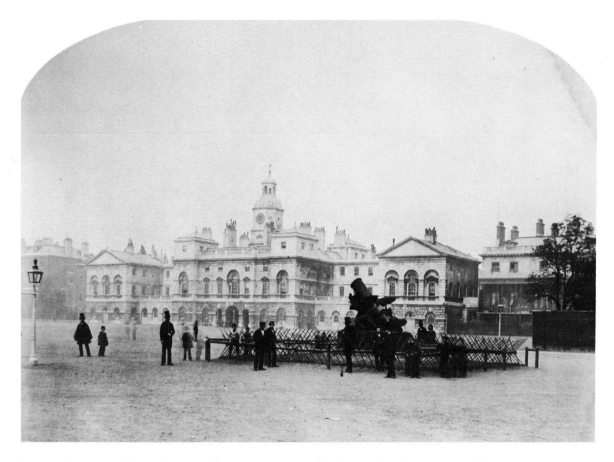

16 THE HORSE GUARDS FROM ST JAMES'S PARK, C. 1860
Roger Fenton

This view of the Horse Guards, designed by William Kent and built after his death by the Board of Works in 1750-59, is essentially unchanged today. However, the French mortar mounted on a dragon, cast at Seville and captured after the Battle of Salamanca and presented to the Prince Regent by the Spanish government, has since been moved much nearer the Horse Guards - presumably to leave more space for car parking. The house to the right, designed by James Paine, built in 1754-8, rebuilt by Henry Holland and now part of Dover House, has since had the iron verandah (which here hides the Venetian window) removed from the first floor, while the Georgian house to the left received in 1910 a stone front from No. 37 Great George Street, which also originally faced the Park (see Plate 122). St James's Park was lit by gas in 1822; possibly the gas lamps visible are the ones erected then. (*National Monuments Record*)

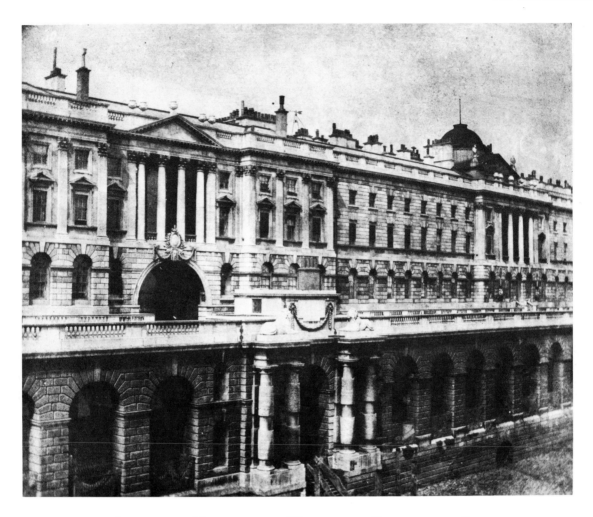

17 SOMERSET HOUSE FROM WATERLOO BRIDGE, C. 1845

William Henry Fox Talbot

(*Calotype*)

Somerset House was designed by Sir William Chambers and built in 1776-96. Talbot took his photograph standing on Waterloo Bridge, two decades before the construction of the Embankment, so the massive rusticated basement to the terrace rises, as Chambers intended, out of the Thames itself. The magnificence of this basement, now spoiled by the raised road in front, is also evident in Plates 18, 19. (*Science Museum, London*)

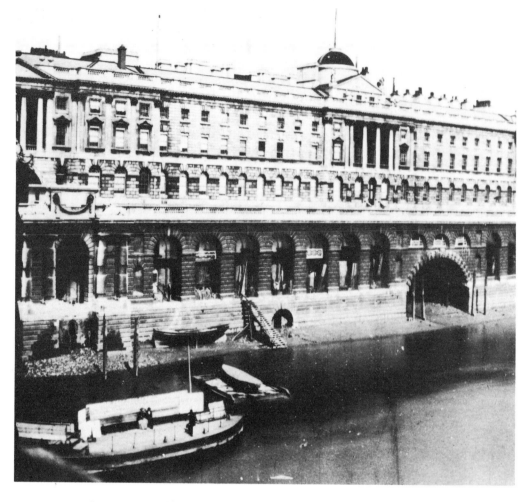

18 SOMERSET HOUSE FROM WATERLOO BRIDGE, 1857

Anon.

(Stereoscopic photograph)

This photograph, unlike Talbot's (Plate 17), shows the vast central Water Gate in Chambers's rusticated basement to Somerset House, which has since been partly obscured and spoiled by the construction of the Victoria Embankment in 1865–70. The upper part of the building remains unchanged today. (*B.E.C. Howarth-Loomes, Esq.*)

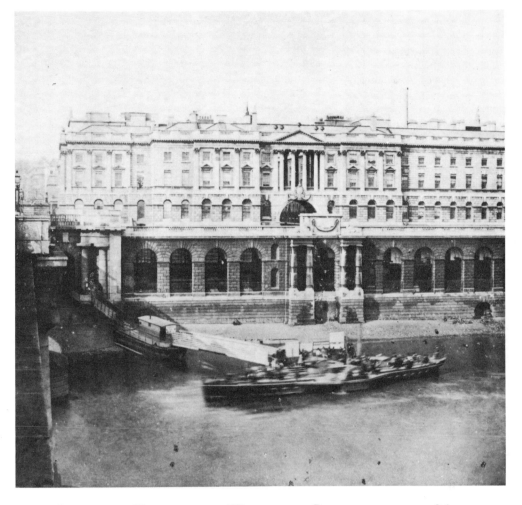

19 SOMERSET HOUSE FROM WATERLOO BRIDGE, EARLY 1860S

Anon.

(Stereoscopic photograph)

See also Plates 17, 18. This view shows the western extension of Somerset House along the Waterloo Bridge approach, built by Sir James Pennethorne for the Inland Revenue in 1851-6 generally following Chambers's style. Also visible is one of the Doric entrances to the river stairs designed by John Rennie as an integral part of his magnificent bridge, opened in 1817 and demolished in 1934. Here, as can be seen, was a floating pier for the paddle-steamers which then plied along the Thames. (*B.E.C. Howarth-Loomes, Esq.*)

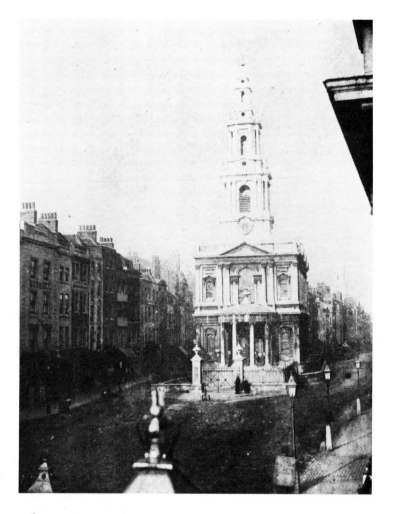

20 ST MARY-LE-STRAND, c. 1845
William Henry Fox Talbot
(*Calotype*)

COVENT GARDEN PIAZZA AND 21
JAMES STREET, 1877
Anon.

This photograph, looking east along the Strand, must have been taken from the first floor of a shop immediately to the west of Somerset House – the nose of a keystone head on Chambers's arcuated ground floor can just be seen. (In Tallis's *London Street Views* of 1838-40, No. 150 Strand, two doors up – Holyland's House, Tailors and Cloak Maker – has a first-floor balcony.) James Gibbs's church, built in 1714-17, remains unchanged, except that it has lost the walls and railings along the sides. All the other buildings on the north side of the Strand were demolished in 1900 when the Aldwych was created and the Strand widened. (*Science Museum, London*)

This photograph was taken shortly before the demolition of the last surviving part of Inigo Jones's original design for Covent Garden. The building on the corner of James Street on the north side of the square had been meanly rebuilt above the ground floor, but the arches over the pavement – the 'piazzas' – and the neighbouring buildings were structures of the 1630s (see Plate 22). The three houses were replaced by the block known as Bedford Chambers, designed by Henry Clutton in a manner influenced by Jones's original design. (*The Bedford Estates*)

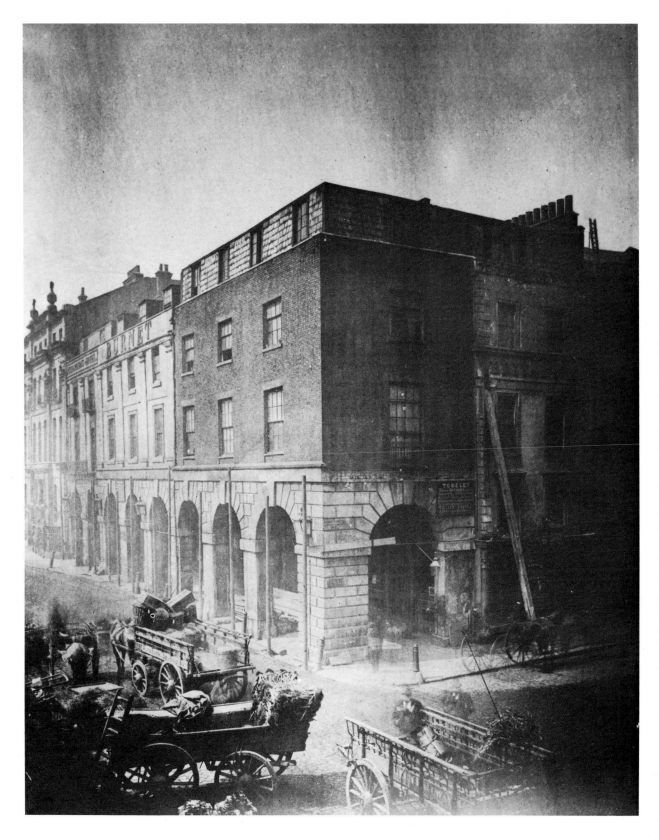

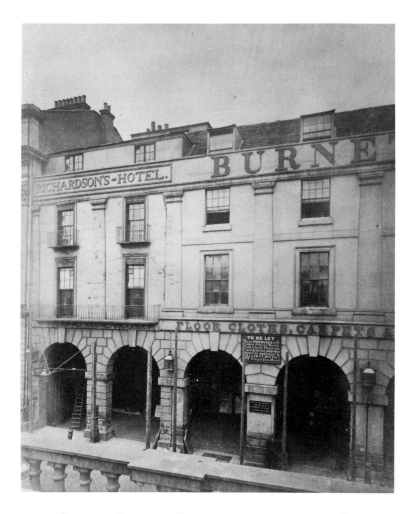

COVENT GARDEN PIAZZA, NORTH SIDE, 1877
Anon.

These two buildings, along with their neighbour to the east (Plate 21) on the corner of James Street, were demolished in 1877. Although much altered above the ground-floor arcades, they were essentially structures of the 1630s, designed by Inigo Jones. The Bedford Estate was conscious of their historical value and here, as elsewhere on the Estate during the rest of the century, made a photographic record of buildings about to be redeveloped. No. 43 King Street, immediately to the left, survives today. (*The Bedford Estates*)

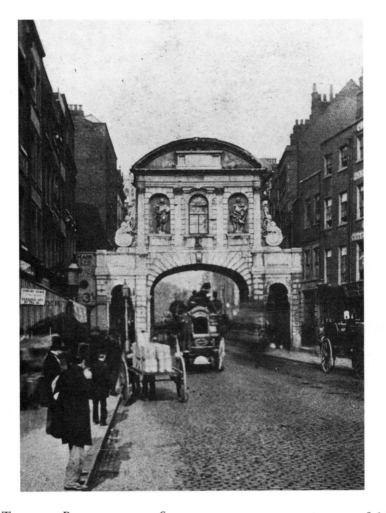

23 TEMPLE BAR AND THE STRAND FROM THE WEST, C. 1866
Anon.

Temple Bar marks the boundary between the Cities of London and Westminster; beyond the Bar, in the City of London, the Strand becomes Fleet Street. The arched structure across the narrow street, complete with wooden gates, was built in 1670–72 and may well have been designed by Sir Christopher Wren, although it was actually built by Joshua Marshall, Master of the Masons' Company, and Thomas Knight, the City Mason. This photograph was evidently taken shortly before the clearance of houses on the north side of the Strand for the building of the new Law Courts in 1866–8: the shop awning on the left bears the notice 'Coming Down ... Cleared out by the 25th'. The Temple Bar itself still had another decade of life in London. It had been condemned as an obstruction to traffic by the Metropolitan Board of Works in 1858, but it came under the independent jurisdiction of the City of London. In 1878 Temple Bar was finally taken down, its stones being left on an empty site off Farringdon Street until 1888, when they were bought and re-erected at Theobald's Park by Sir Henry Meux. (*National Monuments Record*)

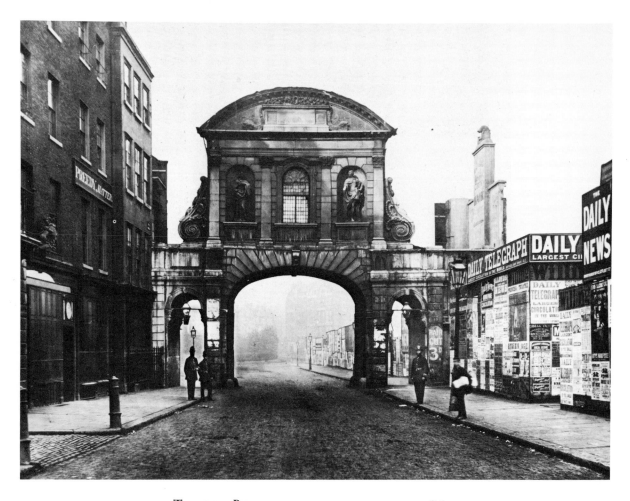

24 TEMPLE BAR FROM THE EAST, LATE 1860S

Anon.

This photograph was taken shortly after the massive clearance of property on the north side of the Strand in 1866-8. Four hundred buildings, housing a population of 4,125, were removed to widen the Strand and to build the new Royal Courts of Justice. Following the decision to remove the Courts from Westminster (see Plates 123, 124), a competition for the design of the new buildings was held in 1866. G.E. Street was eventually appointed architect but, after changes of mind about the site and other vicissitudes, work did not begin until 1874. The new Law Courts were opened in 1882. Temple Bar stood longer than the abutting houses because several schemes were floated to re-erect the structure on the new Embankment, or in Hyde Park. It was finally taken down in 1878 and, in 1880, replaced by the present pylon designed by Sir Horace Jones. Through the arch can be seen the churchyard of St Clement Danes and the remaining buildings of Pickett Street, curving round the north side of the church, laid out by George Dance in 1802-4. (*Gerald Cobb, Esq.*)

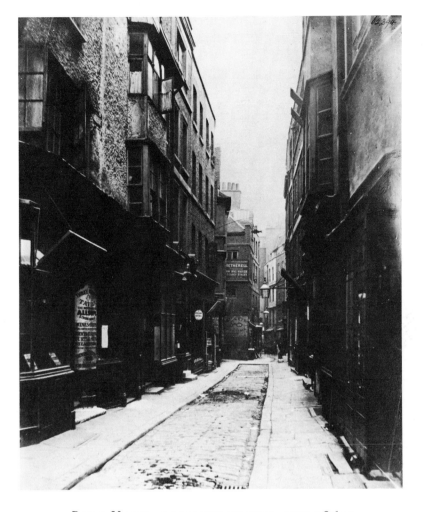

BELL YARD, LOOKING SOUTH, MID 1860s
Anon.

Bell Yard runs from Carey Street, Lincoln's Inn, to Fleet Street. It was accessible from Fleet Street through an arch under a house, just visible in this photograph. All the buildings on the right were demolished in 1866–8 for the Law Courts (see Plate 24: the entrance to Bell Yard is visible on the right). The shops on the left all disappeared shortly afterwards. A number of the buildings employ mirrors hanging out at an angle on chains which were intended to reflect light from the sky above into the interiors; these were a common feature of dark City streets in the nineteenth century. (*Victoria & Albert Museum*)

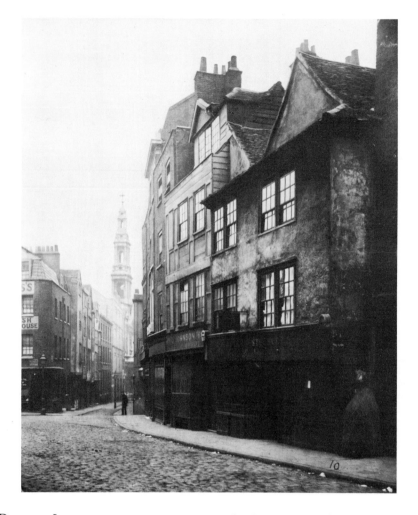

26 DRURY LANE LOOKING TOWARDS ST MARY-LE-STRAND, 1876
Alfred and John Bool and Henry Dixon
(Carbon print)

This photograph was taken for and published by the Society for Photographing Relics of Old London. The Society was founded in 1875 by a number of architects and antiquarians anxious to record the old houses, inns and streets of London which were then disappearing so rapidly: swept away for redevelopments and slum clearances. Between 1875 and 1886 twelve series of photographs were issued, mostly taken by Henry Dixon.

These typical old London houses of the seventeenth century and earlier – gabled and plastered-over timber construction – were demolished in 1890 and the streets themselves swept away for the creation of the Aldwych a decade later. Only the steeple of St Mary-le-Strand survives. (*Guildhall Library, City of London*)

THE OLD CITY OF LONDON

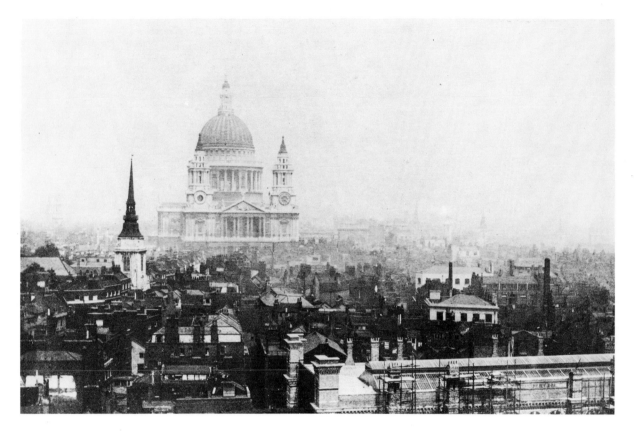

27 ST PAUL'S CATHEDRAL AND THE CITY FROM THE WEST, c. 1865

Anon.

Although the presence of Ludgate Hill Station in the foreground – opened temporarily in 1864 and permanently in 1865 – is a symptom of the great Victorian rebuilding of the City of London in the 1860s and 1870s, this photograph essentially shows the City skyline as created by Wren, with hardly any buildings rising above a low general height to challenge St Paul's and the steeples of the City churches. It was taken from the steeple of St Bride's, Fleet Street. The prominent steeple to the left is that of St Martin's, Ludgate (see Plate 40). Although a large structure, Ludgate Hill Station had a comparatively short and unsuccessful life. The London, Chatham & Dover Railway's Metropolitan Extension over Blackfriars Bridge, of which it was for a time the terminus, was extended to Holborn Viaduct in 1874, leaving Ludgate Hill Station between two other large stations for City commuters. It was closed to passenger traffic in 1929, although much of the structure of the station is still visible today. (*Gerald Cobb, Esq.*)

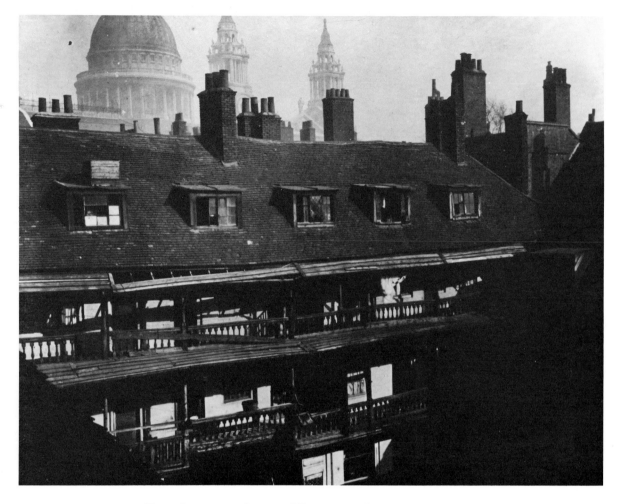

28 THE OXFORD ARMS, WARWICK LANE, c. 1873–5
Alfred and John Bool and Henry Dixon
(*Carbon print*)

This photograph was entitled 'A general view of the inn from the windows of the Old Bailey looking towards St Paul's'. It is the most famous, and the most poignant perhaps, of the photographs published by the Society for Photographing Relics of Old London; indeed, it was the threatened demolition of this inn which provoked the formation of the Society. The inn, rebuilt after the Great Fire of 1666, was at the end of a lane off the west side of Warwick Lane. As the title indicates, it was overlooked by the Sessions House next to Newgate Prison in the Old Bailey (see Plate 41). The Oxford Arms was a quintessential example of the London coaching inn, with galleried wings surrounding the yard where horses and coaches assembled. Today, just one wing of the George in the Borough, Southwark, survives to show what such inns were like. Inns like these were ruined by the advent of the railways and most declined, to be demolished in the 1860s and 1870s. The furniture in the Oxford Arms was sold in 1868 and the rooms let out in tenements. The threat to the inn in 1873 led to efforts to record its appearance – already very dilapidated – and it was demolished in 1878. The site is now occupied by the Old Bailey extension of the 1970s, designed by McMorran and Whitby. (*Guildhall Library, City of London*)

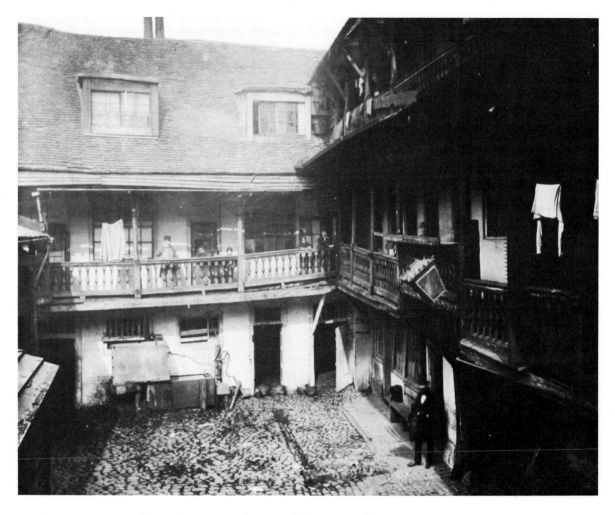

29 THE OXFORD ARMS, WARWICK LANE, c. 1873-5
Alfred and John Bool and Henry Dixon
(*Carbon print*)

This view, another of the first series published in 1875 by the Society for Photographing Relics of Old London, shows the yard of the coaching inn looking north. The entrance from Warwick Lane was under the lamp on the right-hand side. The dilapidation and squalor into which this once proud inn had sunk is painfully evident; it had only a few years of life left. (*Guildhall Library, City of London*)

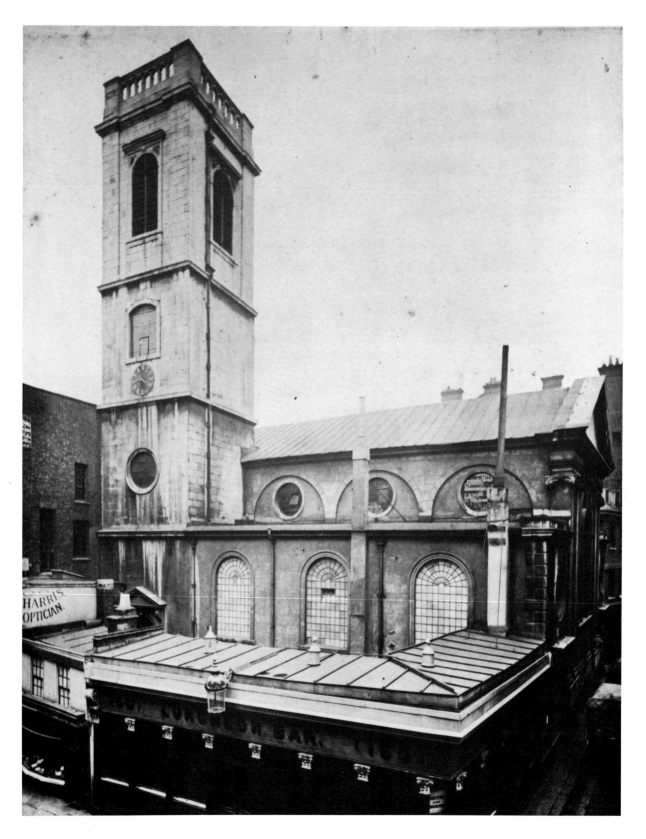

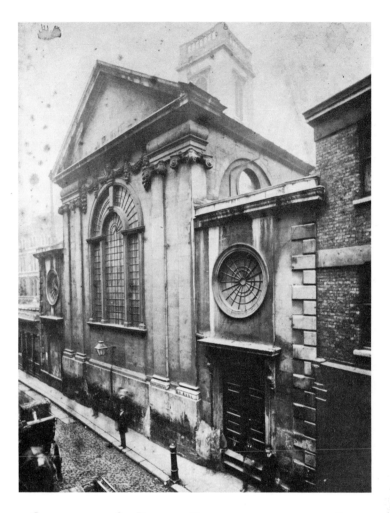

30, 31 CHURCH OF ST DIONIS BACKCHURCH, MID 1870S
Anon.

These photographs show one of several City churches which were demolished for commercial redevelopment in the late nineteenth century. A few had earlier been removed to make way for the expansion of public buildings, such as the Bank of England, but the depopulation of the City effected by the advent of the railways and the consequent replacement of houses by purely commercial buildings in the mid nineteenth century left many City parishes with no resident congregations. As Wren's churches were not then admired architecturally, it seemed sensible to the Church of England to sell the sites of redundant churches and to use the money so raised for the building of new churches to serve the expanding suburbs. This policy was assisted by the Union of Benefices Act of 1860, which allowed the demolition of churches at the discretion of the Bishop.

St Dionis Backchurch was rebuilt by Wren after the Great Fire. The body of the church was built in 1674–7, the tower following a decade later. One photograph shows the church exactly as it appears in early nineteenth-century prints, rising above the little shops which fronted Fenchurch Street. In 1878 the church was demolished but the shops survived – for a while. Some of Wren's fittings were installed in the new church of St Dionis, Parsons Green, built in 1886 to the designs of the Church Commissioners' architect, Ewan Christian. Incredibly, just a few years earlier it had been proposed to rebuild St Dionis on its City site to an Italian Gothic design by G.E. Street. (*National Monuments Record*)

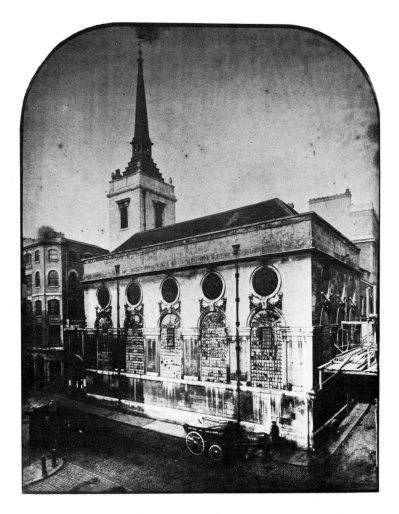

32 CHURCH OF ST MICHAEL, QUEENHITHE, C. 1876
Anon.

St Michael's was another victim of commercial redevelopment in the 1870s. The church, rebuilt by Wren in 1677 after the Great Fire, stood on the north side of Upper Thames Street. Its distinctive steeple, surmounted by a weathervane in the shape of a ship, proclaimed the nearness of the river and Queenhithe dock, and its comparatively elaborate exterior – for a Wren church – indicated the importance of Thames Street in the seventeenth century.

The parapet was added in the 1830s. Originally the roof came down to the upper cornice, so allowing rainwater to fall on passers-by. The church was demolished in 1876. The broken windows and the scaffolding at the east end suggest that this photograph was taken shortly before demolition. Some of the fittings were transferred to nearby St James's Garlickhythe, and the weathervane was re-used on St James's Rectory. (*National Monuments Record*)

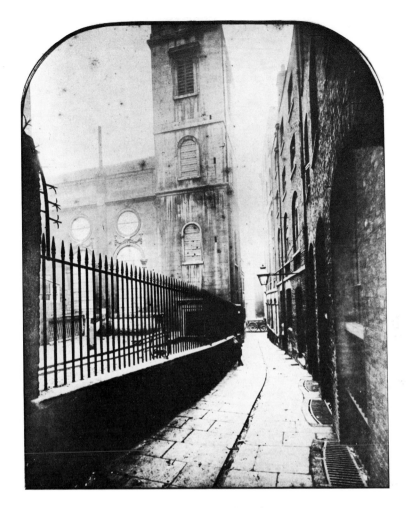

33 HUGGIN LANE AND ST MICHAEL'S, QUEENHITHE, C. 1876
Anon.

This photograph, looking south towards Upper Thames Street, shows the disused graveyard of St Michael's, Queenhithe. It also shows that, unlike almost every other Wren church, it was faced in ashlar stone on all four sides. Huggin Lane was typical of the very narrow alleys which characterized the old City of London and which today have largely disappeared. The church was demolished in 1876. (*National Monuments Record*)

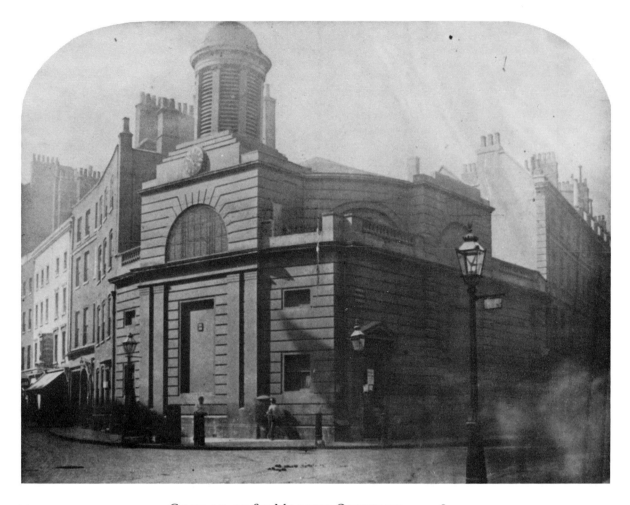

34 CHURCH OF ST MARTIN OUTWICH, c. 1874

Anon.

This church was one of the very few in the City to be built after the period of Wren. The medieval church of St Martin Outwich had escaped the Great Fire but was damaged by fire in 1765. It was then replaced by a new church designed by Samuel Pepys Cockerell and built in 1796–8, which was remarkable for its oval plan. St Martin's stood on a conspicuous site on the corner of Bishopsgate and Threadneedle Street, opposite the Baltic Exchange. As its austere neo-Classical architecture was even less respected than the robust Classicism of Wren, it was obviously a prime target for a profitable redevelopment and in 1874 the church was demolished. The Georgian houses to its left, in Bishopsgate, did not survive for much longer. (*National Monuments Record*)

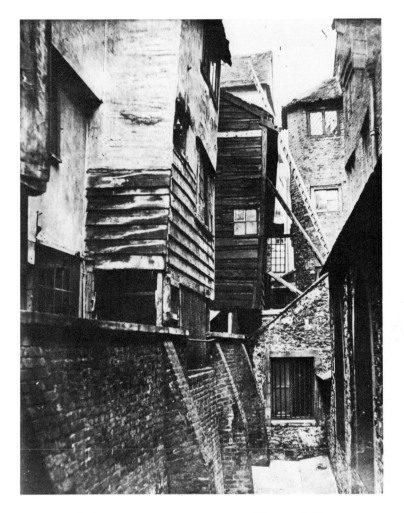

35 ST BARTHOLOMEW'S, SMITHFIELD, AND THE POORS' CHURCHYARD, 1860s
.Anon.

This view is very similar to one taken of the same subject a decade later for the Society for Photographing Relics of Old London. Whether this photograph was taken to show a terrible slum or to record picturesque old London is not clear. These houses, built in traditional forms which were revived by Late Victorian domestic architects (brick, plaster, weatherboarding, with a combination of leaded lights, and windows with wooden glazing bars), were demolished at the end of the century when the venerable and much mutilated church was restored by Sir Aston Webb. (*Greater London Council Photographic Library: the Doulton Group of Companies*)

36　　HOLBORN HILL LOOKING EAST, 1864
Anon.

This photograph shows the steep descent to the valley of the River Fleet which it was necessary for traffic from Holborn to Cheapside to negotiate before the construction of the Holborn Viaduct. At the bottom of the hill, crossing the Fleet, was Holborn Bridge; then the traffic rose up the eastern slope of Holborn Valley up Skinner Street, visible to the right of this view. Before Skinner Street was constructed in 1802 to a plan by George Dance, traffic had to ascend Snow Hill, the beginning of which is just visible in the centre of the photograph. The street opening to the left is the northward extension of Farringdon Street, then called Victoria Street, which was cut through on the line of the Fleet in 1845–56. On the right-hand side of the photograph is the beginning of Shoe Lane; beyond that, out of the frame, is the Wren church of St Andrew, Holborn. Just out of the picture to the left is Fearon's notorious gin shop, No. 94 Holborn Hill, built in about 1830. This is shown in a very detailed drawing of the street, reproduced as Plate 10 in Mark Girouard's *Victorian Pubs* (1975), made at about the same time and from a similar viewpoint as this photograph. Every building visible here was destroyed in the massive works for building Holborn Viaduct, begun in 1867 and completed in 1870 (see Plates 156–60). (*Gerald Cobb, Esq.*)

37 THE CORNER OF NEW BRIDGE STREET AND FLEET STREET, 1873
Anon.

This photograph shows the last remaining corner of the road junction which became Ludgate Circus. The eastern corners were demolished in connection with the works for the London, Chatham & Dover Railway, from Blackfriars to Smithfield across Ludgate Hill, in 1864; the land was purchased by the City Corporation and, in conjunction with the Metropolitan Board of Works, New Bridge Street and Farringdon Street were widened and half a circus constructed. The north-west corner was made in 1868 when St Bride Street was constructed (see Plate 161), and the last corner was demolished and made concave in 1875. The legend on the corner building presumably refers to the fact that the original premises of Lanfear, Outfitter, were on the street corner which was demolished first. The shop front is covered in stickers saying 'Selling Out' and 'Clearing Out'. In Tallis's *London Street Views* of 1834-40, this building – No. 104 Fleet Street – was occupied by J. Waithman & Co.'s shawl warehouse. The narrow house to the right, No. 103, was the *Sunday Times* newspaper office, while the house to the left, No. 1 New Bridge Street, was the Hand in Hand Fire and Life Insurance Office. Above, to the right, is the steeple of St Bride's, Fleet Street, by Wren, which alone of these buildings survives today. (*National Monuments Record*)

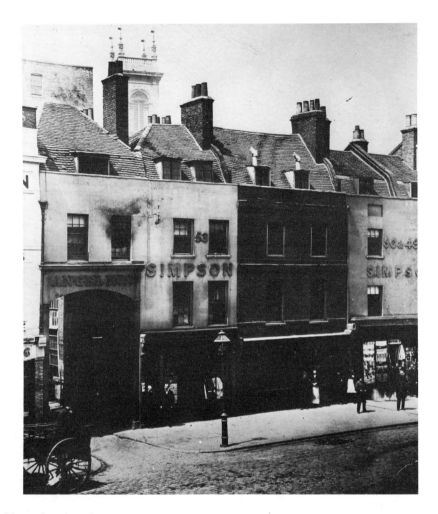

38 THE ANGEL INN,
FARRINGDON STREET, 1860s

Anon.

FLEET STREET AND 39
LUDGATE HILL, c. 1855-7

Anon. (*Calotype*)

The Angel Inn lay off the west side of Farringdon Street, just north of the Farringdon Market, built in 1829 and removed in 1874. The Angel was one of many old coaching inns to be demolished in the 1860s and 1870s as part of the great Victorian rebuilding of the City (see Plates 28-9). The Angel, together with the houses to the north shown in this photograph, was destroyed in 1867 as part of the works for the Holborn Viaduct (see Plates 156-60: the lamp visible on the extreme left of Plate 160 seems to be the same as that on the extreme left of this photograph). Behind, the tower of the Wren church of St Andrew, Holborn, can be seen. (*National Monuments Record*)

This view is in Volume VI of the albums of photographs collected and arranged by the Prince Consort. It shows the famous view of St Paul's Cathedral from the west before the construction of Ludgate Circus (see Plate 37) and before the disastrous advent of the London, Chatham & Dover Railway's bridge across the bottom of Ludgate Hill in 1865 – a proposal which provoked over a thousand signatures on a petition submitted to the City Corporation in 1863. In the two decades after the construction of the circus and the railway bridge, Ludgate Hill was also widened on the south (right-hand) side. Today, of all the buildings visible in this view only St Paul's and St Martin's, Ludgate, still stand. (*Reproduced by Gracious Permission of Her Majesty the Queen*)

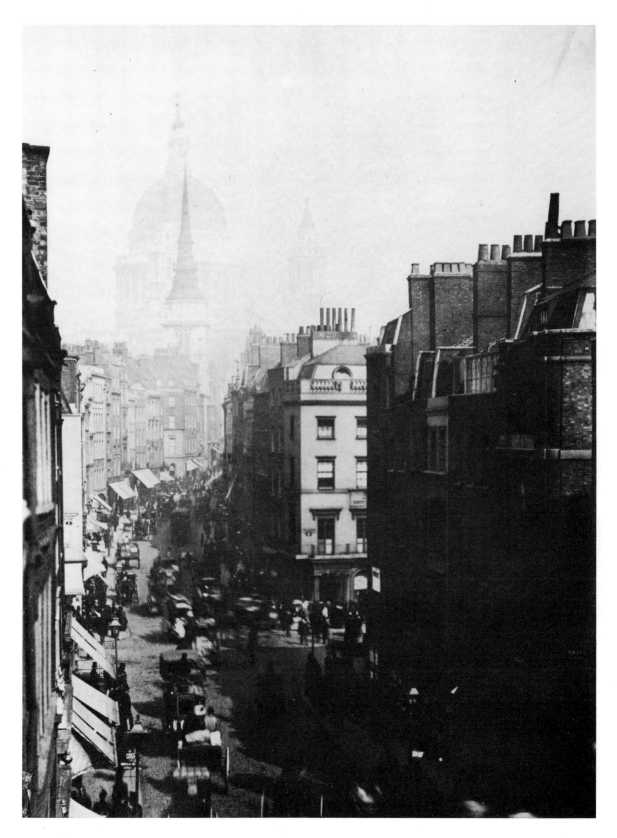

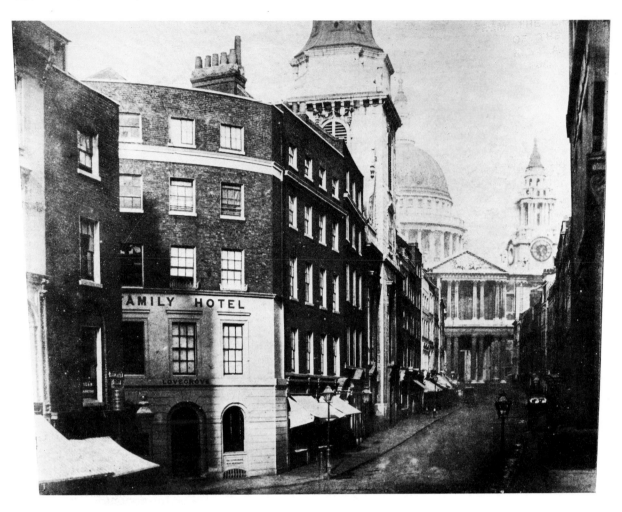

40 LUDGATE STREET AND ST PAUL'S CATHEDRAL, c. 1850

Anon.

(*Calotype*)

This is one of very few photographs to show the original picturesque and widely admired approach to St Paul's Cathedral, taken before the new buildings of the Victorian City of London began to rise above the five-storey height up to the cornice of the lower Corinthian order on Wren's building – and a century before the idiotic setting-back of Juxon House by Lord Holford at the top of Ludgate Hill. When the photograph was taken, Ludgate Hill only ran from Fleet Street to St Martin's Church, in the centre of the picture; beyond, it was called Ludgate Street. This division stemmed from the former existence of the Ludgate, which crossed the street between St Martin's and the London Coffee House on the corner of Old Bailey. By 1850 the London Coffee House had also become an inn and family hotel, owned by S. and J. Lovegrove. The original Coffee House was built in 1731; the Ludgate was taken down in 1760–62 and the corner building in this photograph dated from about 1800. (*Gerald Cobb, Esq.*)

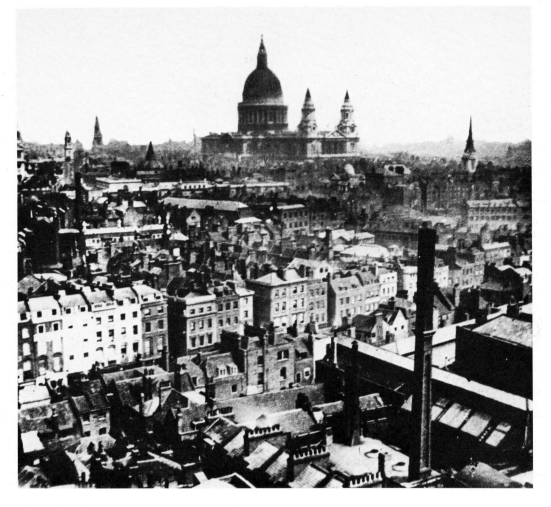

41 ST PAUL'S CATHEDRAL AND THE CITY OF LONDON FROM THE NORTH-WEST, C. 1857

Anon.

(Copy of original print)

This photograph was taken from the tower of St Andrew's, Holborn (see Plate 156). The street running across the picture is Farringdon Street and in the foreground on the right are the buildings of the Farringdon Market, built in 1828-9 and removed in 1874. The squat dome with a lantern immediately to the left of St Paul's covers the octagonal theatre of the Royal College of Physicians in Warwick Lane, designed by Robert Hooke, built in 1672-8 and demolished in 1866. In front of that is the long line of George Dance's Newgate Prison, with the attic windows of the Governor's House conspicuous in the centre. To the right of that is the Sessions House in Old Bailey, also designed by Dance and apparently sporting a dome. To the right of that again is the steeple of St Martin's, Ludgate. *(Sir Benjamin Stone Collection, City of Birmingham)*

42 ST PAUL'S CATHEDRAL AND THE CITY OF LONDON FROM THE EAST, c. 1857
Anon.

Like Plates 27 and 44, this photograph shows the City skyline as Wren intended it, even though most of the ordinary buildings are Georgian. Nothing yet challenges the supremacy of the steeples of the City churches and the great silhouette of St Paul's itself. Within the next twenty years, three of the Wren steeples visible in this view would disappear. The photograph was taken from the top of the Monument. The buildings in the foreground were designed by Sir Robert Smirke to line the approach to the new London Bridge, opened in 1831. Immediately behind Smirke's façades, on the right, is the brick steeple of the former church of St Martin Orgar, which had a curious history. Rebuilt by Wren after the Great Fire, the church was used by French Protestants for a number of years until being demolished in 1820. The tower itself survived until 1851 when it was replaced by an even bigger one, incorporating a rectory house, designed in the style of Wren by John Davies. Today the body of the tower survives but the cupola and its later replacement have gone. Immediately behind that, in this view, is the steeple and lead-covered spire of St Swithun, Cannon Street, bombed in 1941. To the left of that is the stone spire of St Antholin, Budge Row, demolished in 1876. The street stretching from St Swithun's towards St Paul's is Cannon Street West, cut through in 1848–54. Within a few years of this photograph being taken, many of the buildings in the middle distance would be destroyed to make way for the great bulk of Cannon Street Station, one of the largest new buildings in the City, built in 1864–6 (see Plate 204). (*Guildhall Library, City of London*)

43 ST PAUL'S CATHEDRAL FROM THE THAMES, 1854
J.G. Crace (?)
(*Calotype*)

This, one of the earliest photographs taken of St Paul's, well illustrates how Wren's cathedral dominated the City when the rooftops only rose to half-way up its walls, and when the Thames was lined with wharves. In the centre of the photograph – which must have been taken from the top of the old Albion Mill building on the south bank next to Blackfriars Bridge – is Anchor Wharf. However, even as early as this commercial buildings were beginning to challenge the supremacy of St Paul's. To the left of the steeple of the church of St Benet Paul's Wharf is the great mass of Messrs Cook, Sons & Co.'s warehouse on the south side of St Paul's Churchyard, a seven-storey Italianate block designed by James Knowles senior and built in 1852–4. Another print of this photograph is in the Crace Family Album in the Victoria & Albert Museum. (*Gerald Cobb, Esq.; British Museum, Crace Collection*)

44 ST PAUL'S CATHEDRAL FROM THE SOUTH BANK, LATE 1850S

Anon.

This photograph shows a similar view to that in Plate 43, but the photographer was standing a little further east and on the Thames shore rather than at a higher level. Where warehouses and wharves once lined the north bank, today, east of Blackfriars Bridge, there is a concrete box containing a road. Only the tower of St Benet, Paul's Wharf, survives. (*Gerald Cobb, Esq.*)

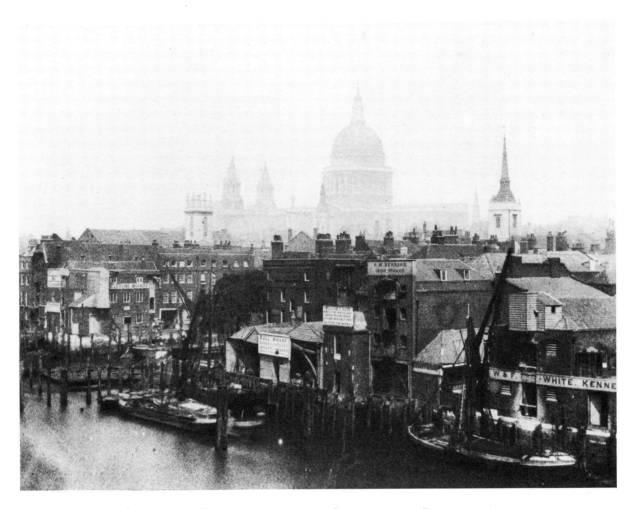

45 ST PAUL'S CATHEDRAL FROM SOUTHWARK BRIDGE, 1854

A. Rosling

(*Calotype*)

This photograph, in Volume IV of the Prince Consort's collection, was entitled 'St Paul's on a misty morning'. In the centre is Bull Wharf and to the left of that Queenhithe, once the principal dock in the City of London, opens out. The steeple on the extreme right is that of St Michael's, Queenhithe, demolished in 1876 (see Plates 32, 33) and furthest to the left is that of St Mary Somerset, which survives today. To the right of that, just visible before the steeple of St Nicholas Cole Abbey under the dome of St Paul's, is the tower of St Mary Magdalen, Old Fish Street, which was demolished in 1886. (*Reproduced by Gracious Permission of Her Majesty the Queen*)

46 THE INTERIOR OF ST PAUL'S CATHEDRAL, C. 1860
George Washington Wilson

This photograph, which is in Volume I of the Prince Consort's collection assembled in 1860-61, is early for a view of a building - but not quite early enough to show the original organ on its screen across the choir. The organ screen was removed in 1858 - when services under the dome were begun - and put in one of the south arches of the choir. The present arrangement, with the organ divided and placed on either side of the first bay of the choir, was effected in 1871. Nevertheless, this photograph shows clearly the cold, Protestant austerity of St Paul's which the Victorians so hated and which, after 1858, Dean Milman and the Cathedral's Surveyor, F.C. Penrose, attempted to relieve with colour and decoration. The spandrils under the dome have yet to be filled with mosaics by G.F. Watts and Alfred Stevens, the vaults of the choir have yet to be coated with Sir William Richmond's gauche mosaics. The apse is bare: a cross was introduced only in 1869, and Bodley and Garner's colossal reredos, since removed, was erected in 1886-8. And the second arch of the nave on the north side was yet to be filled with Stevens's Wellington monument - the only Victorian addition which in any way enhanced Wren's masterpiece. (*Reproduced by Gracious Permission of Her Majesty the Queen*)

47 THE MANSION HOUSE AND POULTRY, C. 1863
Anon.

This view, looking west towards the Church of St Mary-le-Bow in Cheapside, shows the heart of the City at the beginning of its transformation. Some buildings had a very short life; the premises of the National Mercantile Assurance Company (built in 1852), on the corner of Poultry and Charlotte Row, next to the Mansion House, were less than twenty years old when purchased in 1868 by the Metropolitan Board of Works to be cleared away for the construction of Queen Victoria Street. Soon the acute corner so formed would be filled by the familiar shape of Mappin & Webb's

Gothic building. At the same time the Mansion House lost its railings to help widen the street. On the opposite side is Wren's church of St Mildred, Poultry, with its tall ship weathervane. This was demolished in 1872 and replaced by the Equitable Life Assurance building. On the extreme right, work seems to be under way on the building of the Union Bank of London on the corner of Princes Street, designed by P. C. Hardwick and since demolished (see Plate 153). (*National Monuments Record*)

OLD CHELSEA AND THAMESSIDE

48 BATTERSEA BRIDGE AND THE THAMES FROM CHELSEA OLD CHURCH, c. 1870
James Hedderly

Hedderly achieved this panoramic view by taking two overlapping photographs from the top of the tower of Chelsea Old Church. In the foreground are the buildings of Duke Street; all those on the left-hand side, by the river, would be demolished in the next few years. Battersea Bridge is the wooden structure, built in 1766–71, which was painted by Whistler and other Chelsea artists. It was closed to vehicular traffic in 1883 and in 1890 replaced by the present metal bridge designed by Sir Joseph Bazalgette. On the left, beyond the factories and wharves, is the spire of Battersea Parish Church of the 1770s. Beyond that is the bridge of the West London Extension Railway, opened in 1863. On the right bank can be seen the Cremorne Gardens, regularly used for balloon ascents. They were opened in 1845 and closed in 1877. Lots Road Power Station now stands on part of the site, the rest of which was covered by terraced housing. (*Kensington and Chelsea Public Libraries and Arts Service*)

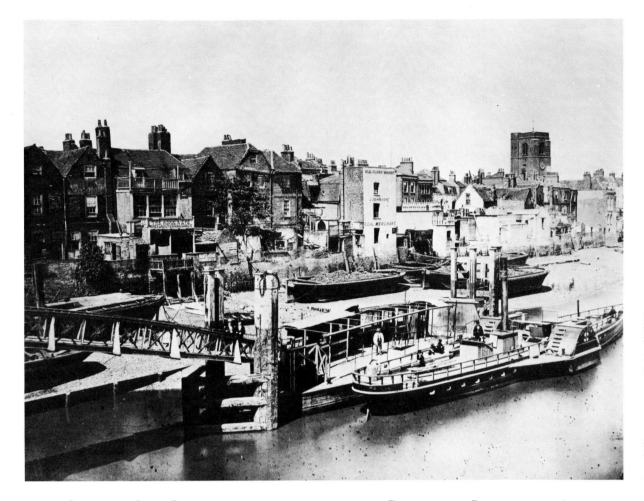

49 CHELSEA OLD CHURCH AND RIVERSIDE FROM BATTERSEA BRIDGE, c. 1870
James Hedderly

This is one of a series of views of old Chelsea taken shortly before the construction of the Chelsea Embankment in 1871–4 which greatly altered the picturesque appearance of the Chelsea riverside - to the annoyance of artists like Rosetti, who lived there. All these photographs were taken by James Hedderly, a signwriter and painter who took up photography in the 1860s and who lived on the side of Duke Street which was swept away by the Embankment. This view shows the backs of the houses in Duke Street which looked on to the Thames. How this area was to be transformed is shown in Plates 145 and 146. There is the Adam and Eve Tavern, the Old Ferry Wharf and, on the right, the brick tower of the sixteenth-century Old Parish Church. In the foreground is the steamboat pier, accessible from Battersea Bridge, with the *Citizen*, a paddle-steamer owned by the City Steamboat Company which made the run from Chelsea to the City. (*Kensington and Chelsea Public Libraries and Arts Service*)

50 CHEYNE WALK AND CHELSEA OLD CHURCH, C. 1870

James Hedderly

This view is looking west along Cheyne Walk, which overlooked the Thames, to the Old Parish Church where the road narrowed and became Duke Street, lined on both sides by houses. Above the shop on the right Holman Hunt painted 'The Light of the World'. Apart from the church, all the buildings in this photograph have disappeared. Even the Old Church itself was blown to bits in 1941, to be painstakingly restored by Walter Godfrey after the end of the Second World War. (*Kensington and Chelsea Public Libraries and Arts Service*)

51 THE ARCHITECTURAL MUSEUM, CANNON WHARF, WESTMINSTER, C. 1856
Charles Thurston Thompson (?)

The Architectural Museum was created in 1852, chiefly through the efforts of George Gilbert Scott. The first home of this collection of casts and architectural fragments, intended for study by architects and students, was the loft of a wharf off Cannon Row, a little downstream from Westminster Bridge behind Richmond Terrace. Access to the collection was by a wooden staircase just to the left of this photograph, which shows a view of the Thames a decade before the Victoria Embankment was built. In 1856 the collection was temporarily housed in the 'Brompton Boilers' at the South Kensington Museum, into which museum it was eventually absorbed. The timber warehouse at the wharf at Cannon Row was typical of the wharves which once lined both banks of the Thames and which had to be sacrificed for the Embankment. (*Victoria & Albert Museum*)

52 THE MILLBANK PENITENTIARY, c. 1870 (?)

Anon.

This vast model prison, hexagonal in plan, occupied a site by the Thames where the Tate Gallery now stands. It was built in 1812. Thomas Hardwick designed the lodge, gateway and boundary wall but, after the failure of the foundations, the Penitentiary was completed by Smirke.

It was closed as a prison in 1890 and part of the site was used for the Tate Gallery and for the London County Council housing scheme behind. The last of the Millbank Penitentiary was demolished as late as 1903. (*Westminster Public Libraries*)

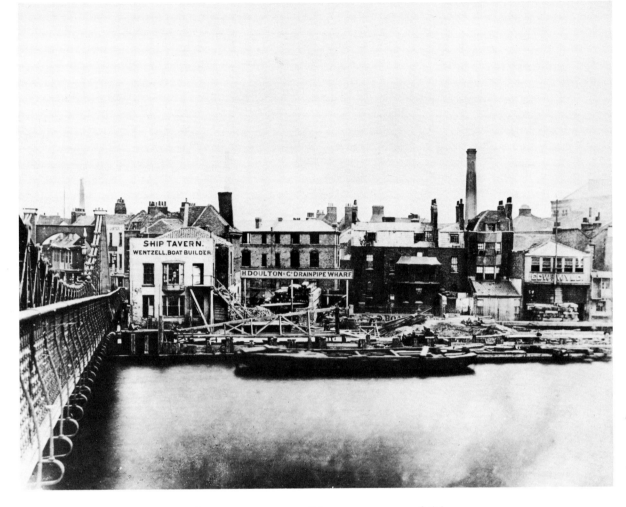

53 LAMBETH FROM MILLBANK, C. 1866
Anon.

This shows part of the south bank a little upstream from Lambeth Palace (see Plate 114). The bridge is the Lambeth Bridge, a suspension bridge designed by Peter Barlow and erected in 1862 from Horseferry Road to Lambeth Church Street, replacing the old horse-ferry. The bridge was itself replaced in 1929 by the present road bridge. This part of the Thames was lined with small wharves and workshops, and Doulton's had their factory for pottery and sanitary ware here. Many of these buildings were demolished for the construction of the Albert Embankment and Doulton's built themselves a new Gothic Revival factory a little further south. Work on building the Embankment seems about to begin (see Plates 112, 118). (*The Doulton Group of Companies; Greater London Council Photography Library*)

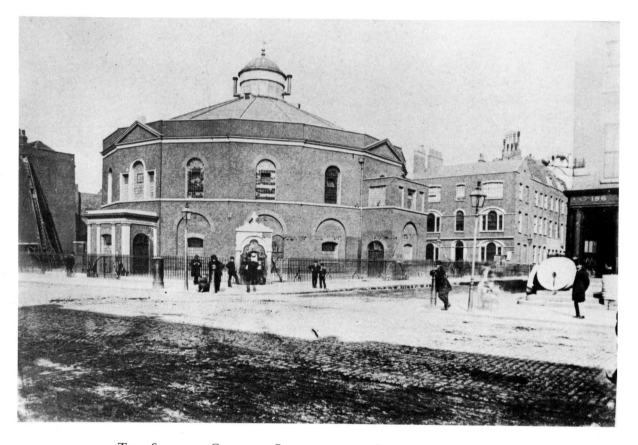

54 THE SURREY CHAPEL, BLACKFRIARS ROAD, EARLY 1870s
Anon.

This photograph must have been taken after 1871, the year in which the London Tramways Company laid down lines along the Blackfriars Road. The road itself was laid out in 1769-71 by Robert Mylne as an approach to his new bridge (see Plate 135). The Surrey Chapel was built soon after, on the east side on the corner of Charlotte (now Union) Street, in 1782-3. It was built by the Reverend Rowland Hill for a congregation of Calvinistic Dissenters and designed by William Thomas. The octagonal shape of the chapel was useful in its later role as a boxing ring. It was bombed in 1940 and a 1960s office block housing the India Office Library now stands on the site. To the left can be seen the viaduct, built in 1862-4, taking the South Eastern Railway to Charing Cross. There was briefly a station at this point, named Great Surrey Street, the former name of the Blackfriars Road. The building behind the Chapel is a National Savings Bank, but seems originally to have been Rowland Hill's house. The house to the right, No. 196, bears the same shop sign as appears in Tallis's *London Street Views* (1838-40), when it housed Henly & Co., Ironmongers and Manufacturers of Patent Kitchen Ranges, Stoves &c. What are the large discs piled outside? At this time, some of the poorest and toughest parts of London were nearby. (*Sir Benjamin Stone Collection, City of Birmingham Libraries*)

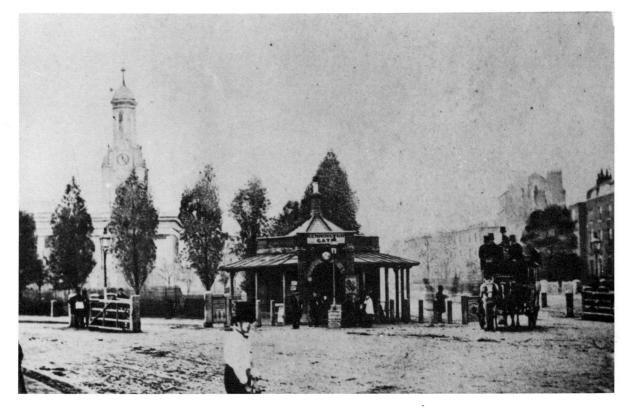

55 KENNINGTON TOLL-GATE LOOKING SOUTH, C. 1865

Anon.

Until the 1860s there were 117 toll-gates in London within six miles of Charing Cross, relics of the days when good roads were privately built and maintained. In 1864 and 1865 most were removed, easing the working of the omnibus routes. One toll-gate survives today in Dulwich. The Kennington turnpike gate was abolished in November 1865. This view shows it standing at the south end of Kennington Park Road, straddling the junction of the Brixton Road, on the left, and the Clapham Road. In the background is St Mark's Church, one of the so-called 'Waterloo Churches' in South London, designed by D.R. Roper and built in 1822–4. See also Plates 58 and 59. (*Guildhall Library, City of London*)

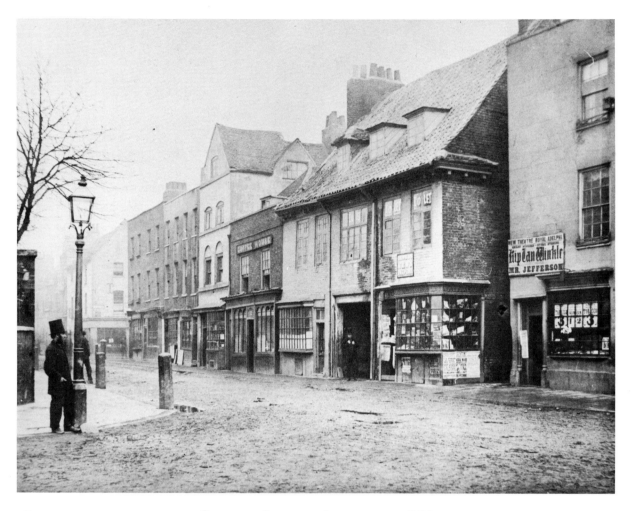

56 CHURCH STREET, LAMBETH, 1866
Anon.

All the buildings in this photograph have disappeared and today Church Street, widened and renamed Lambeth Road, is a main thoroughfare from Lambeth Bridge to St George's Circus. In 1866 the Lambeth Suspension Bridge (see Plate 52) was only four years old and this part of Lambeth retained the character of a village. Between the Georgian houses on the south side of the street is a much older building with a stationer's shop on the corner. On the far left, on the corner of the road to Lambeth Palace, is part of the churchyard wall of St Mary's, the parish church, which still stands although no longer in use. (*Victoria & Albert Museum*)

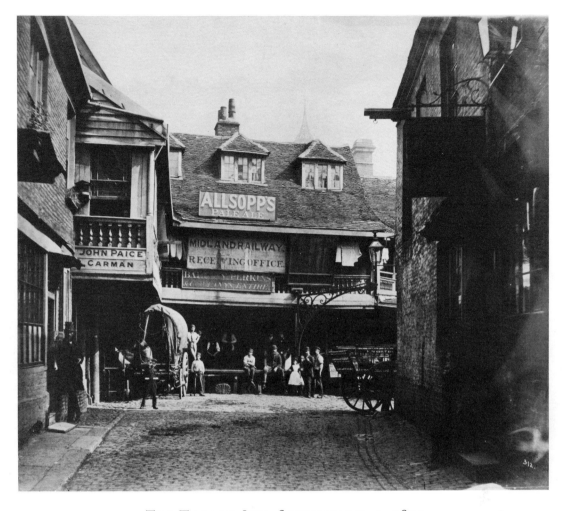

57 THE TABARD INN, SOUTHWARK, C. 1870

Anon.

The old coaching inns of Southwark survived a little longer than those in the City (see Plates 28, 29) but they were all gone by the twentieth century – apart from the single wing of the George which today is owned by the National Trust. All lay off the Borough High Street, the most ancient part of Southwark. The Tabard is associated with Chaucer but the building seen here dated from after a fire in 1676. In their last days, several inns acted as receiving offices for the railway companies which had put paid to their livelihood; the Tabard was used by the Midland Railway. It was demolished in 1875. (*Victoria & Albert Museum*)

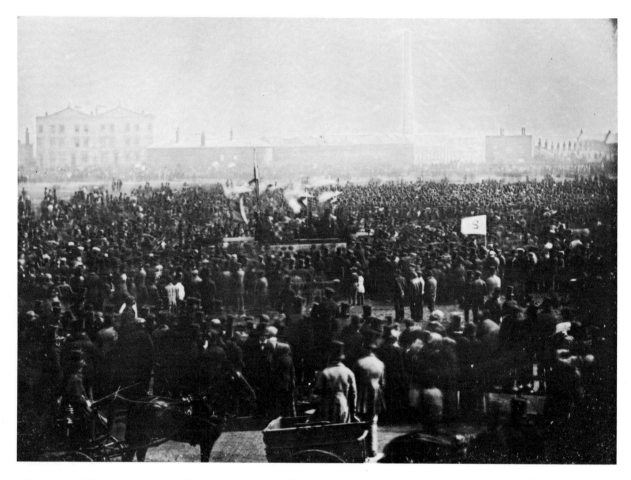

58, 59 KENNINGTON COMMON: THE CHARTIST MEETING, 10 APRIL 1848

W. Kilburn (?)

(Two daguerreotypes, images reversed)

These two daguerreotypes are most remarkable as very early views of an event with people in motion rather than of a building or a sitter in a studio. They also record a great moment in the history of British democracy, although it was one which proved to be as much ridiculous as it was dangerous. In 1848, the Year of Revolutions in Europe, the Chartist leaders decided to present a petition to the government and to hold a giant meeting on Kennington Common

before taking it to Parliament. In the event only about 23,000 assembled rather than the expected 150,000, and when the petition was presented it was found to contain under two million signatures, many of them forged, rather than the 5,600,000 reported by Feargus O'Connor. Nevertheless, on the day the authorities were sufficiently alarmed to have the Duke of Wellington ready with troops and 170,000 special constables on duty. These two photographs

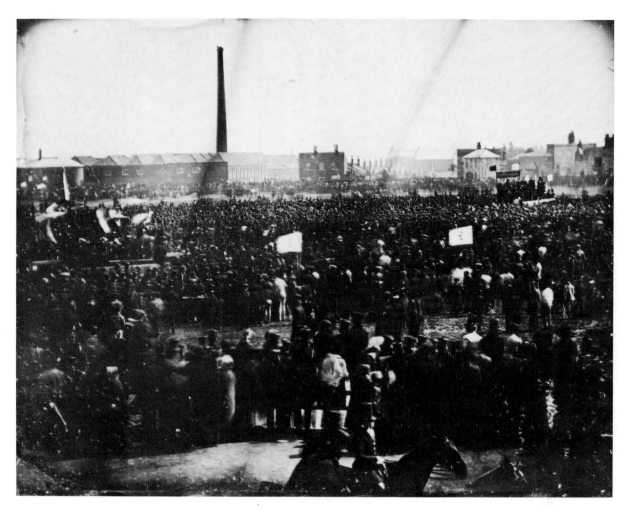

were taken by the police for their records, though it would seem to have been difficult to identify faces from them.

The left-hand platform, decked out with flags, bears the legend: 'Labour is the source of all wealth'. In the background are the buildings lining the north-east side of the Common; the factory is possibly Messrs Farmer's vitriol works. Three years later Prince Albert's model cottages for the Great Exhibition were re-erected on the west side of the Common near where these photographs were taken and in 1852 the land was enclosed as a park. In the 1730s George Whitefield had apparently preached to a larger assembly of people on Kennington Common than were gathered here on 10 April 1848. (*Reproduced by Gracious Permission of Her Majesty the Queen*)

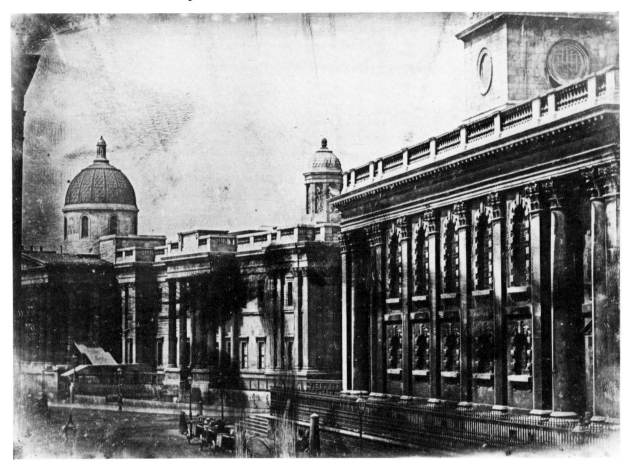

60 THE CHURCH OF ST MARTIN-IN-THE-FIELDS AND THE NATIONAL GALLERY, 1839

M. de St Croix

(Daguerreotype, image reversed)

This daguerreotype, one of the very first to be made in London, must have been taken from a first-floor balcony in the Strand, very close to the Royal Adelaide Gallery in the Lowther Arcade between Adelaide Street and the West Strand, where M. de St Croix's plates were exhibited. As the photograph is so very early and rare it seems rather a pity that M. de St Croix chose to record so familiar a subject, as this view remains virtually unchanged today. In the foreground, along Duncannon Street, is the south side of James Gibbs's celebrated church, built in 1722–6. Beyond is William Wilkins's new National Gallery, which had been opened the previous year. The only changes to the building since then have been some small additions to the roof behind the parapet balustrade and the blocking of the right-of-way through the projecting lateral four-column portico – the path leading to which can just be seen in this plate. (See also Plate 1 for another of M. de St Croix's daguerreotypes.) (*Science Museum, London*)

61

THE STEEPLE OF ST MARTIN-IN-THE-FIELDS, 1839
M. de St Croix
(Daguerreotype, image reversed)

The main interest of this photograph lies in the fact that it was taken so very early, as the steeple of James Gibbs's famous church fortunately remains exactly the same today.

The *Literary Gazette* for 12 October 1839 recorded that M. de St Croix had made a daguerreotype of St Martin's Church. (See also Plates 1, 60.) (*Science Museum, London*)

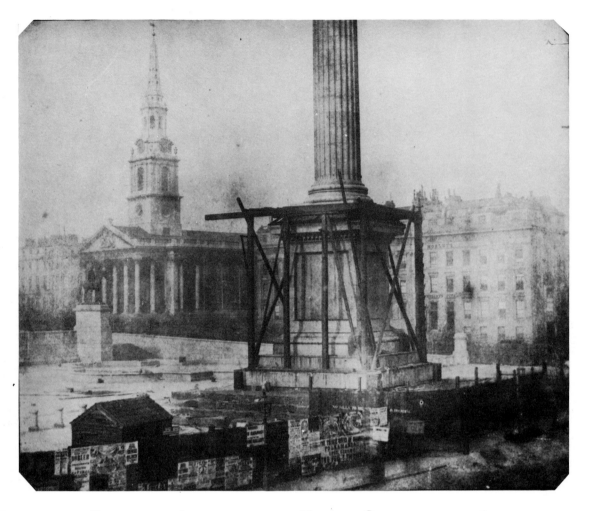

62 TRAFALGAR SQUARE AND THE NELSON COLUMN, LATE 1843

William Henry Fox Talbot

(*Calotype*)

A monument to Nelson was first proposed in 1805, the year of his death, but it was not until 1838 that a site was chosen in the new Trafalgar Square and subscriptions raised. (It was, apparently, G.L. Taylor, the architect of Morley's Hotel seen here behind the column, who tactfully persuaded King William IV that the new square should be named after the Battle of Trafalgar and not after himself.) In 1839 William Railton won the competition. The 145' 6" granite Corinthian column with a bronze capital was raised in 1840-43. On 3 November 1843, the 16'-high statue of Nelson by E.H. Baily was placed in position. Henry Fox Talbot must have taken this photograph from an upstairs window in Cockspur Street shortly afterwards, while the timber scaffolding was still being taken down. In the background, work is proceeding on the fountains and retaining walls designed by Barry in 1840. Chantrey's equestrian figure of George IV is already in place on its granite pedestal. It was originally made for the Marble Arch when it stood in front of Buckingham Palace. (*Science Museum, London*)

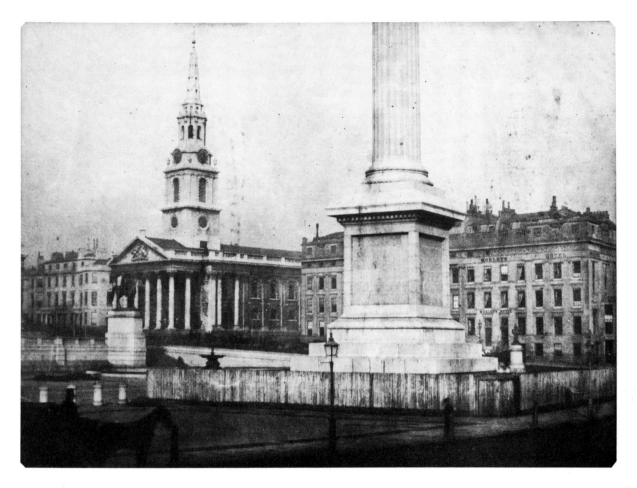

63 TRAFALGAR SQUARE AND THE NELSON COLUMN, 1845
William Henry Fox Talbot
(*Calotype*)

This photograph was taken from the same position as Talbot's earlier view, taken in 1843 (see Plate 62), but from a lower level. Barry's works in the square are now complete: the fountains are in place and the great capstan-like pier on the flanking retaining wall is surmounted by its lamp. But the Nelson Column itself is still not finished. It was not until 1852 that the bronze reliefs on the pedestal were fixed, and not until 1868 that Landseer's lions were put in place on the flanking pedestals (see Plate 73). (*Science Museum, London*)

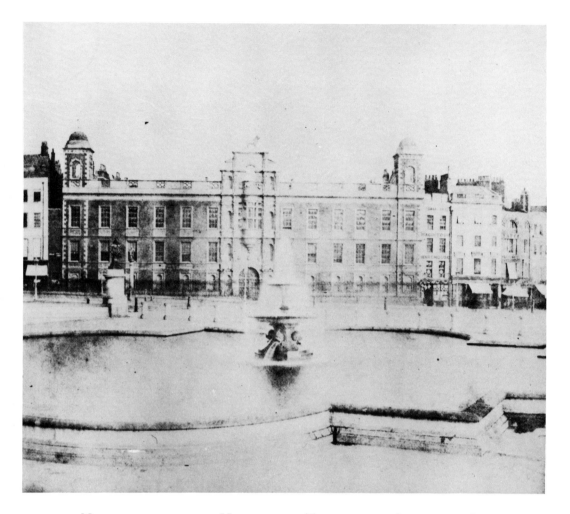

64 NORTHUMBERLAND HOUSE AND TRAFALGAR SQUARE, 1845
William Henry Fox Talbot
(*Calotype*)

Fox Talbot took this photograph looking across one of the new fountains planned as part of the layout of Trafalgar Square by Charles Barry in 1840 and completed in 1845. The creation of this open space, originally conceived by John Nash, gave prominence to Northumberland House, the grand aristocratic mansion with grounds stretching to the Thames, which lay at Charing Cross, where the Strand curved round to Whitehall. This great Jacobean house, probably built between 1605 and 1609 and originally designed, it is thought, by the Dutchman Bernard Janssen,

was destroyed in 1874 to create Northumberland Avenue, connecting Trafalgar Square with the new Thames Embankment. The house was compulsorily purchased by the Metropolitan Board of Works. An earlier attempt at compulsory purchase was successfully resisted by the Duke of Northumberland in 1865, when James Pennethorne proposed another alignment for the street. The splendour of Northumberland House is more evident in the following plates than in this rather faded calotype. (*Royal Photographic Society*)

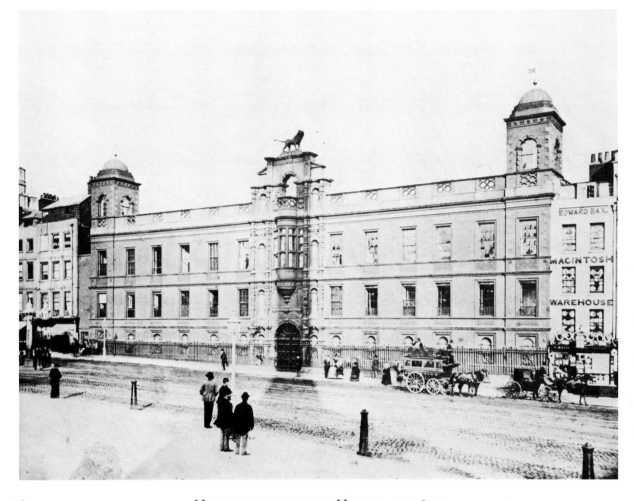

65 NORTHUMBERLAND HOUSE, c. 1870
Negretti & Zambra

This photograph shows the Strand façade of Northumberland House shortly before its sad demolition in 1874. The shadow of Nelson's Column falls neatly on to the central oriel window. Above this is the lion, added in the late eighteenth century and removed to Syon House by the Duke of Northumberland when his house was demolished.

Apart from the Jacobean centre, the Strand front was rebuilt in 1748–53 by James Garrett, when the sash windows were installed. The vehicles in front are a 'knife-board' omnibus and a private brougham. (*Christie's South Kensington*)

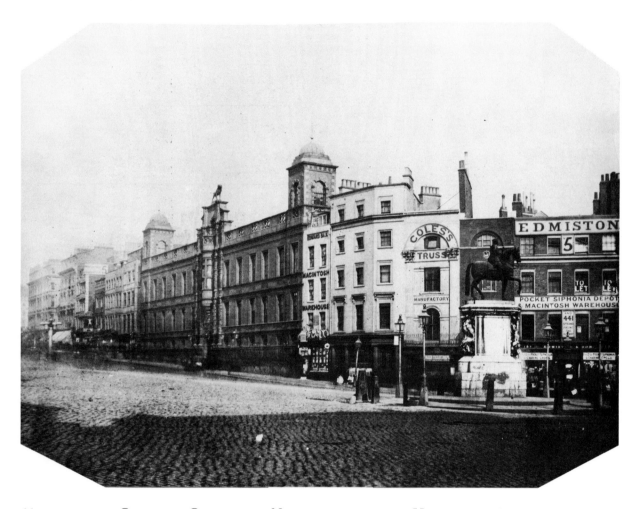

66 CHARING CROSS AND NORTHUMBERLAND HOUSE, C. 1870

Anon.

The high roof of the Charing Cross Hotel (see Plate 202), opened in 1865, is now evident above the parapet of Northumberland House. Edward Bax's Macintosh (*sic*) Warehouse and Coles's Truss Manufactory appear in many early photographs of Trafalgar Square and Charing Cross. They fell victim, along with their distinguished neighbour, Northumberland House, to the clearance for Northumberland Avenue in 1874. (*Westminster Public Libraries*)

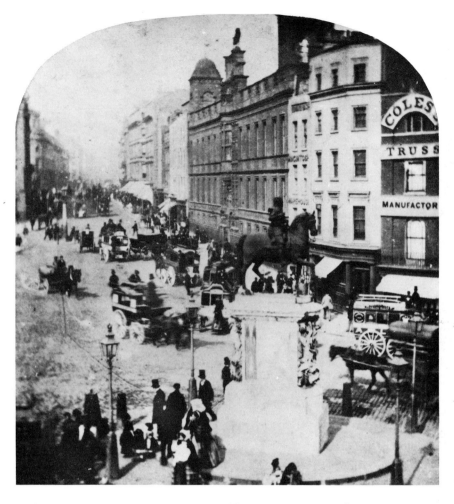

67 CHARING CROSS, NORTHUMBERLAND HOUSE AND THE STRAND, EARLY 1860S

Anon.

(Stereoscopic photograph)

This 'instantaneous photograph' was apparently taken from the second floor of the buildings on the corner of Charing Cross and Spring Gardens, visible in Plate 68, and it shows the bustle of traffic in the Strand not evident in other photographs with longer exposures. Charing Cross Station, with its forecourt, has not yet been built in the Strand beyond Northumberland House. Since Fenton took his photograph in 1857 (Plate 68), Charles I has lost his encircling railings. He had been placed on this site in 1674, which is approximately where the medieval Charing Cross once stood, now replaced in symbolic replica by one in front of Charing Cross Station (see Plate 202). (*B.E.C. Howarth-Loomes, Esq.*)

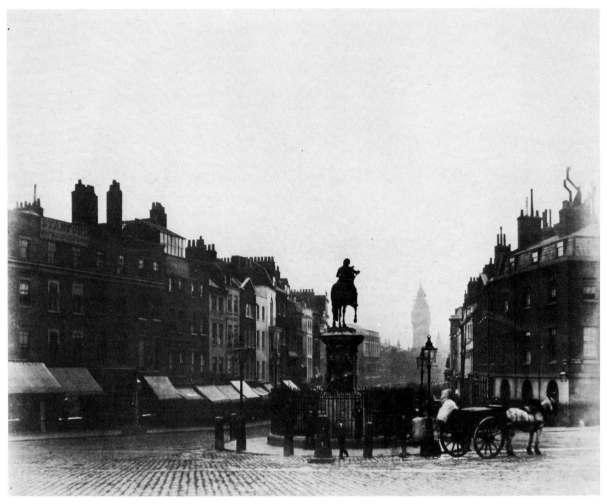

68 WHITEHALL FROM TRAFALGAR SQUARE, C. 1857
Roger Fenton

This is one of several photographs taken in London by Roger Fenton after his return from the Crimean War, many of which show the Clock Tower of the New Palace of Westminster nearing completion. The Banqueting House is just to the right of the statue of Charles I and the houses on the left are those that appear in Plate 1, taken eighteen years earlier. It is interesting to compare the two views for the small changes that took place in between. On the right of Charing Cross is a group of plain houses of the 1740s; that on the corner of Spring Gardens was Drummond's Bank. These were demolished in 1877. (*National Monuments Record*)

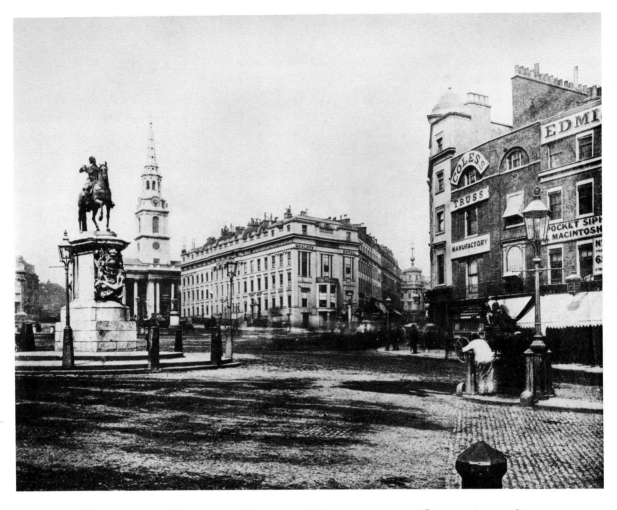

TRAFALGAR SQUARE, CHARING CROSS AND THE STRAND, C. 1870

Anon.

To the left of the statue of Charles I is the end of the National Gallery; to the right is St Martin-in-the-Fields and then Morley's Hotel. This block was designed by George Ledwell Taylor and built in 1830 to enclose the east side of the new square. To achieve a degree of symmetry when seen from the south, Taylor gave his building the same end elevation as Smirke's block on the other side of the square, with tripartite windows and a central bow window. Down the Strand can be seen one of the 'pepper pot' corners of Nash's West Strand Improvements block of 1830–32, surmounted by the Electric Time Signal Ball (see Plate 72). (*Westminster City Libraries*)

70 THE STRAND LOOKING EAST, C. 1860

Anon.

(Stereoscopic photograph)

On the left of this 'instantaneous photograph' is the centre of the Strand front of Nash's West Strand Improvements, built in 1830-32. Behind this centre was the Lowther Arcade, stretching through to Adelaide Street, where stood the Royal Adelaide Gallery of Practical Science. This was removed in 1902 when Macvicar Anderson rebuilt the centre of the Strand front for Coutts' Bank. This itself has since been replaced by a banal glass wall rather than by a restoration of Nash's architecture. Beyond the eastern 'pepper pot' corner is the Westminster Life and British Fire Office building – of stone rather than Nash's stucco – constructed in 1831-2. This, one of C.R. Cockerell's most distinguished Classical designs, was demolished in 1908 for Holden's British Medical Association building (now Zimbabwe House), which still stands on the site. (*B.E.C. Howarth-Loomes, Esq.*)

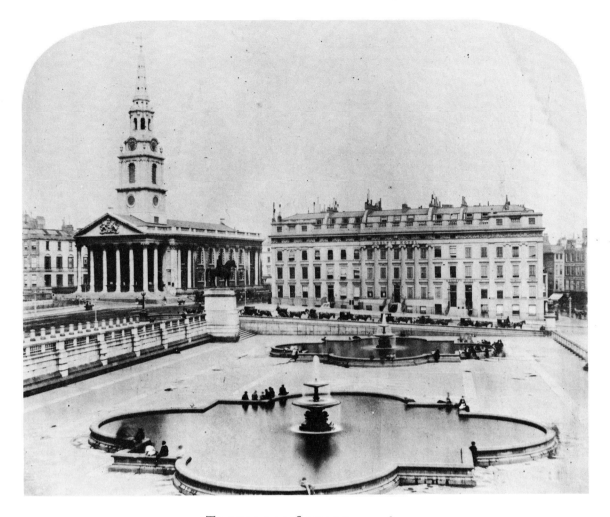

71

TRAFALGAR SQUARE, C. 1857

Roger Fenton

Barry's fountains in the Square were evidently successful, to judge from the people sitting round them. The pools were remodelled in 1937–9 by Lutyens, when larger fountains were installed as memorials to Admirals Jellicoe and Beatty. Beyond the line of hansoms and broughams waiting for hire is Morley's Hotel, a fine stuccoed building in the Nash manner which was a suitable foil to St Martin-in-the-Fields. This is less true of its replacement, for the whole triangular block bounded by Trafalgar Square, Duncannon Street and the Strand was demolished in 1933 to make way for the group designed by Sir Herbert Baker, containing South Africa House facing on to Trafalgar Square. (*National Monuments Record*)

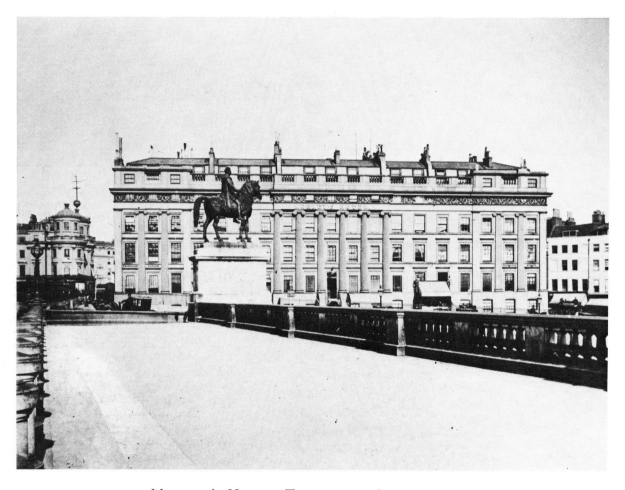

72 MORLEY'S HOTEL, TRAFALGAR SQUARE, 1871
Anon.

This view along the upper terrace of Trafalgar Square, past Barry's granite 'capstans', shows not only George Ledwell Taylor's building housing Morley's Hotel, built in 1830, but also the two 'pepper pots' at the corner of Nash's West Strand Improvements block, built at the same time. On the top of one of these is a strange device: the Electric Time Signal Ball, above the Electric Telegraph Office, installed in 1852. This was designed to give a precise reading of Greenwich Mean Time in central London. The zinc ball, six feet in diameter, was raised by pneumatic pressure and, at one o'clock precisely, was dropped, its descent activated by an electric current transmitted in a wire from the Greenwich Observatory. When fully raised, the ball was 129 feet above the level of the Thames and it fell ten feet. It is not recorded if the descent of the ball also made a noise. (*Sir Benjamin Stone Collection, City of Birmingham Libraries*)

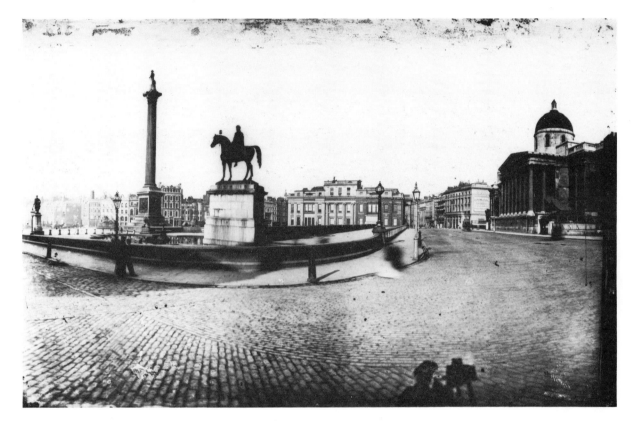

73 TRAFALGAR SQUARE LOOKING WEST, C. 1870
Anon.

To judge by the long shadow in the foreground, the photographer was at work early in the morning to secure comparatively empty streets. Landseer's lions around the Nelson Column were put in place in 1868 (see Plates 62, 63). The west side of Trafalgar Square is closed by the building housing the Royal College of Physicians and the Union Club, designed by Sir Robert Smirke and built in 1822-5. The central attic storey was added by Decimus Burton in 1841-50. This building was modified in 1925 by Septimus Warwick when it became Canada House. Immediately to the left of the Nelson Column pedestal is the insurance office designed by J.M. Gandy in 1804. To the left of the Column is the first piece of Victorian rebuilding in the Square, the Globe Insurance offices. This row of buildings has since been demolished. (*B.B.C. Hulton Picture Library*)

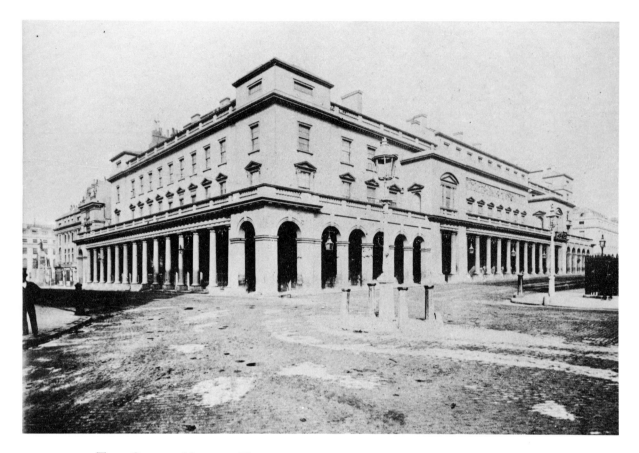

74 THE OPERA HOUSE, HAYMARKET, FROM THE SOUTH-EAST, 1860s
Anon.

Her Majesty's Theatre, or the Italian Opera House, was the second theatre on this site. The first was Vanbrugh's, built in 1705 and burned in 1789. The second was built in 1790 to a design by Michael Novosielski, but the grand colonnaded exterior, visible here, was an enlargement carried out by John Nash and G.S. Repton in 1816-18. The columns were of iron. The long bas-relief frieze along the Haymarket façade to the right was of lithargolite and designed by Bubb. The interior of the theatre was destroyed by fire in 1867 and rebuilt in 1868-9. In 1895 the theatre was demolished, apart from the Opera Arcade at the west end of the site, off Pall Mall, which survives today. It was replaced by a new Her Majesty's Theatre, further north by Charles Street, and the Carlton Hotel, opened in 1899. Both were designed by C.J. Phipps. In the 1960s the Carlton Hotel, on this corner site, was replaced by New Zealand House, the first building utterly to wreck the civilized scale of Nash's West End. On the extreme left the Guards Crimean Memorial in Waterloo Place, erected in 1860, can just be seen. (*Sir Benjamin Stone Collection, City of Birmingham Libraries*)

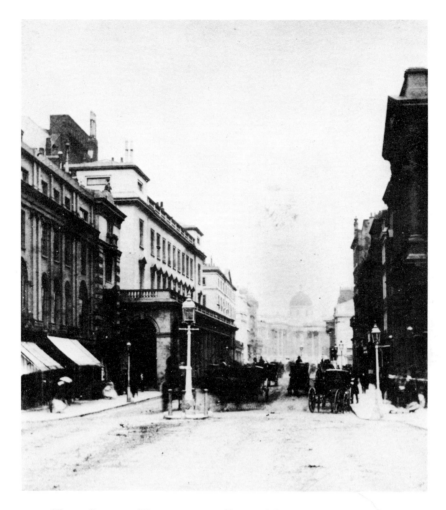

75 THE OPERA HOUSE AND PALL MALL EAST, 1860s

Anon.

(Stereoscopic photograph)

On the left is the colonnade of the Italian Opera House, a building of 1790-91, remodelled in 1816-18 by Nash and G.S. Repton who were responsible for the elegant colonnades over the pavements of Pall Mall and the Haymarket.

On the extreme right is the United Services Club, designed by Nash, which still stands today, although no longer a club. In the distance is the National Gallery. (*B.E.C. Howarth-Loomes, Esq.*)

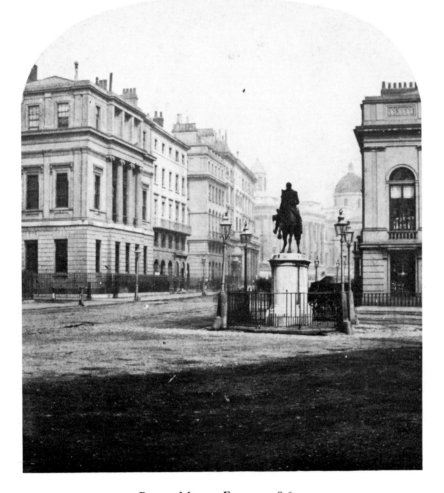

76

PALL MALL EAST, 1860s
Anon.
(Stereoscopic photograph)

This view beautifully conveys the original effect of Nash's Metropolitan Improvements. Behind the equestrian figure of King George III by Matthew Cotes Wyatt can be seen the National Gallery. These are the only two structures which survive today; all the other early nineteenth-century buildings in this view have been rebuilt. On the left, on the corner of Suffolk Street, is the United Universities Club, designed by William Wilkins (the architect of the National Gallery) with J. P. Gandy in 1821 and built in 1822–6. The attic storey was added in 1850–51, removing the original pediment above the Pall Mall East portico on the first floor. The building was demolished in 1902 when the club was rebuilt by Reginald Blomfield. On the right is the corner of the glass and lamp shop of Messrs Hancock, Rixon & Dunt. (*Museum of London*)

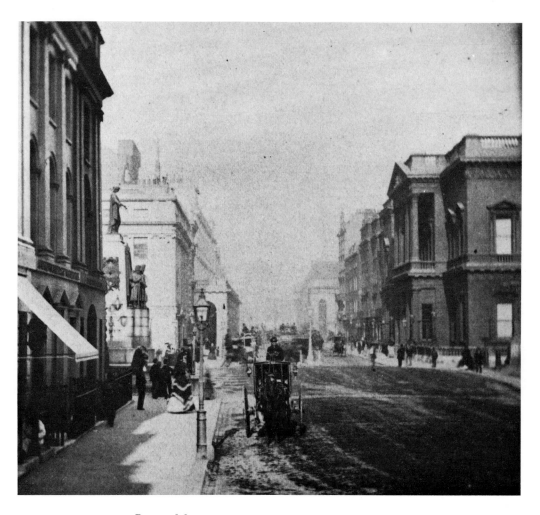

77 PALL MALL LOOKING EAST, c. 1860–65
Valentine Blanchard
(*'Instantaneous' photograph*)

In Blanchard's 'instantaneous' photograph – the original is only 3″ × 3¼″ – pedestrians and a stationary hansom cab are clearly visible, but the National Gallery, which closes the eastern vista down Pall Mall, is not. On the right is the United Services Club, designed by Nash. On the left, at the bottom of Waterloo Place, the Guards Memorial can be seen. This, the work of the sculptor John Bell to commemorate the 2,162 members of the Brigade of Guards who died in the Crimean War, was erected in 1860. (*Royal Photographic Society*)

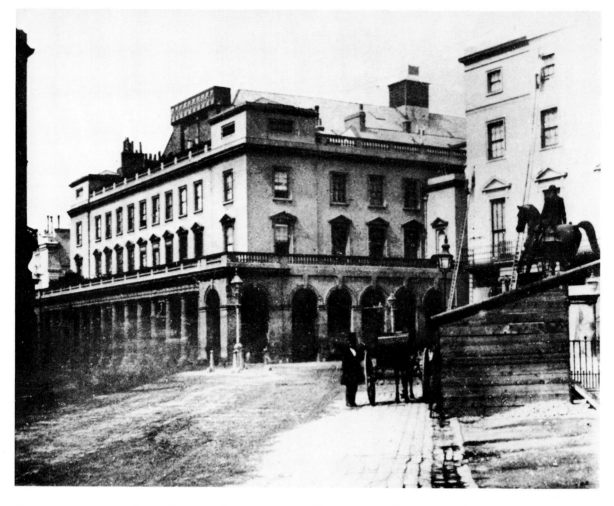

78 THE OPERA HOUSE FROM COCKSPUR STREET, 1857
Anon.

This photograph of the Italian Opera House, or Her Majesty's Theatre, was taken from further away than Plate 74, so not only is George III visible on the right but also the ugly and obtrusive roof of the theatre. The water tank must have been modern, but the plate in Thomas Shepherd's

Metropolitan Improvements (1828) confirms that the original roof was of a high pitch which, presumably, Nash and Repton could not altogether hide when they built the exterior in 1816–18. (*Sir Benjamin Stone Collection, City of Birmingham Libraries*)

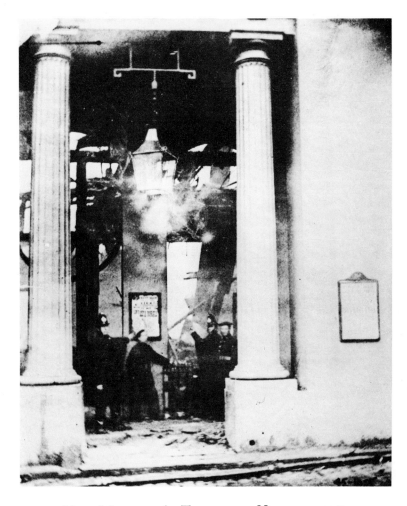

79

HER MAJESTY'S THEATRE, HAYMARKET,
AFTER THE FIRE, 6 DECEMBER 1867

Anon.

This is one of a series of photographs taken the morning after the fire which completely gutted the interior of the building. This view shows the entrance lobby off Haymarket. (*Victoria & Albert Museum*)

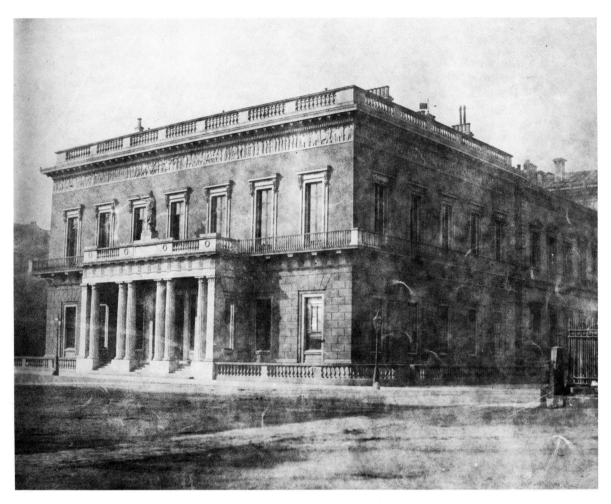

80 THE ATHENAEUM CLUB, WATERLOO PLACE, EARLY 1840s
William Henry Fox Talbot
(*Calotype*)

The Athenaeum is one of the two club-houses planned by Nash for either side of Waterloo Place following the removal of Carlton House in 1827. This one was built in 1829-30 and was designed by Decimus Burton, the son of James Burton, the builder who did so much work with Nash. This photograph of the club - of which Talbot was a member - shows it before the addition of the attic in 1899-1900 and the replacement of the surrounding railings by solid sheets of marble. Nor are there flares on the balcony. The exterior of the club-house looks as if the stucco has been painted: the walls possibly Bath stone colour and the background to the Parthenon frieze picked out in a darker paint. To the right is the Travellers' Club, built in 1830-32, and above that the Italianate roof and cornice of the Reform Club, built in 1838-41. Both of these were designed by Charles Barry. (*Science Museum, London*)

81

LOWER REGENT STREET, LOOKING NORTH, 1860S
Anon.

The photograph shows Regent Street almost as Nash left it. Closing the vista, north of the Regent (Piccadilly) Circus, is the County Fire Office, designed by Robert Abraham in association with Nash on the model of the south front of old Somerset House, and built in 1819. Lower Regent Street itself was created in 1817–20, but lacked the unity of design of Waterloo Place to the south or the Quadrant further north. The tower on the left (west) side of the street is that of St Philip's Church, designed by G. S. Repton. The nearest building on the right, with the Ionic order, is part of the unified design of Waterloo Place, built by James Burton in 1815–16. Further up the street on the right are the two projecting colonnaded wings of the pair of houses, Nos. 14 and 16 Regent Street, built by Nash for himself and his cousin John Edwards in 1819–23. In between is the only interloper at this stage: the Junior United Services Club with its distinctive protruding central bay surmounted by a sculptured allegory of the Army and Navy by John Thomas. This Italianate palazzo, in stone rather than stucco, was designed by Nelson and James and built in 1855–7, replacing the earlier club-house by Smirke. All the buildings in this view were demolished and rebuilt in the twentieth century. (*National Monuments Record*)

82 THE QUADRANT OF REGENT STREET, 1850s
 Anon.

This view looks towards what is now the irregular triangu-
lar space called Piccadilly 'Circus', but before 1885 was the
continuation of Lower Regent Street north of the Regent
Circus before turning sharp left into the Quadrant. The
Circus is just round the corner to the right in this photo-
graph. Between the island block by Nash straight ahead
and the County Fire Office to its left (see Plate 81) can be
seen one side of Tichborne Street, an ancient street running
at quite a different angle to Nash's later plan. In 1885 the
island building (bounded by Regent Street, Tichborne
Street and Coventry Street) was removed when the Metro-
politan Board of Works laid out Shaftesbury Avenue. Had
this photograph been taken before 1848, it would have
shown the colonnades over the pavement of the Quadrant,
a distinctive feature of Nash's unified design which were
disliked by the shopkeepers and proved conducive to vice.
James Pennethorne designed the replacement first-floor
balcony where the roof above the iron columns met the
building. That all the shops have their shutters and blinds
closed suggests that the photograph was taken on a Sunday.
(Gerald Cobb, Esq.)

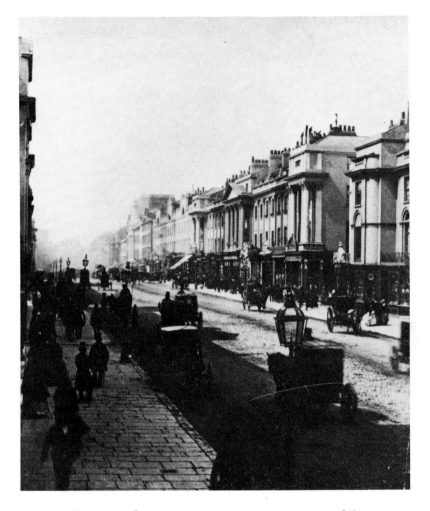

83 REGENT STREET LOOKING NORTH, C. 1860
George Washington Wilson
(*'Instantaneous' photograph*)

This 'instantaneous' view by the prolific Scottish photo-grapher on his first photographic visit to London is in Volume I (1860-61) of the Prince Consort's collection of photographs. Something of the quality of the businesses then in Regent Street is suggested by the opulence of the shop fronts. The block on the east side of the streets with the central pediment was one of those designed by Nash himself. (*Reproduced by Gracious Permission of Her Majesty the Queen*)

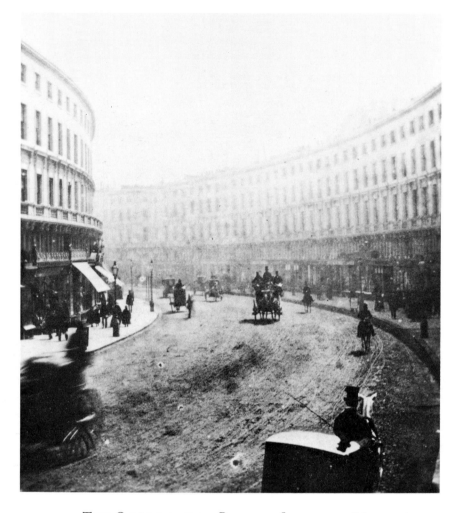

84 THE QUADRANT OF REGENT STREET, 1860s

Anon.

('Instantaneous' photograph)

Regent Street, then highly fashionable, looks rather more lively in this 'instantaneous' photograph than in Plate 82. It is interesting to note that as well as cabs and carriages there are single horsemen. Above the curving top cornice on the right can be seen the roof of St James's Hall, opened in 1856 and demolished in 1905, along with the first chunk of Nash's buildings, to make way for the Piccadilly Hotel. (*Science Museum, London*)

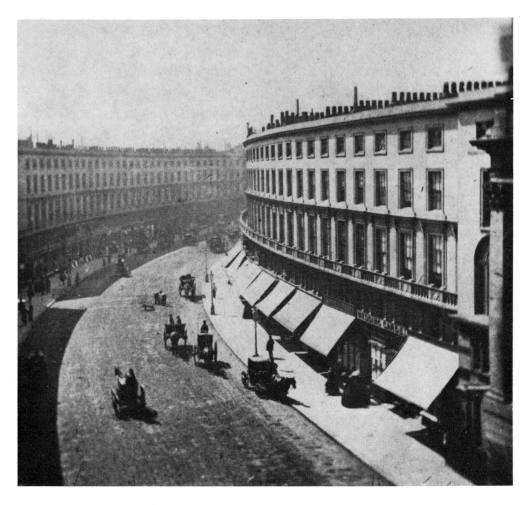

85 THE QUADRANT LOOKING WEST, C. 1856-65
Valentine Blanchard
(*'Instantaneous' photograph*)

The beauty of this formal, curving part of Regent Street, which was particularly dear to its creator John Nash, is enhanced both by the elevated viewpoint of the photograph and the dramatic shadows. Blanchard must have taken this photograph from the top floor of the island block just north of the original, small Piccadilly Circus which was swept away in the 1880s by the advent of Shaftesbury Avenue (see Plate 82). Descriptions of the hazy atmosphere in Victorian London as well as the evidence of many photographs suggest that strong sunlight, as in this early afternoon view, was comparatively rare in Victorian London. Traffic seems sparse in the wide street, but the blinds being down confirms that the shops are open and that the photograph was taken on a weekday. (*Royal Photographic Society*)

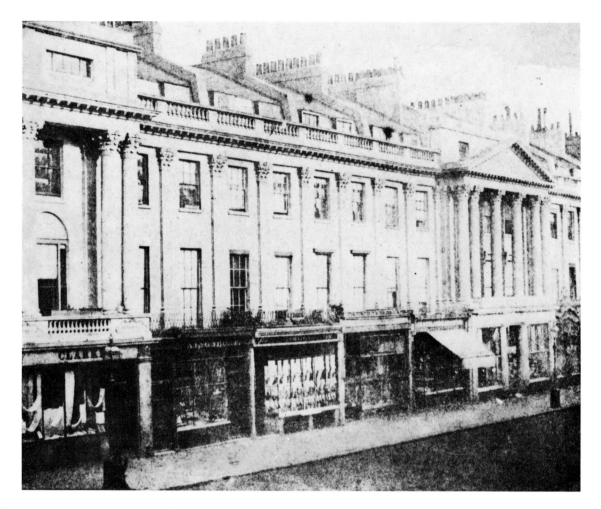

86 NOS. 154–140 REGENT STREET, C. 1845
William Henry Fox Talbot (?)
(*Calotype*)

This, and Plate 87, were taken from a first-floor balcony half-way along Regent Street on the west side. Why these calotypes were taken is not recorded. In 1847 Talbot opened a studio at 122 Regent Street, but that was further south on the opposite side of the street. This photograph shows part of the block designed by Nash himself and built by James Burton between Beak Street and Leicester Street. The shops, clearly visible here, can be precisely identified from the information in the second series of Tallis's *Lon-don Street Views* (1847). The shop on the left, labelled 'Clarke', is Miss Clarke's Antique and Modern Lace Warehouse. To the right of that is Kingbury, Razor Maker; then Lodge, Shirt Maker; Lehocq, French Boot Warehouse; Hitchins & Toole, Tailors; Rowlands & Son, Goldsmiths (with the blind down); then, under the portico, Warwick House: Merrett, Simes & Merrett, Silk Mercers. (*Science Museum, London*)

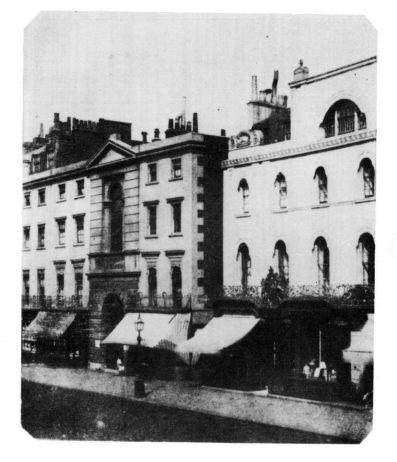

87 N O S . 1 7 6 - 1 7 0 R E G E N T S T R E E T , c . 1 8 4 5
William Henry Fox Talbot (?)
(*Calotype*)

This photograph was taken from the same position on the west side of Regent Street as Plate 86. The block on the right was idiosyncratic in style and typical of its architect, Sir John Soane. It was built in 1820-21 for J. Robins, the auctioneer. The oddness of the design is enhanced by the blind hoods at the tops of the windows. The elaborate shop front is that of Benham & Co., Paper Hangers. North of Chapel Court, the prominent feature in the more commonplace block is the stone façade of Archbishop Tenison's Chapel. The body of the chapel was of 1702 but it was given a new front and vestibule in 1824 following the creation of Regent Street. The façade was designed by C.R. Cockerell. It was altered in 1854 and demolished in 1903 – the chapel itself, as St Thomas's Church, surviving for another seventy years. The shop to the right of the chapel housed Coleman, Laceman, and Farey, Hosier. That to the left is Grignon, Chemist and Druggist. Like almost all buildings in Regent Street, these blocks were redeveloped in the 1920s. (*Science Museum, London*)

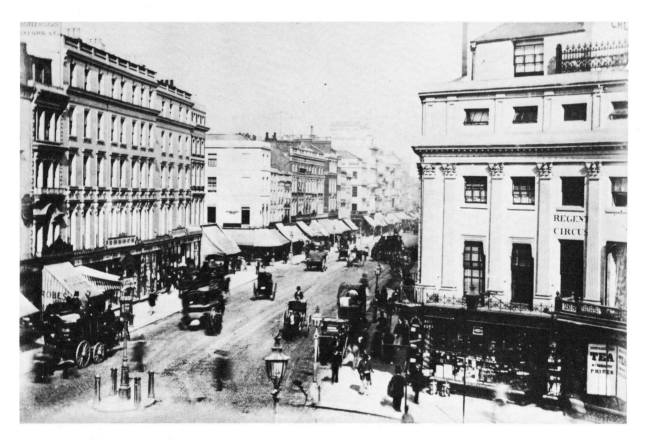

88 OXFORD CIRCUS AND
 OXFORD STREET, 1870S

 Anon.

This is a view looking east along Oxford Street. Both the
circuses designed by Nash to make suitable crossings of
Oxford Street and Piccadilly by the new Regent Street were
originally (and confusingly) called Regent Circus. (*Science
Museum, London*)

THE CONSERVATIVE 89
 CLUB-HOUSE,
ST JAMES'S STREET, C. 1845

William Henry Fox Talbot (*Calotype*)

This club, on the west side of St James's Street, designed
by George Basevi and Sydney Smirke, was built in 1843-5
and so was one of the latest examples of modern architec-
ture in London when Talbot photographed it. The exterior
survives today; the interior has been destroyed. The Con-
servative Club's immediate neighbour, further down the
street, was the Albion Club-House, formerly Saunder's
Chocolate House, No. 85 St James's Street. This, with its
Venetian window, was designed by Samuel Pepys Cockerell
and built in 1786. It was demolished in 1862 to make way
for the Thatched House Club by Knowles, which still
stands on the site. (*Science Museum, London*)

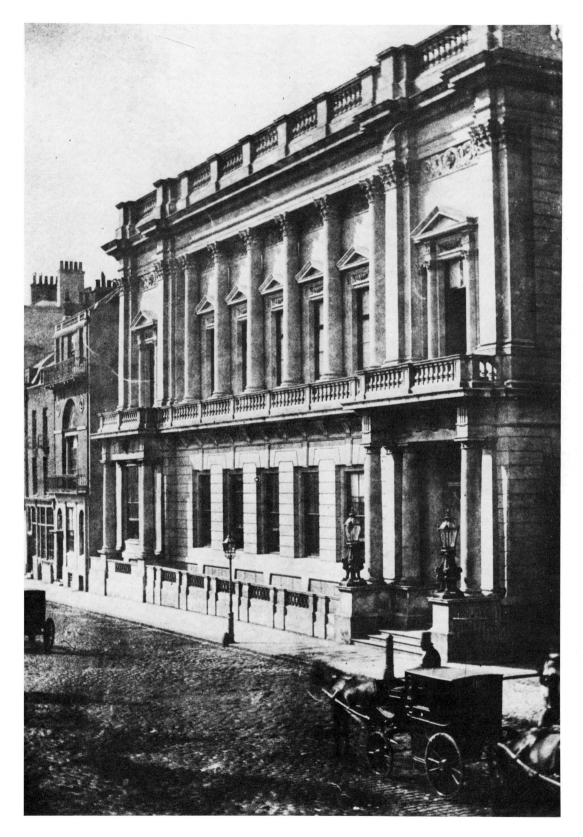

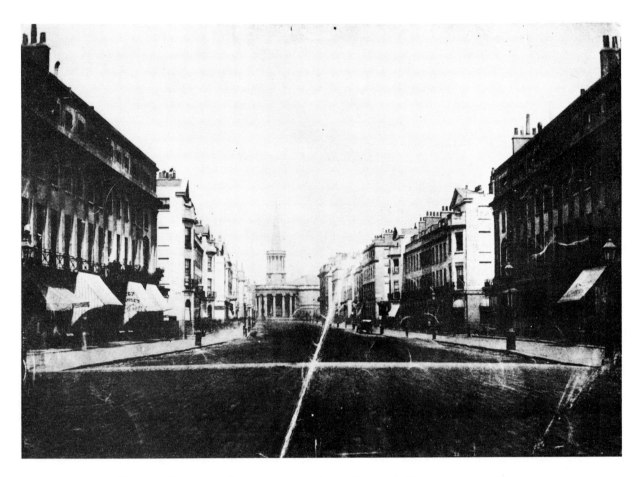

90 UPPER REGENT STREET AND ALL SOULS' CHURCH, C. 1845
William Henry Fox Talbot
(*Calotype*)

This photograph, taken looking north from the centre of the Regent (Oxford) Circus, shows the elegant scale of Nash's Regent Street to even better advantage than the familiar prints in Shepherd's *Metropolitan Improvements*, drawn less than two decades earlier. Today all the buildings have been replaced by higher blocks in stone. Only All Souls', Langham Place, survives, but the effect of it at the end of the street is ruined by the bulk of Broadcasting House rising up behind. The first part of Upper Regent Street was symmetrical. The outer blocks in the photograph were part of the pilastered composition which went right round the Circus. These, like the adjacent blocks with projecting end bays, which mirror each other across the street, were built by Samuel Baxter. All Souls' Church, which with its unorthodox combination of spire and circular colonnade was so criticized and which yet turned the corner into Langham Place so brilliantly, was built in 1822–5 and was no more than twenty years old when Talbot took this photograph. In 1832 he had been married there. (*Science Museum, London*)

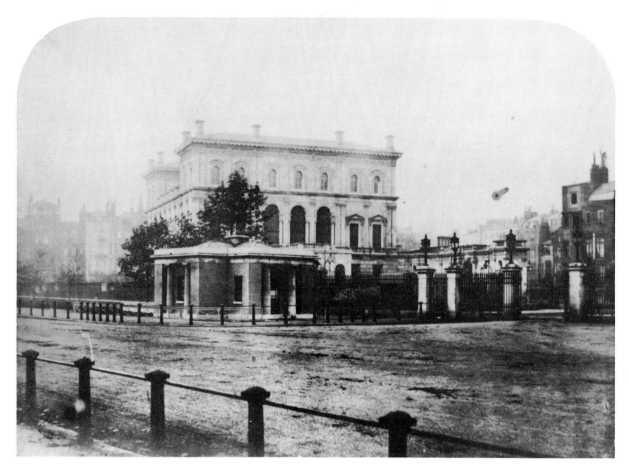

91

DORCHESTER HOUSE, PARK LANE, C. 1857
Roger Fenton

Dorchester House was one of the most magnificently finished and splendid private houses in London. It was designed by Lewis Vulliamy in the manner of an Italian *palazzo* for R.S. Holford and built in 1849–55. Mr and Mrs Holford took up residence in 1856. This view, looking from the south across Park Lane, shows the entrance front and forecourt. Dorchester House was sold and demolished in 1929, one of its chimneypieces by Alfred Stevens going to the Victoria & Albert Museum. The Dorchester Hotel now stands on the site of the house and grounds. In the foreground is one of the Stanhope Gate lodges to Hyde Park, designed by Decimus Burton in 1824. These were later enlarged and were destroyed in the 1960s when the railings were set back and Park Lane converted into a dual-carriageway. (*Sotheby Parke Bernet & Co., London*)

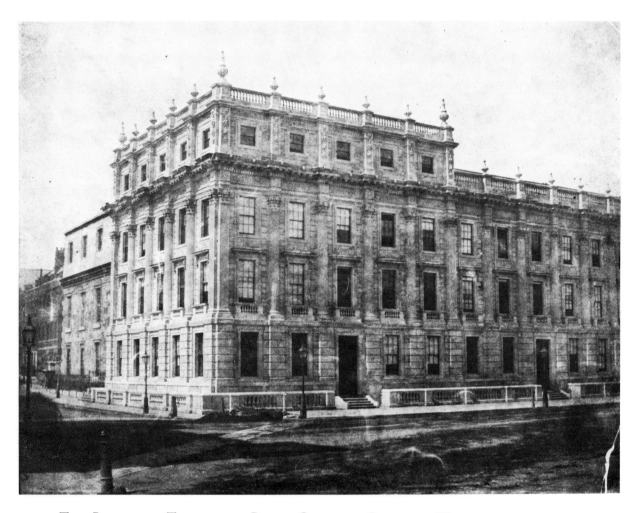

92 THE BOARD OF TRADE AND PRIVY COUNCIL OFFICES, WHITEHALL, c. 1846
William Henry Fox Talbot
(*Calotype*)

Again one wishes that this photograph could have been taken just a few years earlier, for until 1844 a façade by Soane stood on the site. It had only been built in 1824–6 and did not last twenty years before being enlarged and remodelled by Charles Barry in 1845–6. Barry's taller de-sign re-used Soane's Corinthian columns and frieze. Barry's Treasury stands today, as does a surviving fragment of Soane's building, visible on the left in Downing Street. (*Science Museum, London*)

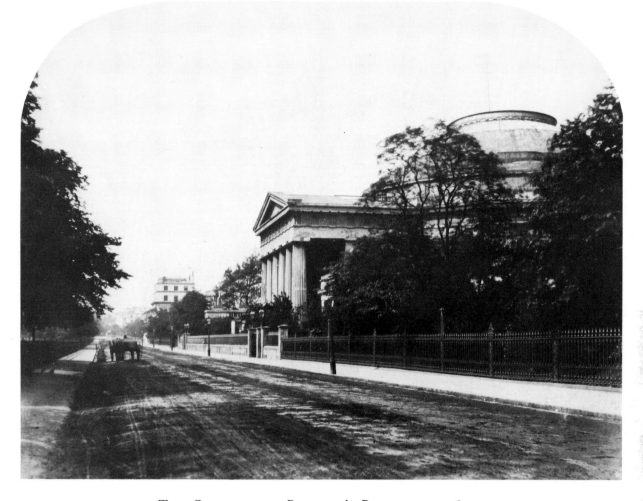

93 THE COLOSSEUM, REGENT'S PARK, LATE 1850s
Roger Fenton

The Colosseum stood on the east side of the Regent's Park near Park Square on a site now occupied by Cambridge Terrace. It was designed by the young Decimus Burton and built in 1823–6. 'Pantheon' would have been a more appropriate name, for it was a circular domed structure (sixteen-sided, in fact), 126 feet in diameter, with a (Greek Doric) portico. Its purpose was to display the great Panoramic View of London. This was painted on canvas by Thomas Hornor and was based on studies he had drawn in 1820–21 from a wooden observatory erected above the ball and cross on the top of St Paul's Cathedral dome. Hornor completed his great work in 1829 and visitors could ex-perience the effect of the view from the top of St Paul's by going up in the 'Ascending Room' (a lift) in a central column to viewing galleries. They could also climb up above the glass roof at the top of the dome. Unfortunately, although visited by large numbers of people, the profits of the Colosseum did not pay off the investment and Hornor followed his backer across the Atlantic. In 1845 the interior was altered and further subsidiary entertainments added, but although new panoramas were provided and the building was refurbished several times, it was dilapidated by the 1860s and in 1875 was demolished. (*Royal Photographic Society*)

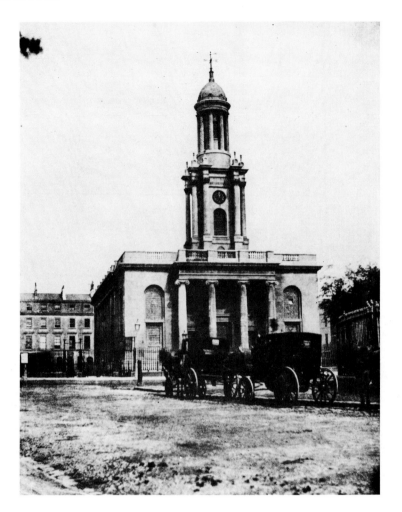

94

HOLY TRINITY CHURCH, MARYLEBONE, C. 1845
William Henry Fox Talbot
(*Calotype*)

Holy Trinity Church, on the north side of the New (Marylebone) Road on the corner of Albany Street, was designed by Sir John Soane and built in 1826-7. The church survives, albeit turned into offices, but the stuccoed terrace behind was replaced in the 1930s by Robert Atkinson's block of flats called the White House. In the foreground are two broughams, a vehicle introduced to London streets in about 1839 and originally designed by Lord Brougham. (*Science Museum, London*)

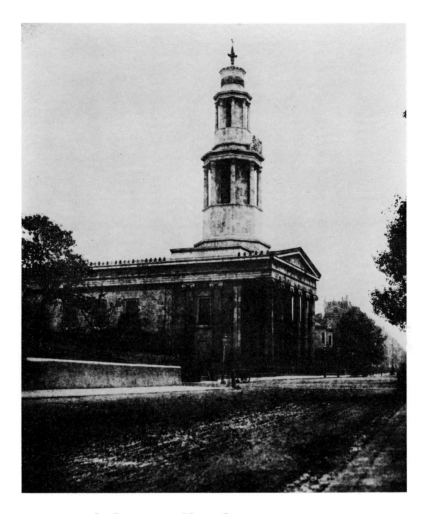

95 ST PANCRAS NEW CHURCH, c. 1845
William Henry Fox Talbot
(*Calotype*)

The New Church of St Pancras, built in 1819–22 on the south-east corner of Euston Square, was the most lavish and expensive Greek Revival building erected in London apart from the British Museum. It was designed by William Inwood and his son William Henry Inwood. The New Road (Euston Road), which then bisected Euston Square, can be seen running across the picture in front of the side elevation of the church. Generous front gardens, like the one on the left in front of a house where the L.C.C. Fire Station now stands, were gradually sacrificed to road-widening. Woburn Lodge, with its twin-bowed front just beyond the Greek Ionic portico, and the rest of the houses in Upper Woburn Place beyond all perished in the 1930s, as did the gardens on the south side of Euston Square. (*Science Museum, London*)

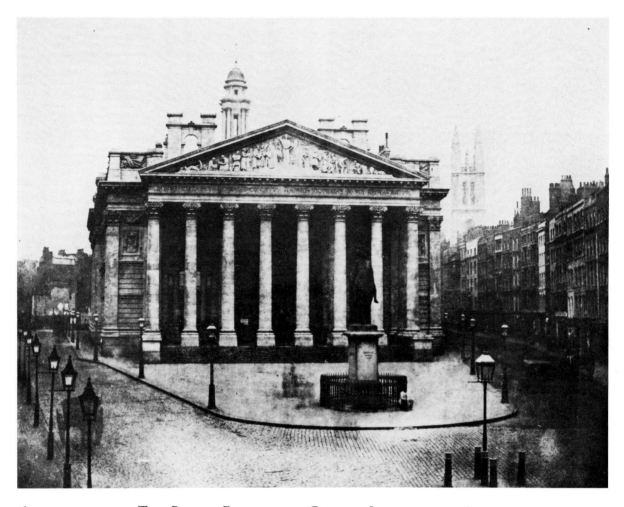

96 THE ROYAL EXCHANGE, CITY OF LONDON, c. 1844
William Henry Fox Talbot
(*Calotype*)

This photograph, taken from one of the houses then on the corner of Poultry and Princes Street, shows the new Royal Exchange very soon after it was opened by Queen Victoria in October 1844. The former Exchange had been burned down in 1838 and, after a corruptly managed competition, the designs of William Tite were chosen. Construction began in 1842. In 1844, the houses between Cornhill and Threadneedle Street were cleared to make a new forecourt to the Exchange, on which was placed Chantrey's equestrian figure of the Duke of Wellington. To the right of the Exchange is the tower of St Michael's, Cornhill, built in 1718–24 by Hawksmoor in the Gothic manner. All the little houses lining Cornhill have since been demolished. To the left of the Exchange, the site on the corner of Threadneedle Street and Old Broad Street is empty. (See also Plate 153.) (*Science Museum, London*)

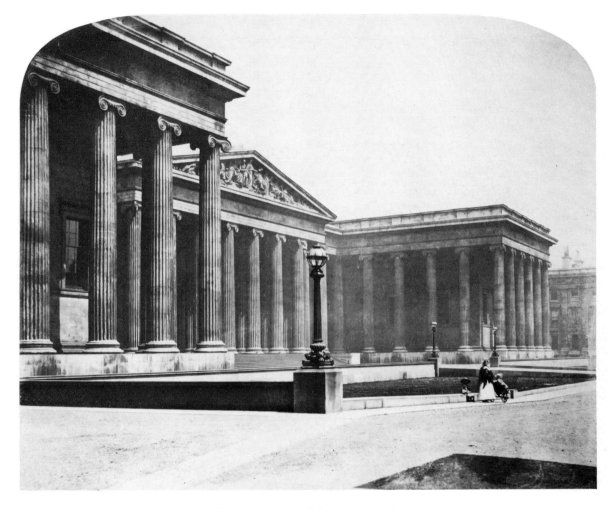

97 THE BRITISH MUSEUM, 1857
Roger Fenton

When Fenton took this photograph, the great south front of the Museum and its flanking wings had only been finished only eight years before, but in the 1850s this monumental Greek Revival design seemed very old-fashioned as it was essentially a product of the 1820s when Sir Robert Smirke began his great work. This view remains quite unchanged today. Fenton was employed by the British Museum between 1854 and 1858 to make photographs of individual exhibits and interiors. (See also Plates 98, 99.) (*Science Museum, London*)

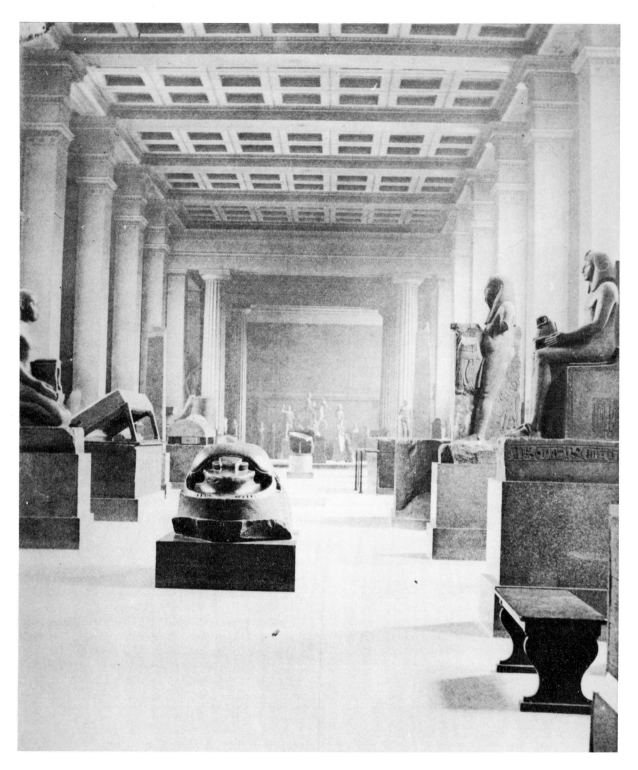

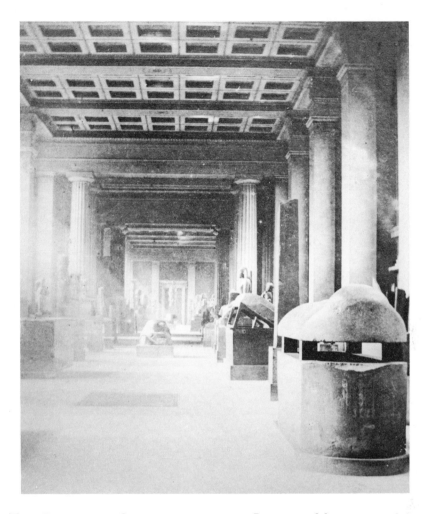

98, 99 THE EGYPTIAN GALLERIES OF THE BRITISH MUSEUM, 1860S
J.D. Burton

These two photographs show the grandeur of Smirke's long Egyptian Galleries after they had finally been completed in 1850. The northern part had been finished in 1829 but the southern arm had to await the completion of the whole south range of the Museum. In 1850 the intervening partition was at last removed and the whole room decorated with a scheme dominated by Pompeian red, designed by Sydney Smirke. The photograph looking north shows the Northern Egyptian Gallery through the Central Egyptian Saloon bounded by pairs of Doric columns; that looking south shows the First Graeco-Roman Saloon at the end. This great room does not look so well today. Smirke's substantial granite plinths were thrown away at the end of the 1970s when the Galleries were redecorated in a uniform porridge colour. (*Victoria & Albert Museum*)

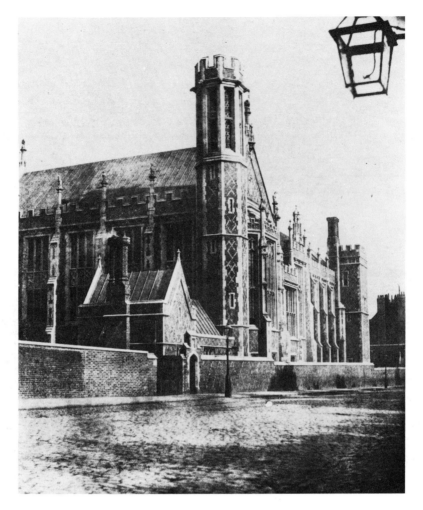

100 THE NEW HALL AND LIBRARY, LINCOLN'S INN, C. 1845
William Henry Fox Talbot
(*Calotype*)

Talbot took this photograph from the north-east corner of Lincoln's Inn Fields. It shows the new Library with the Hall beyond built for Lincoln's Inn in 1843–5 in an uncharacteristic (at this stage) Tudor style by Philip Hardwick and Philip Charles Hardwick, the architects of Euston Station. Although the Library was extended to the east by Scott in 1871–3, this view remains unchanged today. (*Science Museum, London*)

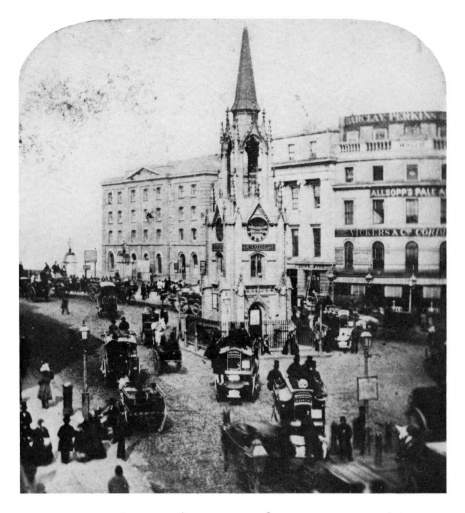

101 LONDON BRIDGE APPROACH, SOUTHWARK, C. 1860

Anon.

(Stereoscopic photograph)

This was the view towards the Thames and London Bridge from what was then called Wellington Street and is now the northern part of the Borough High Street near the junction with Tooley Street (to the right). In the centre of the road is a Gothic clock tower, doubling as a telegraph office, erected in 1854 and designed by Arthur Ashpitel. Funds did not permit the intended installation of a statue of the Duke of Wellington under the canopy at the top. In 1862 the tower was removed and re-erected at Swanage to make way for the immensely destructive South Eastern Railway extension from London Bridge to Charing Cross and Cannon Street, opened in 1864 and 1866 respectively. The buildings behind the clock tower are typical of the elegant approaches to London Bridge on both banks, planned by Smirke. Several of the Southwark buildings were designed by George Allen, a local architect who had made suggestions for the approaches to the new bridge, which was a little upstream of Old London Bridge, in 1827–8. Allen designed the London Bridge Tavern, to the right of this view, in 1834 and also Fenning's Wharf, on the left close by the bridge, in 1836 and which was later altered and demolished in 1984. (*B.E.C. Howarth-Loomes, Esq.*)

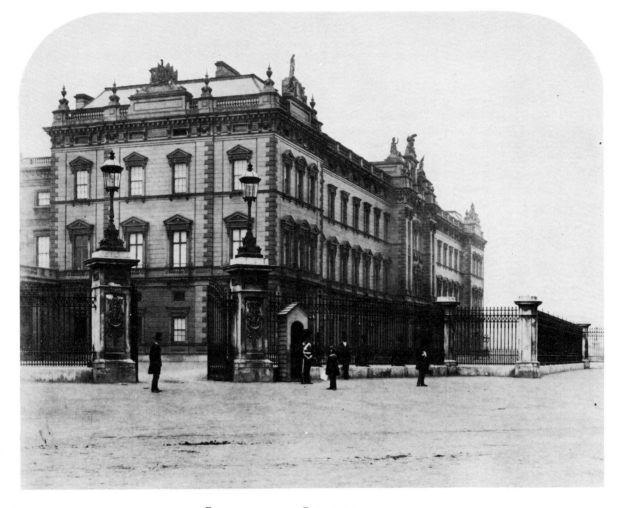

102 BUCKINGHAM PALACE, c. 1857
Roger Fenton

This photograph shows the new East Wing added to Buck-ingham Palace by Edward Blore in 1847–50, which closed the open courtyard of the Palace designed by Nash. Despite the sculptured groups on the parapet, this prominent façade always seemed dull and unimpressive for a Royal palace. Oddly, John Timbs in *Curiosities of London* (1868) de-scribed this front as 'German, of the last century', which suggests that the Prince Consort might have influenced the design. Blore used Caen stone on the building which soon began to decay and had to be painted as if it was stucco – the stone looks painted in this photograph. Blore's east front survives but was completely refaced in Portland stone in 1913 by Sir Aston Webb, who provided a new, grander design but who did not alter the position of a single window. Webb also re-used and copied Blore's gate piers, visible here, which were of Portland stone. (*National Monuments Record*)

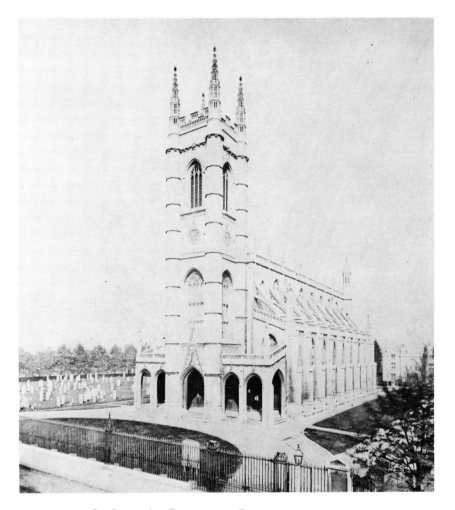

103 St Luke's Church, Chelsea, c. 1870
James Hedderly

St Luke's, Chelsea, built in 1820–24, was designed by James Savage and was celebrated as one of the first serious attempts to revive Gothic forms of construction. The building survives today; the interest of this photograph, taken by Chelsea's local photographer, is that it shows the Gothic gate lodge to the churchyard, on the right, since demolished, and because it is not overshadowed by Late Victorian red brick blocks on the left in Belle Grove, or Cale Street, as it is today. (*Kensington and Chelsea Public Libraries and Arts Services*)

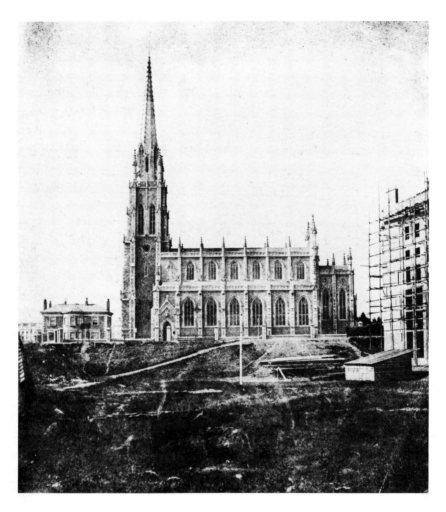

104 HOLY TRINITY CHURCH, BISHOP'S ROAD, PADDINGTON, c. 1846
William Henry Fox Talbot
(*Calotype*)

Holy Trinity Church, Paddington, was one of several new churches built in the 1840s in new suburbs and designed in the fashionable 'correct' Gothic manner. This example was designed by Thomas Cundy junior in 1844 and consecrated on 3 July 1846. It was built to serve the new neighbourhood rapidly growing up to the west of the Great Western Railway's nearby terminus, opened in 1838, and the rows of stuccoed terrace houses became very typical of the fashionable area north of Hyde Park. Talbot took this photograph when the church was new and while the surrounding estate was still being built. On the right are the backs of the houses being built along the west side of Westbourne Terrace. This photograph reveals a marked drop in the level of the land below the church. This was because, by agreement with the owners of the estate, the Great Western Railway built up the level of the roads when the bridges over the railway were built. At considerable cost, therefore, the site for the church had to be raised up to the new level of Bishop's Road before construction could begin. Holy Trinity was demolished in 1972, apart from the bottom of its west tower. Most of the housing round the site still survives. (*Science Museum, London*)

105 LONDON HOUSES UNDER CONSTRUCTION, c. 1846

William Henry Fox Talbot

(*Calotype*)

This photograph, entitled 'House building in London', shows the backs of a terrace of houses under construction. Their exact location cannot be identified but it is likely that they are on the estate around Westbourne Terrace, which can be seen in Plate 104. With the wooden centering in the round-headed windows and the scaffolding of poles lashed together with rope, this photograph shows the traditional method of building by which all the Georgian terraces of London were erected. (*Science Museum, London*)

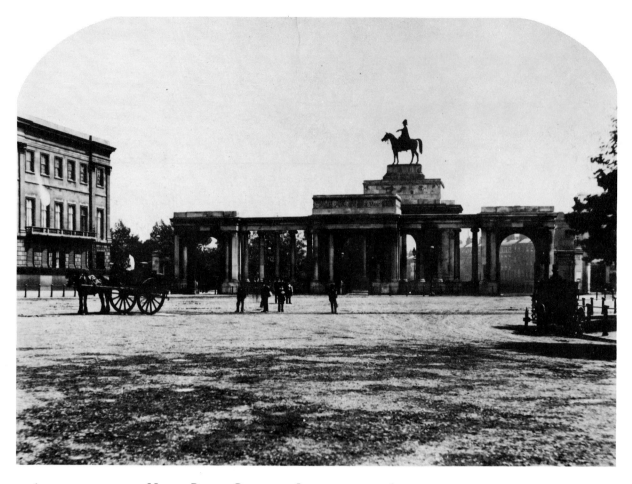

106 HYDE PARK CORNER SCREEN AND ARCH, c. 1857
Roger Fenton

This photograph was taken from Hyde Park looking south. On the left is Apsley House, the town house of the Duke of Wellington. The Ionic Screen between Piccadilly and the Park was designed by Decimus Burton and built in 1824–5. The Arch was also designed by Burton and was built in 1827–8 on the opposite side of Piccadilly as a Royal Entrance to Buckingham Palace from the north. It no longer stands in this position; nor does it still carry the colossal equestrian figure of the Iron Duke, to the installation of which in 1846 Burton strenuously objected. When the statue was removed and banished to Aldershot in 1883, the Arch was taken down and rebuilt in a more appropriate position on the axis of Constitution Hill – although the logic of this was gravely marred by making Hyde Park Corner into a giant roundabout in the 1960s. (*Royal Photographic Society*)

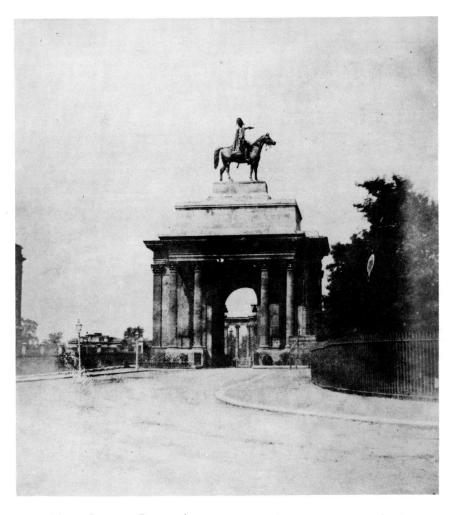

107 THE GREEN PARK ARCH FROM THE SOUTH, C. 1846
William Henry Fox Talbot
(*Calotype*)

Talbot took this photograph of the Arch at Hyde Park Corner shortly after the colossal equestrian figure of the great Duke of Wellington had been raised into position. It had been modelled by Matthew Cotes Wyatt, who began work on it in 1840. The statue was much ridiculed and it infuriated the architect of the Arch, Decimus Burton, who left money in his will to have it removed. It was taken away in 1883 when the Arch was re-erected on its present site, approximately where Talbot stood to take his picture. In 1911 the present quadriga by Adrian Jones was placed on top of what is still sometimes – inaccurately – called the Wellington Arch. (*Royal Photographic Society*)

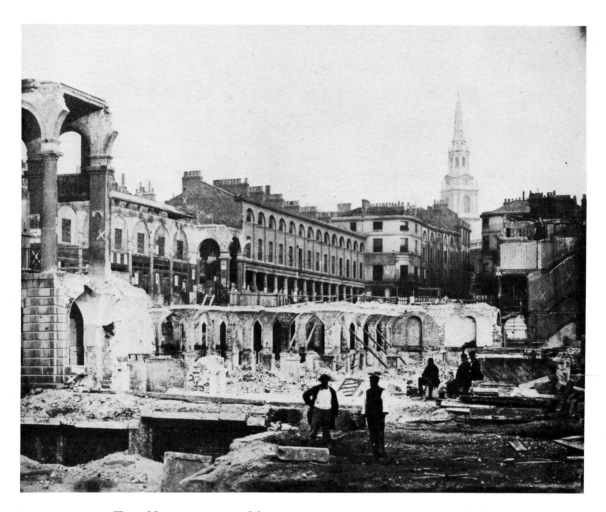

108 THE HUNGERFORD MARKET BEING DEMOLISHED, 1862
Anon.

The Hungerford Market was very short-lived but it was one of the most interesting buildings in London; its destruction still seems lamentable. It was built in 1831–3 on the site of an older market established by Sir Edward Hungerford in 1680. The architect was the architect of the market buildings in Covent Garden, Charles Fowler, an accomplished designer equally able to handle new forms of construction and raw materials like iron, which was extensively employed here. On the long, narrow site stretching from the Strand to the Thames, Fowler planned two market areas at different levels, separated by arcades of the Tuscan granite columns familiar at Covent Garden and surrounded by colonnades, behind which there were shops. The Hungerford Market anticipated modern 'shopping precincts' by over a century and executed the idea with rather more elegance. By the Thames there was a formal composition of public terraces flanked by towers, and from the terrace in 1845 leapt the Hungerford Suspension Bridge, designed by I.K. Brunel (see Plates 130–32). Unfortunately the Market was not profitable and in 1859 it was purchased for the construction of the West End terminus of the South Eastern Railway Company, who utilized the piers of Brunel's bridge for their railway bridge (see Plate 143). This view was taken in 1862 when the Market was being demolished and looks west from the lower court. In the distance is Market Street, leading to the Strand, and beyond that the steeple of St Martin-in-the-Fields. In the foreground are the vaults under the upper court, which had been surmounted by arcades supporting a roof (see Plate 110). The mediocrity of the resultant Charing Cross Station and Hotel makes the loss of the Hungerford Market and Bridge all the more painful – even after 120 years. (*Westminster Public Libraries*)

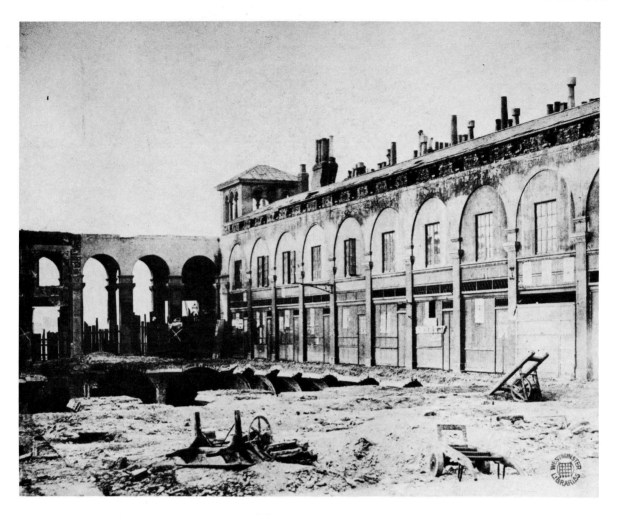

109 THE HUNGERFORD MARKET BEING DEMOLISHED, 1862
 Anon.

This view was taken in the lower court looking towards the Thames. The buildings by the river already seem to have gone, for beyond the arcade on the left was an upper terrace overlooking the Thames, flanked by larger square towers, and from this terrace the footway of the Suspension Bridge led to the south bank. See also Plates 2, 132, 202. (*Westminster Public Libraries*)

110 PERSPECTIVE VIEW OF
THE HUNGERFORD MARKET LOOKING
WEST FROM THE LOWER COURT, c. 1832

Charles Fowler (*Watercolour*)

(*RIBA Drawings Collection*)

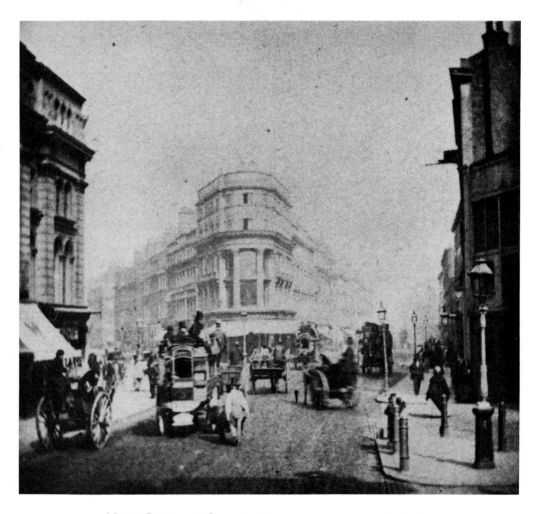

III NEW OXFORD STREET LOOKING EAST, 1856–65

Valentine Blanchard

('*Instantaneous*' *photograph*)

New Oxford Street, an extension of Oxford Street east of Tottenham Court Road, was both a traffic improvement and a slum clearance exercise, for the works cleared the notorious St Giles's 'rookery' just north of the old, winding St Giles High Street and Flitcroft's eighteenth-century church. The architect in charge of this new street was James Pennethorne, Nash's pupil and architect to the Commis- sioners for Woods and Forests, who planned several new London streets in 1832 and who provided the design for the stuccoed façades in the new street. New Oxford Street was opened in 1847. In the distance is visible the curved corner building between the new street and the old line of Hart Street, now Bloomsbury Way. (*Royal Photographic Society*)

THE NEW PALACE OF WESTMINSTER

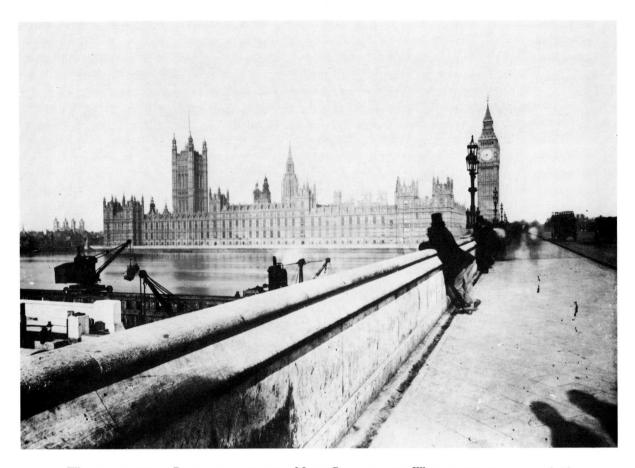

112 WESTMINSTER BRIDGE AND THE NEW PALACE OF WESTMINSTER, C. 1868
Anon.

The Parliament Clock confirms what the shadows reveal: that the photographer was up early to take this view. Nevertheless, men are working on (and others are up watching them work on) the building of the Albert Embankment. The parapet wall at this point seems almost complete; stones were lifted into position by steam cranes which ran along a temporary railway on shoring in the river. The Albert Embankment was opened in 1869. The new Westminster Bridge, with its Gothic lamps, was opened in 1862 (see also Plate 15). To the left of the New Palace of Westminster can be seen the four towers of St John's, Smith Square, the church by Thomas Archer of 1713–28 which represented the nadir of architectural taste, as far as most Victorians were concerned. (*BBC Hulton Picture Library*)

113 THE NEW PALACE OF WESTMINSTER UNDER CONSTRUCTION, C. 1842
William Henry Fox Talbot (?)
(*Calotype*)

This must be the earliest surviving photograph of the New Palace of Westminster. Work had begun on Barry's building in 1839 and by 1843 the river front was largely complete. We see here the south façade with one of the towers along the Thames front on the right. The view has been taken looking across the wharves to the south of the building which were used by the contractors to bring in stone: piles of stone can be seen in the foreground and Barry's Perpendicular Gothic behind is still covered in wooden scaffolding. This area is now part of Victoria Tower Gardens. (*Christopher Gibbs, Esq.*)

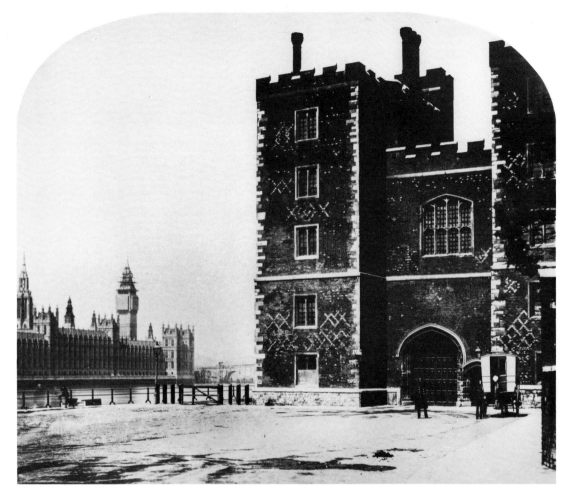

114 LAMBETH PALACE AND THE NEW PALACE OF WESTMINSTER, C. 1857
Roger Fenton

In the foreground is the Gatehouse of Lambeth Palace, the residence of the Archbishop of Canterbury. The Gatehouse was originally built at the end of the fifteenth century. Across the Thames (there is no Albert Embankment yet – see Plate 54) the New Palace of Westminster is nearing completion. The second bell, 'Big Ben', was installed in the Clock Tower in 1858 (the first Big Ben cracked). In between the two palaces can be seen an arch of old Westminster Bridge, already cased in scaffolding for demolition prior to the construction of the new bridge, designed by Thomas Page, which was opened in 1862. The last of Labelye's bridge, opened in 1750, was taken down in 1861. (*National Monuments Record*)

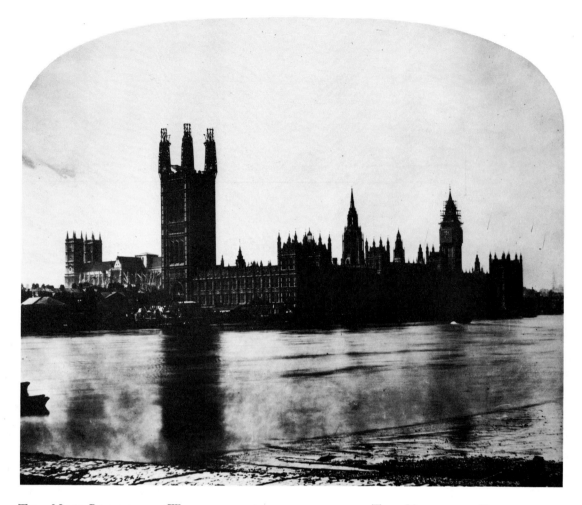

115 THE NEW PALACE OF WESTMINSTER
FROM LAMBETH, C. 1857

Roger Fenton

This view of the New Palace of Westminster nearing completion was taken by Fenton from a point by the Thames near Lambeth Palace (see Plate 114). The land immediately to the south of the Houses of Parliament, where Plate 113 was taken fifteen years before, is still being used by the contractors. Beyond are the backs of houses in Abingdon Street. (*Royal Photographic Society*)

THE VICTORIA TOWER 116
FROM THE SOUTH, C. 1861

Anon.

This photograph was taken in Millbank Street looking north to the recently completed Victoria Tower of the New Palace of Westminster. This superb photograph brings out both the charm of Georgian London and the drama of Barry's colossal tower, 336 feet high. Both, indeed, are interdependent and the picturesque quality of Barry's composition is enhanced by its setting. The Palace of Westminster today has lost much by the removal of the surrounding buildings. Those on the right of this photograph were cleared in 1911 to create the Victoria Tower Gardens by the Thames. The buildings on the left were all rebuilt early this century. The block beyond the public house on the corner of Great Peter Street is now occupied by the Church Commissioners' Office, designed by W.D. Caroë in 1903 and built on a line further back from the Thames. (*Gerald Cobb, Esq.*)

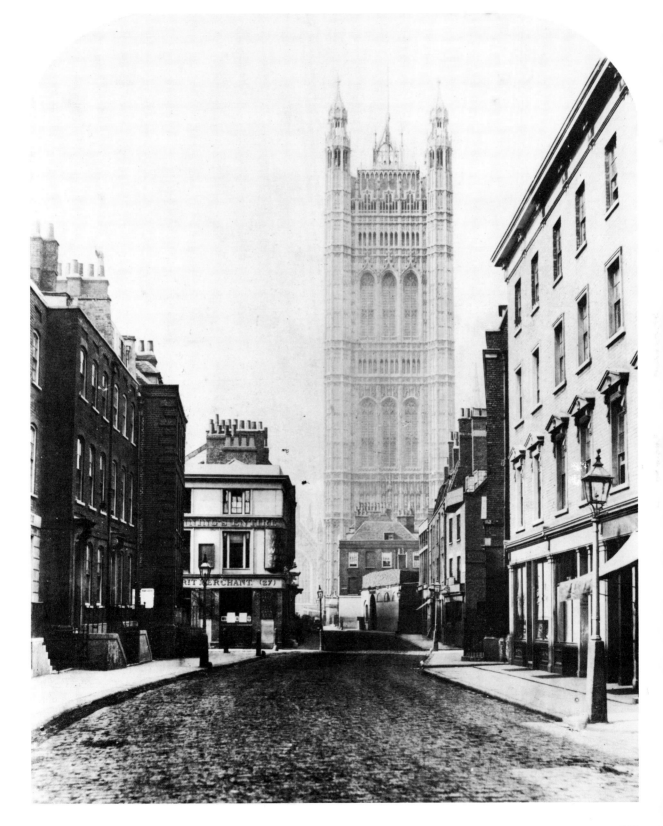

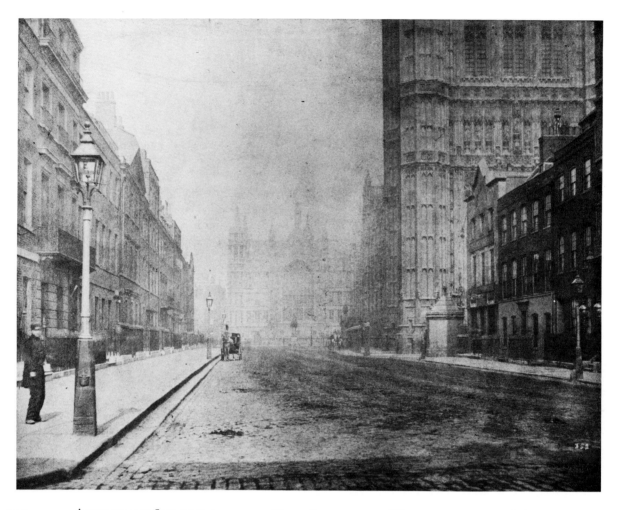

117 ABINGDON STREET AND THE NEW PALACE OF WESTMINSTER, 1860s
Anon.

This photograph admirably demonstrates the way in which the houses of old Westminster emphasized the height and splendour of Barry and Pugin's new Houses of Parliament by dramatic changes in scale and contrasts in style. The impact of the Victoria Tower on the left becomes that of a skyscraper in contrast with the adjacent three-storey Georgian houses. Indeed, the 336-foot tower was almost a skyscraper for its internal structure was all of iron, its purpose being the storage of records. The houses on the left were removed in 1911 to clear an open space by the Thames.

Those on the right survived longer. In 1938 a threat to demolish them for a memorial to King George V and an office block for the Church Commissioners was strenuously and successfully resisted by the newly founded Georgian Group. In 1943, after some bomb damage, the terrace was all pulled down. Today its site is occupied by the ramp to an underground car park, a sculpture by Henry Moore and an open space affording a prospect of the dull, restored masonry of the quite uninteresting Jewel Tower. (*Westminster Public Libraries*)

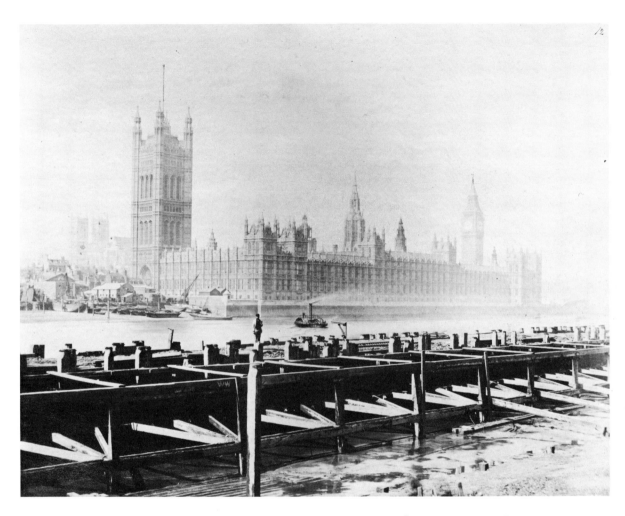

118 THE NEW PALACE OF WESTMINSTER FROM LAMBETH, C. 1867

Anon.

This photograph was taken from a similar position to that used for Roger Fenton's view of a decade earlier. In the meantime Westminster Bridge has been rebuilt, while in the foreground work has begun on building the Albert Embankment. Opposition from wharf owners prevented Bazalgette from duplicating the Victoria Embankment on the south side of the Thames, but in 1866 work was able to begin on an embankment further south, from Westminster to Vauxhall Bridge. Much of it ran in front of the new St Thomas's Hospital, built on a site opposite the Houses of Parliament in 1868-71. The Albert Embankment was opened in 1869. (*Victoria & Albert Museum*)

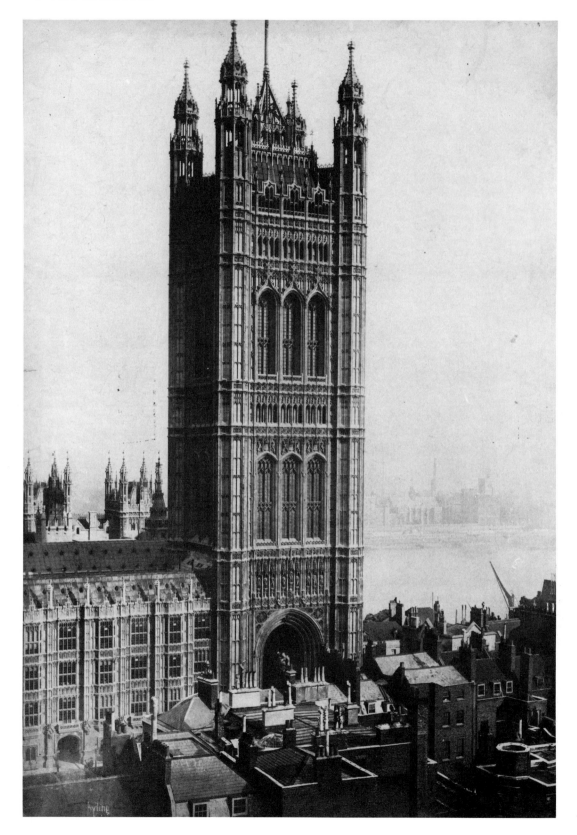

119 THE VICTORIA TOWER
FROM WESTMINSTER ABBEY,
c. 1861

Stephen Ayling

THE PEERS' ENTRANCE TO 120
THE NEW PALACE OF WESTMINSTER,
c. 1857

Roger Fenton

Sir Charles Barry's colossal tower was finished in 1860. This photograph must have been taken from an opposite viewpoint from Plate 7, with the photographer standing on the roof of the as yet unrestored Chapter House of Westminster Abbey. In the right foreground is the top of the medieval Jewel House, whose existence was later used as an excuse to pull down all the far more beautiful houses surrounding it. Most of the houses in the foreground were demolished in the 1940s. Beyond, across the Thames to the right of the Victoria Tower, can just be seen Lambeth Palace (see Plate 114). (*National Monuments Record*)

This elaborate Gothic porch is in Old Palace Yard in the range of the New Palace of Westminster running from Westminster Hall to the Victoria Tower. The House of Lords had been completed and first occupied in 1847. (*Sotheby Parke Bernet & Co., London*)

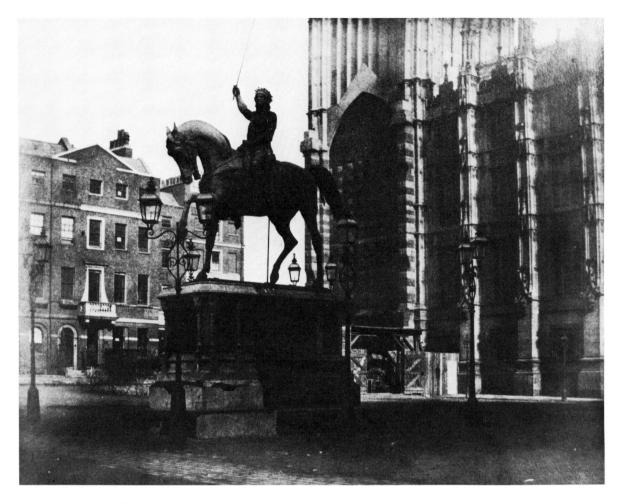

121 RICHARD CŒUR DE LION AND NEW PALACE YARD, 1853

Anon.

This photograph is in Volume III of the Prince Consort's collection, assembled in 1853-4. It is, at first, a puzzling view as Baron Marochetti's equestrian figure of Richard I now stands in Old Palace Yard south of the window of Westminster Hall. It was placed there in 1860 but had first, after its appearance at the Great Exhibition, been installed in New Palace Yard at the other end of Westminster Hall. The plinth in this photograph does not yet have its sculptured panels. Behind the statue is the base of the Clock Tower. Its unfamiliar and ragged appearance is explained by the fact that provision had been made for the abutment of a wing to enclose New Palace Yard. This project, for which Sir Charles Barry made designs, was not finally abandoned until 1864. The base of the west side of the Clock Tower was finished, like the other sides, in 1865-7, when Barry's son, E. M. Barry, also built the Gothic arcade in Portland stone along the west side of New Palace Yard and enclosed it from the street with the Gothic railings that are there today. The Georgian houses on the left, behind, are doubtless some of the thirteen built in two terraces in 1741 by Andrews Jelfe on the north side of New Palace Yard and thus on the south side of Bridge Street. These houses were removed in 1860 and 1864 as part of the works connected with the rebuilding of Westminster Bridge and the widening of Bridge Street. (*Reproduced by Gracious Permission of Her Majesty the Queen*)

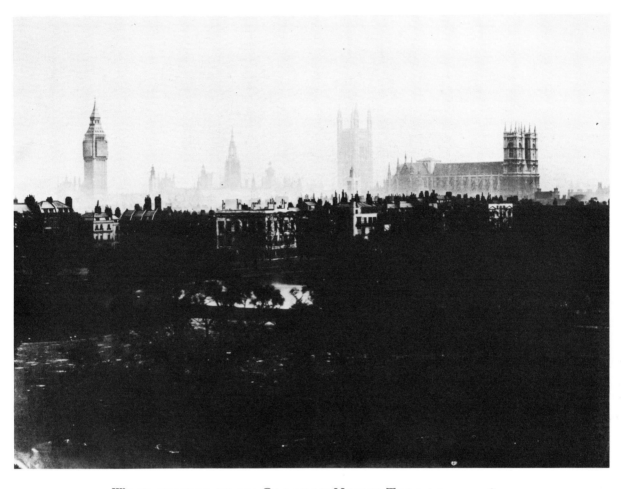

122 WESTMINSTER FROM CARLTON HOUSE TERRACE, C. 1857
Anon.

This photograph is in Volume VI of the Prince Consort's collection, which was assembled in 1855–7. As there is no scaffolding on either the Victoria Tower (which is yet lacking its lantern) or the Clock Tower (which still has no clock), it must have been taken not long after Roger Fenton's views of Westminster (Plates 68, 114). The interest of this view lies not so much in the distant skyline of Westminster but in the buildings in the middle distance on the edge of St James's Park, for almost all have since gone. Most were removed to make way for the two big blocks of offices which run from the Park to Parliament Street: Gilbert Scott's Government Offices (Foreign Office, etc.) of 1863–74 and J.M. Brydon's New Government Offices (Board of Trade, etc.) of 1900–1915. From ordinary houses like these, placed in ordinary streets, the government of Great Britain was carried on until the gradual expansion of bureaucracy and bureaucratic exclusiveness began in the mid nineteenth century. On the far left are eighteenth-century buildings at the end of Downing Street (a little further north was the Foreign Office). The stone building in the centre, above the lake, is the State Paper Office, which was the last work of Sir John Soane, built in 1830–34 and demolished in 1862 to make way for Scott's Foreign and India Offices. The buildings further to the right are the garden fronts of houses in Duke Street, which all disappeared, along with Duke Street itself, King Street and Gardiner Street, in the first decade of the twentieth century. The stone façade is that of No. 37 Great George Street, on the corner of Duke Street, which was re-erected in 1910 as the Park façade of the former Paymaster General's Office, just north of the Horse Guards (see Plate 16). (*Reproduced by Gracious Permission of Her Majesty the Queen*)

123 NEW PALACE YARD FROM WESTMINSTER ABBEY, C. 1874

Anon.

(Stereoscopic photograph)

This photograph would appear to have been taken from the top of one of the west towers of the Abbey; in the right foreground, in front of St Margaret's, Westminster, is one of the pinnacles on the north transept. Beyond that, Soane's Law Courts are still attached to Westminster Hall. Beyond, the Victoria Embankment is finished and Bridge Street is being rebuilt. Unfortunately this photograph has been deliberately pricked with pin-holes to achieve the nocturnal effect of street-lamps when the stereoscopic viewer is held against the light. A better and earlier photograph taken by Francis Frith from a similar vantage point was once in the collection of the Victoria & Albert Museum but, at the time of writing, cannot be found. (*B.E.C. Howarth-Loomes, Esq.*)

124 THE LAW COURTS AT WESTMINSTER, C. 1860

Anon.

(Stereoscopic photograph)

Both Westminster Hall and the Law Courts along St Margaret's Street survived the fire of 1834 which destroyed the Palace of Westminster. Barry wished to remove the Law Courts to make way for his proposed office building around New Palace Yard but they continued to exist on this site until 1883. These buildings were not redundant until 1882 when the new Royal Courts of Justice in the Strand were opened. They were then demolished to expose the medieval west side of Westminster Hall which, after a battle with the Society for the Protection of Ancient Buildings, J.L. Pearson refaced and against which he built new offices in 1888. The history of the old Westminster Law Courts is complicated and their external appearance was the work of Kent, Vardy and Soane. Vardy was chiefly responsible for the fragment of the 'New Stone Building' erected in 1755-8: a five-bay centre and a south wing. This Soane retained and extended when he built the new Courts of Chancery and King's Bench in 1822-4. Soane so respected Westminster Hall that he felt a new building abutting it should be in a completely different style, in this case Palladian. His critics did not agree and in 1825 Parliament ordered the demolition of the north end of the new Law Courts next to Westminster Hall and the erection of a Gothic façade. This design, which Soane disowned, is the building on the left of this photograph. Then follows the Kent-Vardy-Soane façade, which is missing the tower with a Palladian window at the south end to balance the one to the north. The south tower was destroyed in the fire of 1834, and not replaced.
(National Monuments Record)

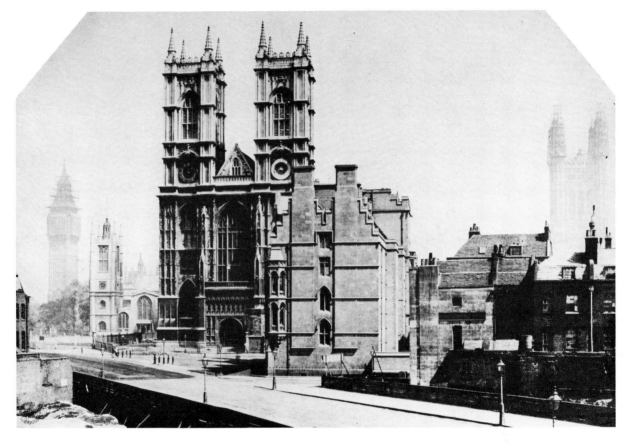

125 WESTMINSTER
FROM VICTORIA STREET, 1854
Anon. (*Stereoscopic transparency*)

WESTMINSTER 126
FROM VICTORIA STREET, c. 1857
Roger Fenton (?)

Victoria Street was laid out in 1847–51, destroying in the process the notorious slums around Tothill Street and necessitating a rearrangement of the buildings round the Sanctuary at the west end of Westminster Abbey (see Plate 4). The buildings immediately to the south of the Abbey west front were demolished and a new block, acting as an entrance to Dean's Yard, erected in 1852–4. These, seen under construction, were designed in the Gothic style by Gilbert Scott, Surveyor to the Abbey. To the left of the tower of St Margaret's Church, the Clock Tower of the New Palace of Westminster is rising. (*Kodak Museum*)

Compare Plate 125, taken from a similar position three years before. Scott's new Broad Sanctuary building is now finished but other sites in Victoria Street remain empty, although the street was formally opened in 1851. The photograph looks across the site of the future Westminster Palace Hotel (see Plate 7) and on the right are the exposed backs of old houses in Dean Street. In the distance, the towers of Barry's New Palace of Westminster are nearing completion. Compare with Plate 4. (*Westminster Public Libraries*)

127 THE WESTMINSTER HOSPITAL AND CRIMEA MEMORIAL,
BROAD SANCTUARY, C. 1861

Anon.

On the triangular space created by the advent of Victoria Street in front of Westminster Abbey - which is seen empty in Plate 126 - Westminster School put up a monument to the 'Old Westminsters' who died in the Crimean War of 1854-6. Designed by Gilbert Scott, this was erected in 1859-61. Behind is the new Westminster Hospital, built in 1832-4 and designed in a rather less serious and heavy style of Gothic than Scott's by the Inwoods, father and son, who were responsible for the Greek Revival St Pancras Parish Church (see Plate 95). This building was shaved to make it look more modern in 1923-4 and demolished in 1951. To its right is the old Westminster Guildhall or Sessions House, designed by Samuel Pepys Cockerell and built in 1804-5. Its Doric portico faced east, towards Parliament. It was replaced in 1913 by J.S. Gibson's suave late-Gothic Middlesex Guildhall. (*National Monuments Record*)

128 BROAD SANCTUARY, WESTMINSTER, C. 1861

Anon.

This photograph shows the buildings in Broad Sanctuary to the left of those shown in Plate 117. It was taken from an upstairs window in Scott's Broad Sanctuary building. In the foreground is the Westminster School Crimea Memorial. To the left, on a site shaped like a piece of cake between Victoria Street and Tothill Street, is the sharp angle of the Westminster Palace Hotel, designed by W. and A. Moseley and built in 1859–61. With 400 rooms, it was the most luxurious in London at the time and the first to be equipped with lifts. It has now been demolished. The older buildings in the centre of the photograph, between Tothill Street and Princes Street, were removed shortly afterwards to make way for the Westminster Aquarium, built in 1875–6. This in turn gave way to the Methodist Central Hall in 1902, which today stands on the site. (*Gerald Cobb, Esq.*)

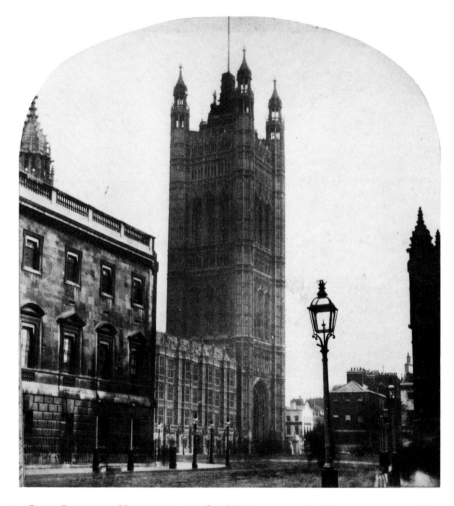

129 OLD PALACE YARD FROM ST MARGARET'S STREET, c. 1860

Anon.

(Stereoscopic photograph)

In the centre is the Victoria Tower, almost finished. To the right is the end of Henry VII's Chapel; to the left, part of the façade of the Law Courts by Kent and Vardy, 1755-8, but ending abruptly as the corner tower (see Plate 124) was gutted in the 1834 fire and not rebuilt. To the right of the Victoria Tower are the houses on the east side of Abingdon Street, removed in 1911, then the end house of the terrace on the west side, pulled down in 1943 (see Plate 116). To the right of that can be seen part of the stone-fronted houses, Nos. 6 and 7 Old Palace Yard, which have mercifully been permitted to survive. (*National Monuments Record*)

LONDON'S BRIDGES AND THE THAMES

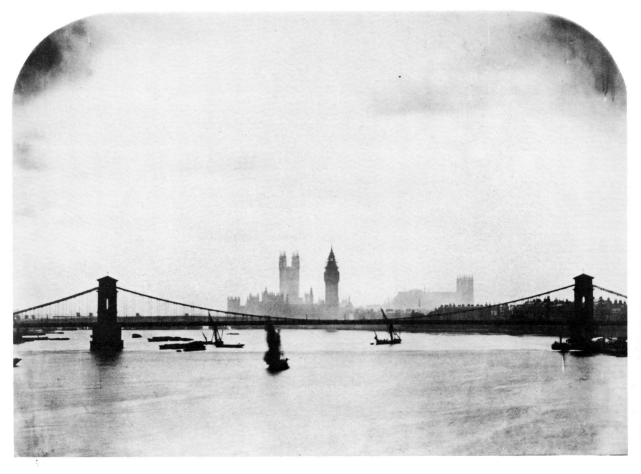

WESTMINSTER FROM WATERLOO BRIDGE, C. 1857
Roger Fenton

This view of the Thames should be compared with that taken by Talbot sixteen years before (Plate 2). In the intervening years the New Palace of Westminster has risen up and is here almost complete, and a new suspension bridge, the Hungerford Bridge, has been thrown across the river.

Seen beyond the bridge on the right is Richmond Terrace and other houses in Whitehall Gardens by the Thames. The Victoria Embankment has not yet been built. (*Christie's South Kensington*)

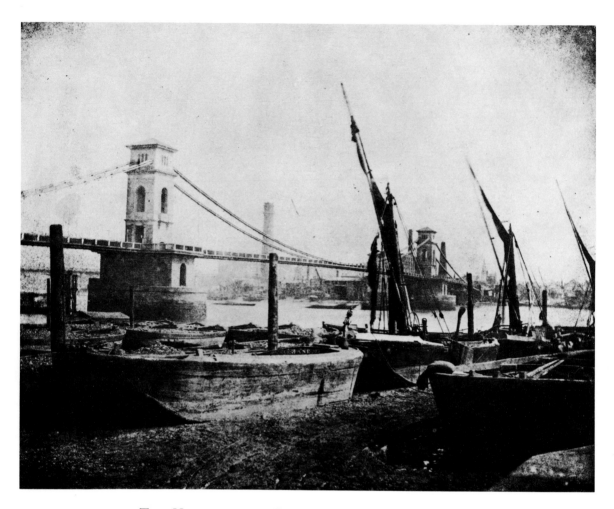

131 THE HUNGERFORD SUSPENSION BRIDGE, C. 1845

William Henry Fox Talbot

(*Calotype*)

The Hungerford Bridge was a pedestrian bridge built in 1841–5 to achieve a new crossing to the south bank on the long stretch of the Thames between Waterloo Bridge and Westminster Bridge. Hungerford was then the most important point for ferries and Thames navigation. On the north bank the bridge began on the upper terrace of the Hungerford Market (see Plates 108, 109) and for that reason it is a pity that Talbot did not take his photograph on the Surrey shore looking north. In this view are Waterloo Bridge and the Shot Tower of 1826, demolished in the 1960s. This most elegant and practical bridge was designed by the great engineer Isambard Kingdom Brunel, and had a clear span of 676 feet. The Italianate architecture of the towers was the work of J.B. Bunning. The bridge was opened in 1845 when, presumably, Talbot took this photograph. (*Lacock Abbey Collection*)

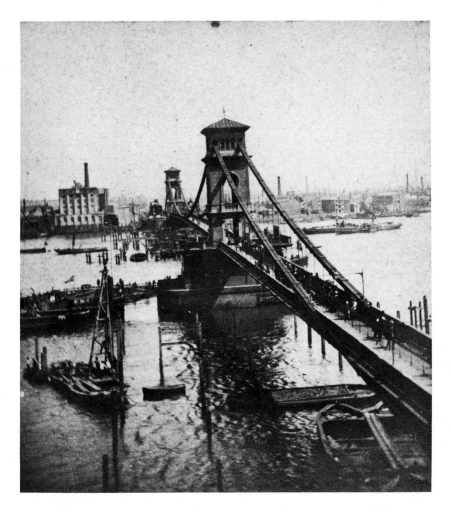

132 THE HUNGERFORD SUSPENSION BRIDGE, C. 1860

Anon.

(Stereoscopic photograph)

This photograph, looking towards the Surrey side of the Thames, was taken from one of the two towers of the Hungerford Market by the river. On the opposite bank, next to the bridge, is the Lion Brewery, designed for Messrs Goding & Co. in 1836 by Francis Edwards. The brewery was demolished in 1950 to make way for the Festival of Britain; the lion on its parapet survives and is now at the Lambeth end of Westminster Bridge. Beyond can be seen the factories and warehouses in Belvedere Road, typical of Lambeth in the nineteenth century.

This photograph shows Brunel's beautiful bridge near the end of its short but happy life. Extensive piling in the centre of the river suggests that work is about to begin on the horrible railway bridge that replaced it. The Act of 1859 which prepared the way for the Charing Cross Railway allowed the compulsory purchase of the public company which built the bridge. The Act also required that the railway bridge which utilized Brunel's piers to take the South Eastern Railway from London Bridge to Charing Cross (see Plate 143) should have a footway on one side, which it still does. Work began on the new bridge in 1860 and the Hungerford Suspension Bridge was taken down; but in 1862, the chains were taken to Bristol where they were used to complete the Clifton Suspension Bridge as a memorial to Brunel. (*B.E.C. Howarth-Loomes, Esq.*)

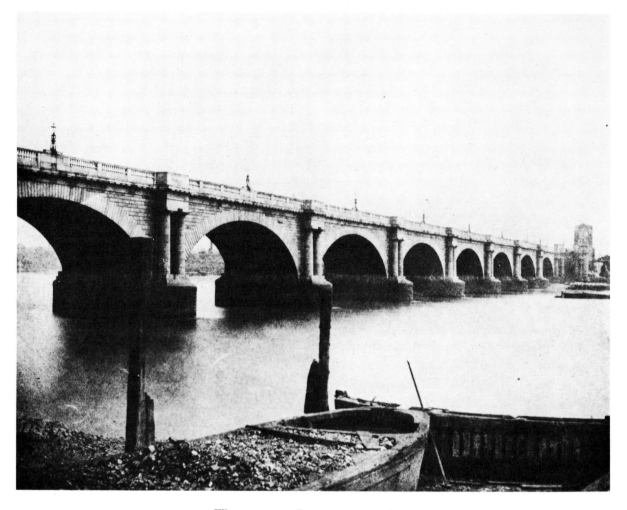

133 WATERLOO BRIDGE, C. 1845
William Henry Fox Talbot
(*Calotype*)

Designed by John Rennie and opened in 1817, Waterloo Bridge, with its use of a rugged Greek Doric order, was the most architecturally magnificent bridge in London and one of the finest neo-Classical structures in the country. This view was taken by Talbot from the north shore of the Thames looking to the Surrey side (what is the tower at the end of the bridge? Is it the end of a terrace of houses?).

Interesting though this photograph is, it seems a pity that Talbot did not take Westminster Bridge or Blackfriars Bridge instead; both of those eighteenth-century structures had been replaced by the mid 1860s without being photographed at close quarters, whereas Waterloo Bridge survived until 1934. (*Science Museum, London*)

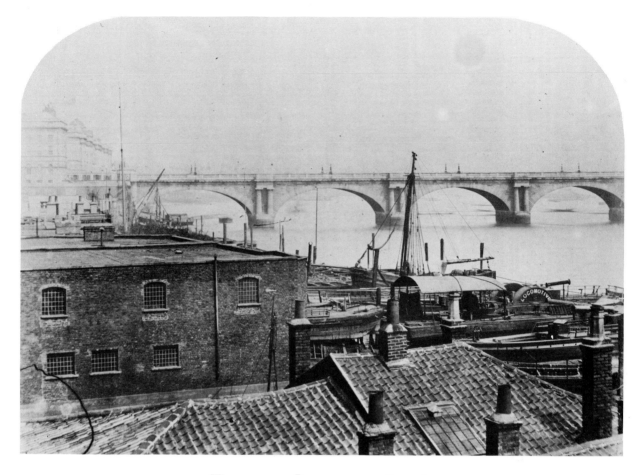

134 WATERLOO BRIDGE, c. 1857–60
Roger Fenton (?)

This photograph was probably taken from the vantage point of Adelphi Terrace shortly before work began on constructing the Victoria Embankment – in the foreground, in Adelphi Wharf, is the small paddle-steamer *Locomotive*.

On the left, at the end of the Bridge, can be seen Somerset House and the Duchy of Lancaster Office (see Plates 19, 199). (*National Monuments Record*)

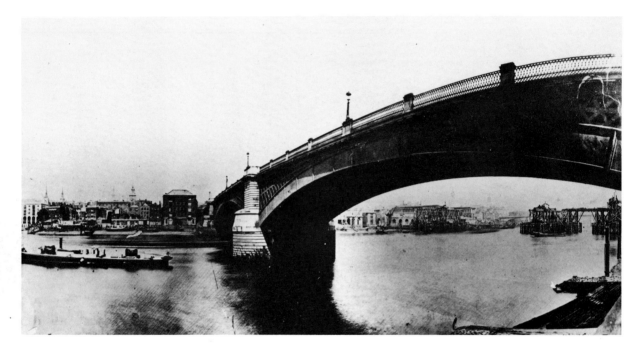

135 SOUTHWARK BRIDGE AND THE CITY OF LONDON, c. 1864
Anon.

Southwark Bridge was designed by Rennie and built in 1815-19. It was the 'Iron Bridge' in Dickens's *Little Dorrit*. It gave way eventually to another iron bridge, opened in 1921, designed by Rendel, Palmer & Tritton, engineers, and the architects Sir Ernest George & Yeates. Further down the Thames, to the right, the railway bridge into Cannon Street Station is being built. It was opened in 1866. Beyond that can be seen the colonnades of the City of London Brewery, a mysterious neo-Classical building altered in 1885 and destroyed in the Second World War. (*The Mansell Collection*)

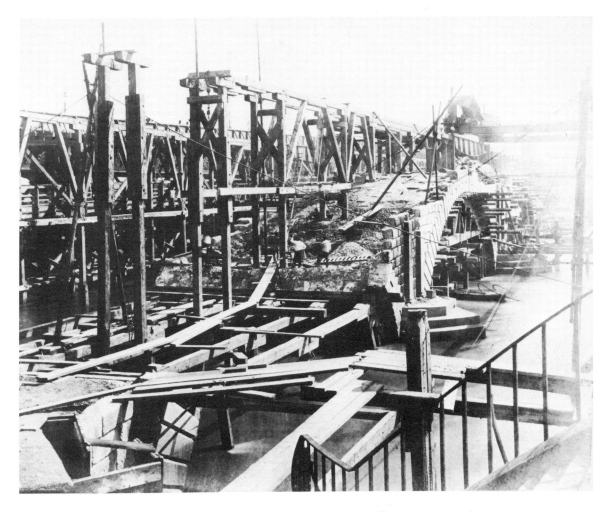

136 DEMOLISHING OLD BLACKFRIARS BRIDGE, c. 1864

Anon.

Blackfriars Bridge had been designed by the architect Robert Mylne and built in 1760–69. It was the third bridge to cross the Thames in London. In the 1830s the structure was repaired and altered. In 1863 the decision was taken to demolish Mylne's nine-arched stone bridge and replace it by a bridge of five metal arches designed by the engineer James Cubitt. This photograph – one of a series – of the last of Mylne's bridge must have been taken from the north bank in 1864 or 1865. With the wooden centring to support the arches, it bears a strong resemblance to the etching made by Piranesi for his friend Mylne showing the construction of the bridge. Beyond the old bridge can be seen the temporary timber bridge erected before demolition began, and beyond that the lattice girder bridge built by the London, Chatham & Dover Railway to take lines from Herne Hill to Ludgate Hill. This bridge was opened in 1864. In 1865 the first stone of the new road bridge was laid. (*Greater London Council Photograph Library*)

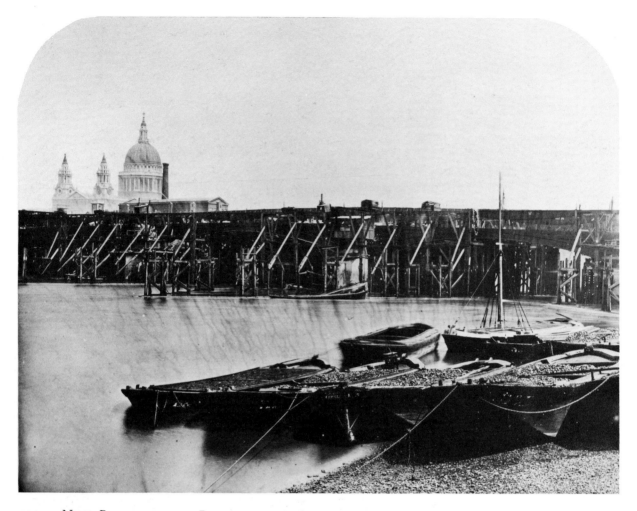

137　NEW BLACKFRIARS BRIDGE
UNDER CONSTRUCTION, C. 1868
Anon.

THE SOUTH END OF　138
BLACKFRIARS BRIDGE NEARING
COMPLETION, C. 1869
Anon.

This photograph was taken from the Surrey bank of the Thames. Work seems well advanced on the new Blackfriars Bridge, which was opened in 1869. Visible above the bridge in front of St Paul's Cathedral are the tall City Flour Mills of the 1860s in Upper Thames Street, where the Mermaid Theatre stands today. (*Victoria & Albert Museum*)

This view, taken looking south, shows the Gothic detailing of both the granite piers and the steel arches of the new Blackfriars Bridge. In the foreground is one of four 'towers' at the ends of the bridge, which have since been cut down. On the right is the end of No. 1 Blackfriars Road. On the left is the brick bulk of Blackfriars Station (the present Blackfriars Station, on the north side of the Thames, was originally called St Paul's), opened in 1864 for passengers and goods. It stood on the site of Samuel Wyatt's Albion Mill. (*Greater London Council Photograph Library*)

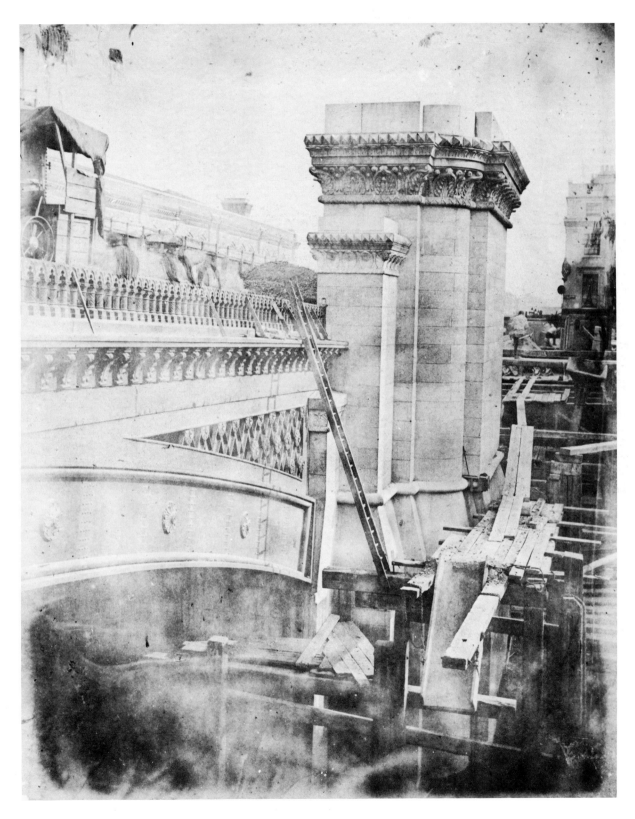

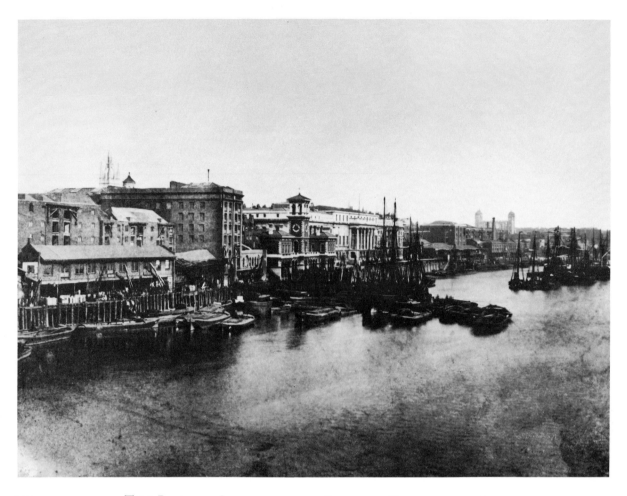

139 THE POOL OF LONDON FROM LONDON BRIDGE, C. 1870
London Stereoscopic & Photographic Co.

The particular interest of this photograph is that it shows the Italianate building with a tower designed for Billingsgate Fish Market by J.B. Bunning in 1854. This was replaced in 1875 by the present market building designed by Bunning's successor as City Architect, Sir Horace Jones. Behind Billingsgate is the Custom House, designed originally by David Laing in 1812 but later reconstructed by Smirke. Above the warehouse to the left of Billingsgate can be seen the steeple of Wren's St Dunstan-in-the-East and the corner tower of Bunning's Coal Exchange, now destroyed. (*BBC Hulton Picture Library*)

THE NEW THAMES EMBANKMENT

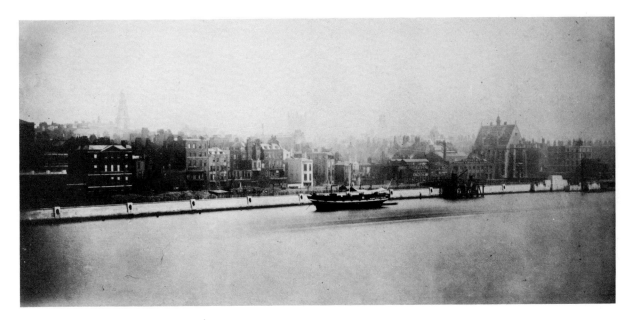

THE VICTORIA EMBANKMENT FROM ACROSS THE THAMES, C. 1869
Anon.

Long-discussed plans for embanking the Thames at last came to fruition in 1862 when an Act of Parliament allowed the building of the first stretch between Westminster and Blackfriars Bridges. This, the Victoria Embankment, was the work of the engineer Sir Joseph Bazalgette, who not only designed the massive granite retaining walls but also the vital outfall sewer beneath, for one of the principal reasons for building the Embankment was to collect and divert all the sewers which then ran straight into the Thames and gravely polluted the water. The architectural elements were designed by George Vulliamy. Work began in 1864 and was largely complete by 1868, but the road was not opened until 1870 owing to the construction of the Metropolitan District Railway under the Embankment. The trench dug for the railway can be seen in this photograph. It was completed and roofed over in 1870, when the line was opened to Blackfriars.

On the river is the floating Thames Police Station, in an old hulk. To its right is the tall Gothic Middle Temple Library, designed by H. R. Abraham in 1858 and now demolished. On the far left, just next to Somerset House, is a fine mid-Georgian house at the end of Surrey Street on the site of Arundel House; it was demolished in the 1880s. (*National Monuments Record*)

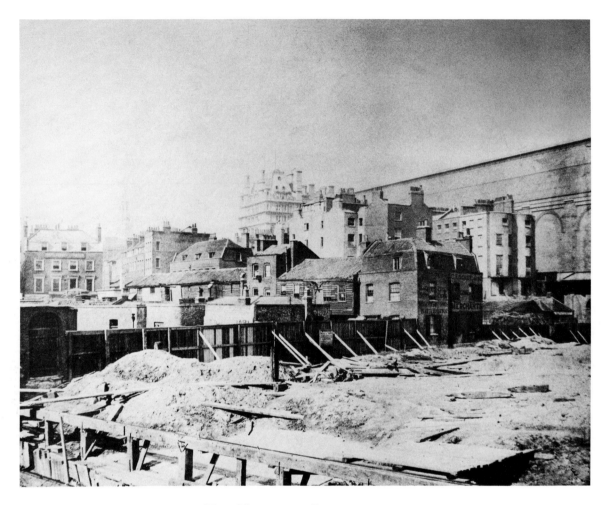

141 THE VICTORIA EMBANKMENT
UNDER CONSTRUCTION NEAR CHARING CROSS, MID 1860S
Anon.

On the far right is the great bulk of Charing Cross Station, completed in 1865. Running parallel with it towards the Thames from the Strand are, first, Craven Street, then Northumberland Street. Until the Embankment works intervened after 1864, these streets ran to riverside wharves, hence the more humble buildings nearer the camera. Northumberland Street led to Percy Wharf, which must have been near the foreground. The notice on the wooden fence advising 'Caution' is signed by the Metropolitan Board of Works. To the left, out of the picture, is what was left of the garden of Northumberland House (see Plates 64, 65). After this was compulsorily purchased in 1874, Northumberland Avenue was built, sweeping away all the buildings in the foreground of this photograph, but some of the Georgian buildings in the background – in Craven Street – survive today, including the house with the double bow front on the right. (*Westminster Public Libraries*)

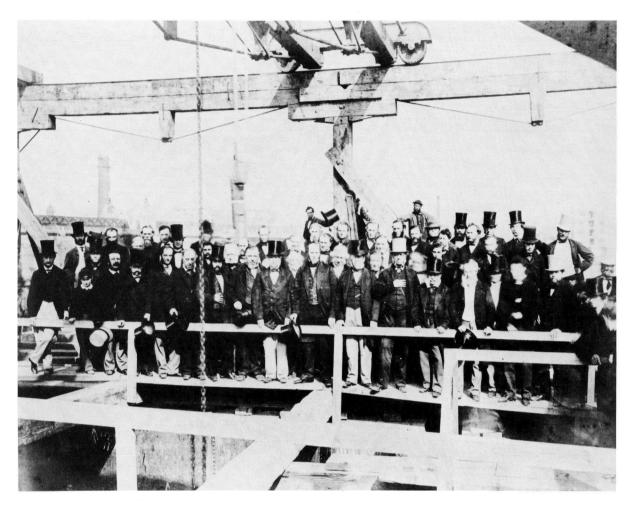

142 A GROUP OF GENTLEMEN ON
THE VICTORIA EMBANKMENT WORKS, LATE 1860s

London Stereoscopic & Photographic Co.

Unfortunately, the names of these men inspecting the Embankment building works are not recorded. Are they the members of the Metropolitan Board of Works, with their engineer, Joseph Bazalgette, in the centre? Or, as they are standing by a large trench, are they the directors of the Metropolitan District Railway? In the background, on the left, is the Shot Tower on the south bank and the railway bridge which replaced the Hungerford Bridge. (*Christie's South Kensington*)

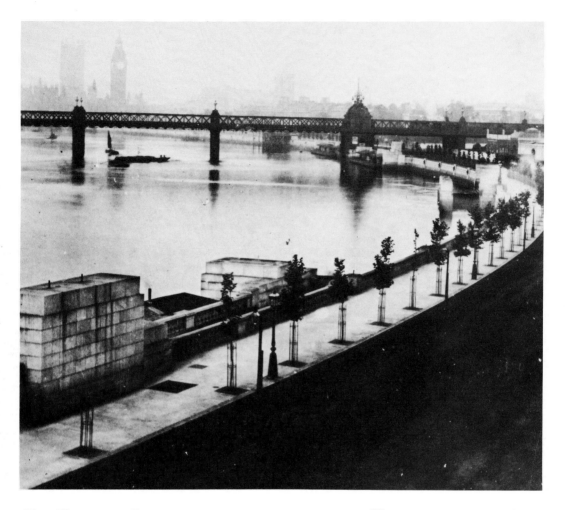

143 THE VICTORIA EMBANKMENT LOOKING TOWARDS WESTMINSTER, c. 1875

Anon.

(Stereoscopic photograph)

The Embankment is complete and the trees, planted in 1872, are growing up, but the lamps have not yet been fixed to the parapet wall. In the background is the Hungerford Railway Bridge, opened in 1864, and on the right, by the bridge, Embankment Station on the Metropolitan District Railway beneath the road. Compare Plate 130. (*B.E.C. Howarth-Loomes, Esq.*)

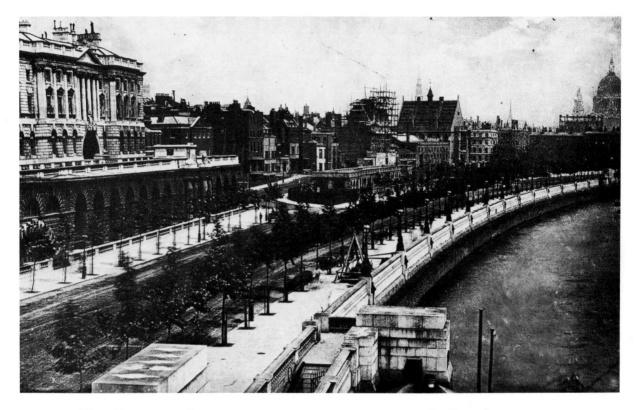

144 THE VICTORIA EMBANKMENT LOOKING TOWARDS ST PAUL'S, C. 1875

Anon.

In the foreground, the dolphin lamp standards are being raised into position. In the background, behind Temple Underground station, the London School Board Offices, designed by Bodley and Garner, are under construction. They were demolished in the 1920s. On the far right the view of St Paul's is obscured by the gasholders of the City of London Gasworks, just west of New Bridge Street, which were removed at the end of the decade. (*The Mansell Collection*)

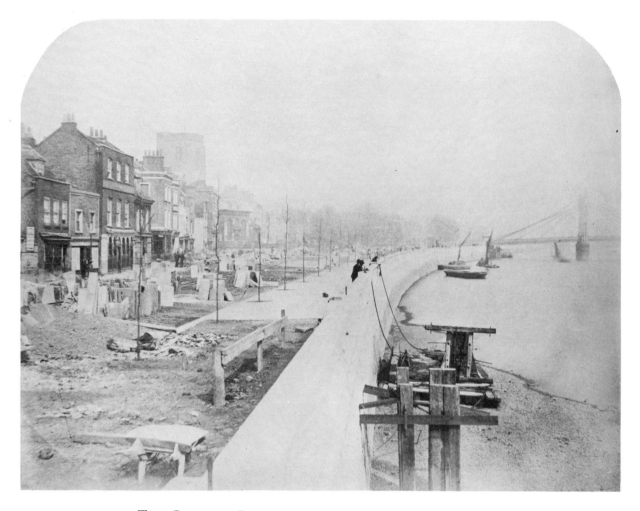

145 THE CHELSEA EMBANKMENT LOOKING EAST, C. 1873
James Hedderly

The new stone retaining wall of the Chelsea Embankment, designed by Joseph Bazalgette and begun in 1871, is here nearing completion. It was opened in 1874. This photograph was probably taken from Battersea Bridge and it should be compared with Plate 49. On the left are the houses on the north side of Duke Street. All those on the south side, including Hedderly's own studio, were removed and the area cleared is being paved. In the distance is the Royal Albert Bridge, the suspension bridge from Oakley Street to Battersea Park designed by R. W. Ordish and built in 1871-3. (*Christie's South Kensington*)

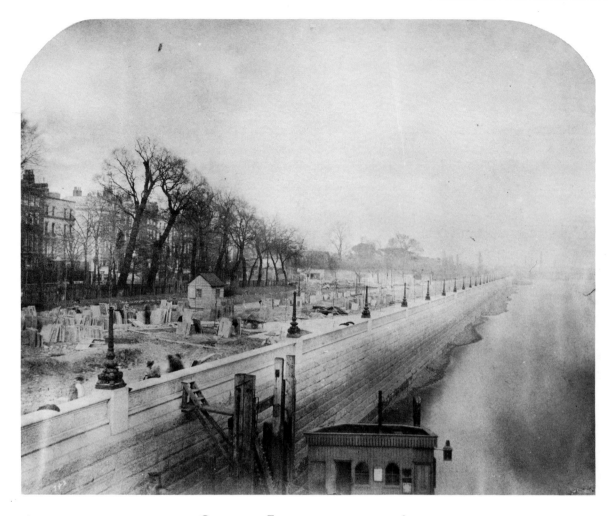

146 CHELSEA EMBANKMENT, C. 1874
James Hedderly

The Embankment is nearing completion, with the parapet lamps in place. Behind the trees are the eighteenth-century buildings of Cheyne Walk. All the land in front was reclaimed by the construction of the Chelsea Embankment.

On the reclaimed land further east, beyond the trees in the middle distance, new 'Queen Anne' houses by Norman Shaw and others would rise in the next three years. (*Kensington and Chelsea Public Libraries and Arts Service*)

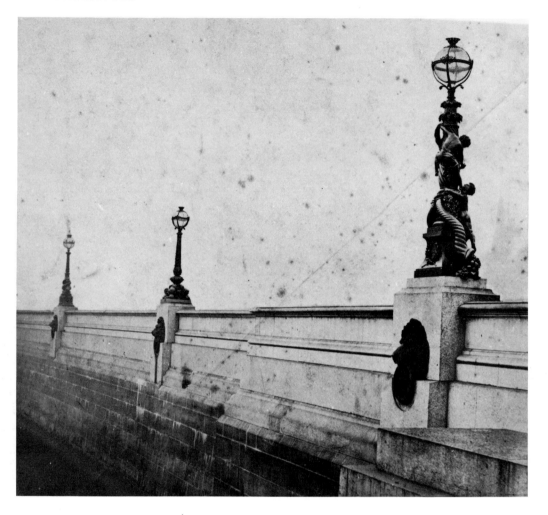

147 ALTERNATIVE DESIGNS FOR
LAMPS ON THE VICTORIA EMBANKMENT, C. 1870
Anon.

Three designs for ornamental lamps on the granite parapet wall of the Victoria Embankment were tried out *in situ*. One can only be thankful that the best choice was made. The dolphin lamp standard, modelled by Timothy Butler and manufactured in 1870, is the most distant of the three. The middle design was used on the Chelsea Embankment (see Plate 146) and the nearest design, mercifully, was not used at all. The architectural elements of the Embankment, like these lamps and the details of the parapet wall, were the responsibility of George Vulliamy, Architect to the Metropolitan Board of Works. (*Museum of London*)

NEW STREETS IN THE CITY OF LONDON

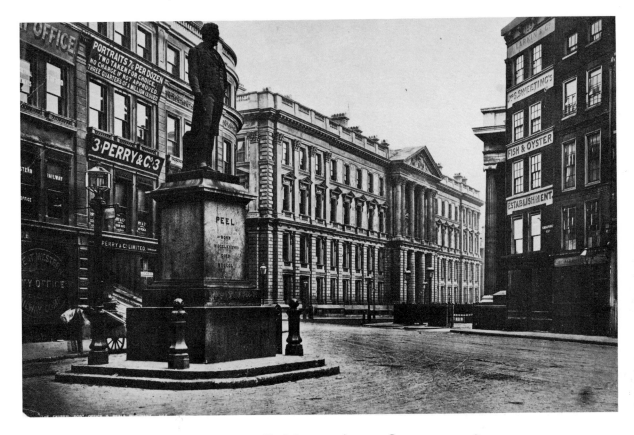

148 CHEAPSIDE AND ST MARTIN'S-LE-GRAND, C. 1873
George Washington Wilson

Every building in this once familiar City of London view has been destroyed and even William Behne's statue of Peel, erected in 1851, has been moved. On the right, next to the Georgian houses on the corner of Cheapside, is one of the lateral Greek Ionic porticos of Smirke's General Post Office (1824–9), demolished in 1912. Opposite it is the West Block, a large extension to the G.P.O. built in 1870–73 and destroyed in the Second World War. This was designed by James Williams, a now obscure architect who did good work exclusively for the Post Office in a Classical manner. On the left are buildings on the corner of Newgate Street. Further to the left, out of the picture, is St Paul's Church-yard. (*The Mansell Collection*)

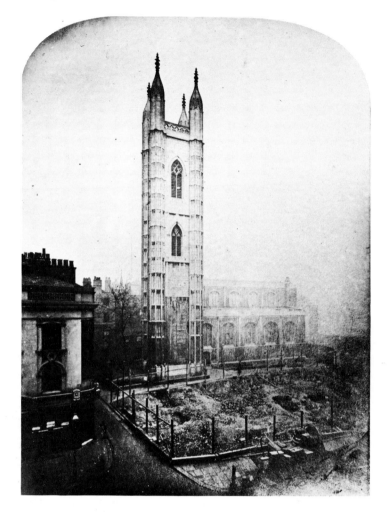

149 THE CHURCH OF ST MARY
ALDERMARY, c. 1868

Anon.

The Church of St Mary Aldermary was rebuilt in a Gothic
manner after the Great Fire of 1682. The tower, which may
not be by Wren but by Dickinson, was built in 1701-4. The
church was originally hemmed in by buildings and acces-
sible by an alley from Bow Lane to the west, but in the late
1860s the block of buildings to the south was removed to
allow Queen Victoria Street to pass by its east end. This
photograph suggests the scale of destruction of old City
houses required for Victorian street improvements. The
public house on the left, on the corner of Bow Lane and the
extension of Cannon Street, created in 1849-54, survived
for a while longer. (*National Monuments Record*)

THE CHURCH OF ST MARY 150
ALDERMARY, 1871

Anon.

This photograph was taken shortly after Queen Victoria
Street was opened. The street is still lined with hoardings
but no buildings were erected on the awkward triangular
sites created next to the newly exposed church behind. One
poster announces that the Metropolitan District Railway's
Mansion House Station, across the road, is now open;
trains began running into it from the west in July 1871.
Other posters advertise travel to Paris, possible once again
after the disruption caused by the Franco-Prussian War and
the Commune. (*National Monuments Record*)

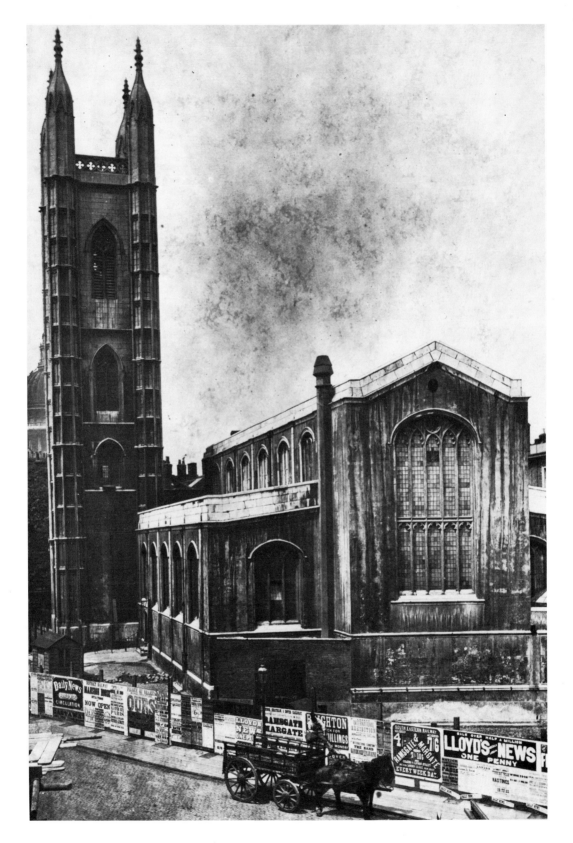

151 THE ROYAL EXCHANGE, C. 1863
Valentine Blanchard
(*'Instantaneous' photograph*)

This is one of the 'instantaneous' photographs taken in London by Blanchard between 1856 and 1865. Unlike Talbot's view of the Royal Exchange (Plate 96), the streets here are filled with moving traffic. This photograph must have been taken from an upstairs window in one of the buildings in Poultry later removed to make Queen Victoria Street (Plate 47). On the left the shoring suggests building work, which must be on the Union Bank of London, built in 1863, as St Mildred's Church, just to the left of this picture, was not demolished until 1872. (*Royal Photographic Society*)

FARRINGDON ROAD FROM ST ANDREW'S, HOLBORN, C. 1862
Anon.

This view, looking north from the top of the tower of St Andrew's, Holborn, shows the destruction of property caused by Victorian 'improvements'. Across the picture runs the Farringdon Road, the northward extension of Farringdon Street originally called Victoria Street. Like other street improvements, this was as much a slum clearance exercise as a road building project. Cut through between 1845 and 1856, the new street necessitated the demolition of houses in the Fleet Valley east of Saffron Hill in its path from Holborn Hill to Clerkenwell (see Plate 155). The road was raised up on brick arches and, beneath, the Fleet River was encased as a sewer. Along its length, on the far side, is the new building for the terminus of the Metropolitan Railway, the first underground railway in the world, opened from Paddington to Farringdon Street in 1863. Beyond are the houses on the east side of Turnmill Street. All the intervening property has been cleared. In 1864, George Godwin, the editor of the *Builder*, estimated that about a thousand dwellings, housing 12,000 people, had been destroyed in making the cuttings for the Metropolitan Railway along the Fleet Valley from King's Cross to Farringdon Street. (*Sir Benjamin Stone Collection, City of Birmingham Libraries*)

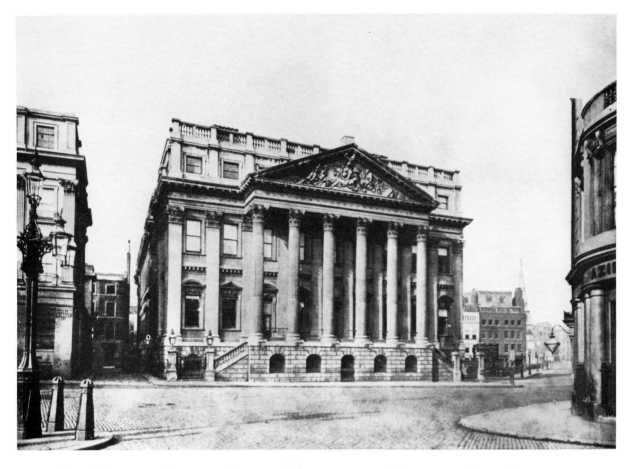

153 THE MANSION HOUSE, 1871
Anon.

NATIONAL SAFE DEPOSIT 154
BUILDING, QUEEN VICTORIA STREET,
c. 1873
Anon.

Queen Victoria Street to the right of the Mansion House is now open, but the site later occupied by the National Safe Deposit remains empty. In the distance is the spire of Wren's Church of St Antholin, Budge Row, demolished in 1876. On the extreme right, late Georgian houses on the corner of Princes Street and Poultry - the tops of which have been erased on the photograph - survive but would be replaced by the Union Bank building in 1886. Compare with Plate 47. (*Sir Benjamin Stone Collection, City of Birmingham Libraries*)

This building occupies one of the two triangular sites created by the advent of Queen Victoria Street by the Mansion House. Designed by John Whichcord and built in 1871-3, it is perhaps the most distinguished of the new buildings at the east end of the street. Underneath the building are large vaults for secure storage. To the left is the steeple of Wren's St Stephen's Walbrook; to the right can just be seen the spire of St Antholin's, doomed to come down in 1876 even though the new street had managed to avoid it. Today the upper parts of Whichcord's building have been altered and it is threatened with removal by Mr Palumbo to create an open space: Mansion House Square. (*Victoria & Albert Museum*)

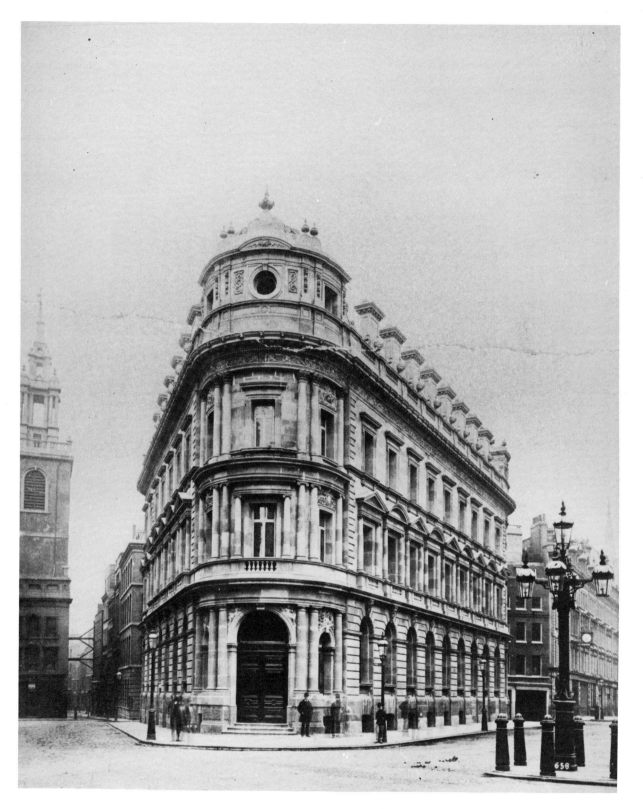

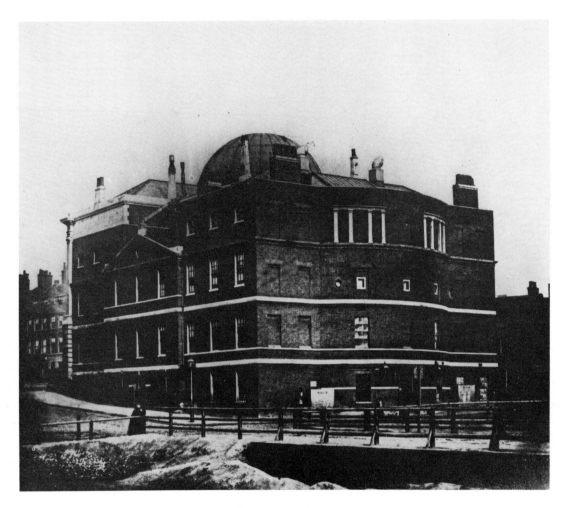

155 THE MIDDLESEX COUNTY SESSIONS HOUSE, CLERKENWELL, 1854
Anon.

The Sessions House at the west end of Clerkenwell Green was designed by Thomas Rogers and built in 1779-82. Facing the Green is a fine stone Palladian façade. This photograph shows the rear, in brick, which the architect never expected to be seen from a distance; the construction of the Farringdon Road in 1845-56 has exposed the whole building. The photograph must have been taken from the new road looking across cleared land where, in a few years, the cutting for the Metropolitan Railway would be made. On the left can be seen part of Clerkenwell Green. Later, the sides and rear of the Sessions House were rendered and the fenestration altered. (*Museum of London*)

HOLBORN VIADUCT

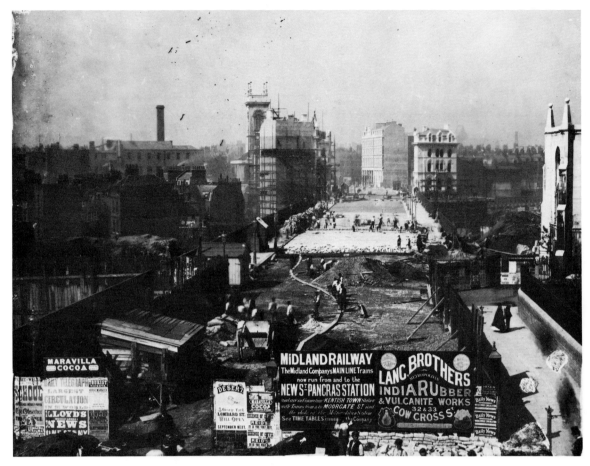

156 HOLBORN VIADUCT UNDER CONSTRUCTION, LOOKING WEST,
11 SEPTEMBER 1869

Anon.

One of the greatest mid-Victorian street improvements was the construction of the Holborn Viaduct, carried out between 1867 and 1869. This resulted in a massive destruction of older property and caused chaos for a number of years, as can be seen in the fine series of large plate photographs taken to record the progress of the work. For many years proposals had been made to bridge the steep descent into the Holborn valley that traffic between Holborn and the City had to negotiate (see Plate 36). In 1863 the City Corporation chose the plans by William Haywood and began work on a level viaduct from Holborn to Newgate Street, crossing Farringdon Street by a bridge. The first stone of the Viaduct was laid in 1867 and the completed construction was opened by Queen Victoria on 6 November 1869.

This photograph was taken at the extreme east end of the Viaduct from the houses on the corner of Newgate Street and Giltspur Street. On the right is the porch of St Sepulchre's church, Newgate. The Viaduct first crosses the cutting carrying the London, Chatham & Dover Railway from Ludgate Hill to the Metropolitan Railway under Smithfield Market, opened in 1866 – a north-south railway connection which still exists but which is now never used. The crossing of Farringdon Street is marked by the four corner buildings containing staircases to the lower level, three of which are already up in this view. Behind the pair on the left is the tower of St Andrew's, Holborn, a Wren church through whose churchyard the Viaduct ran. On the right can just be seen the outline of William Butterfield's Church of St Alban, Holborn, built in an area of notorious slums in 1861-2. This photograph was taken only two months before the Viaduct was opened; work is proceeding on laying the road surface. (*National Monuments Record*)

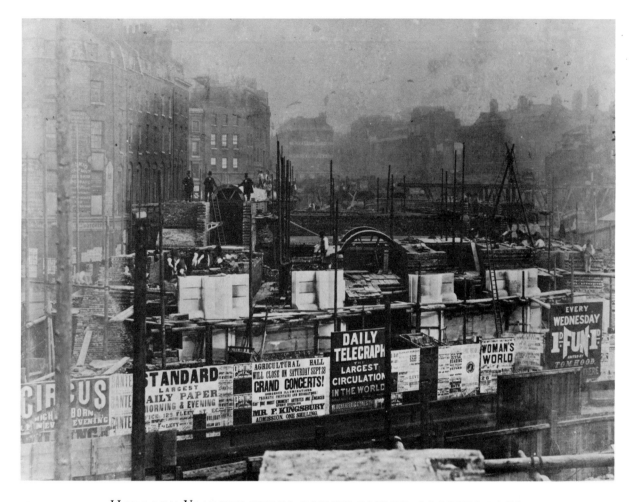

157 HOLBORN VIADUCT UNDER CONSTRUCTION, LOOKING EAST,
24 SEPTEMBER 1867

Anon.

This view, looking eastwards across Farringdon Street, shows the works at an early stage and indicates the massive scale and complexity of the project. The substructure of the Viaduct carries sewers and mains services for the buildings on the higher level, and also vaulted areas and cellars. The gentlemen on the upper left are standing by one of the passages for mains services. Behind the hoardings the wall on the east side of Farringdon Street, which will carry the bridge, is under construction. The openings in the stone facing will give access to the vaults. The Georgian terrace on the left is the south side of Skinner Street, laid out by Dance in 1802. Opening to the left, beyond the first group of houses, is Snow Hill, the ancient route down to the level of the Fleet at Holborn Bridge. Skinner Street was replaced by the Viaduct (see Plate 36). (*Guildhall Library, City of London*)

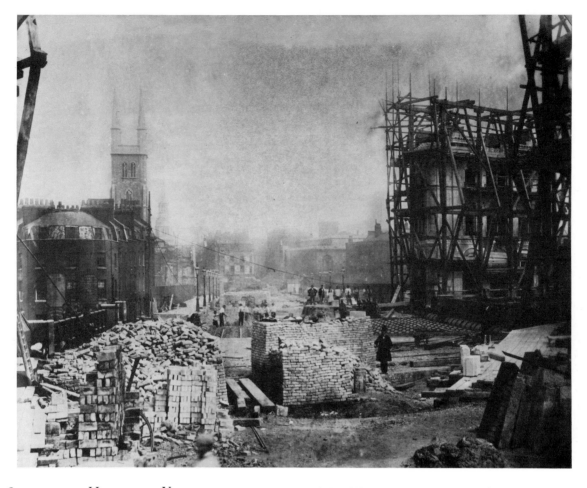

158 HOLBORN VIADUCT UNDER CONSTRUCTION, LOOKING EAST,
5 JULY 1869
Anon.

This view was taken from roughly the same position as Plate 157, and shows the rapid progress of the works in less than two years. Farringdon Street is now bridged and the finishing of the road surface is under way. The houses at the eastern end of Skinner Street have been demolished; the surviving ones on the left will not last much longer (the building which curves round to Snow Hill is advertising the wines of Hungary, with Imperial Tokay at 48 shillings –

for a bottle or a case?). On the right the two 'step buildings' carrying staircases down to Farringdon Street are nearing completion. They were apparently designed by William Haywood, the engineer. In the distance, on the right, is Newgate Prison and, on the left, the steeples of St Sepulchre's and Christ Church, Newgate Street. (*Guildhall Library, City of London*)

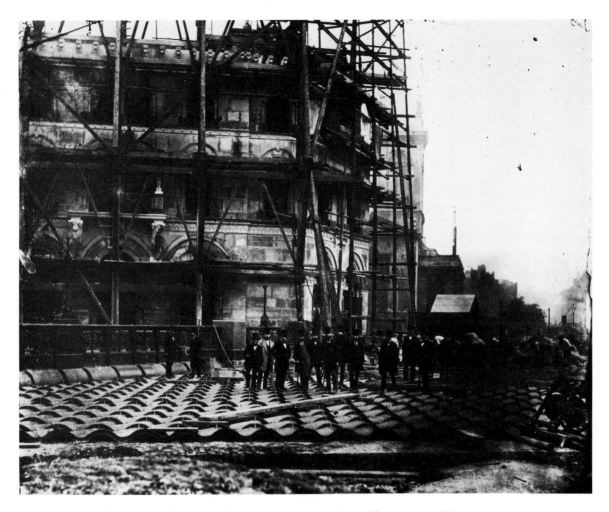

159 THE SOUTH-WEST 'STEP BUILDING' OF HOLBORN VIADUCT
 UNDER CONSTRUCTION, 3 JULY 1869
 Anon.

Members of the Holborn Valley Improvement Committee
of the Corporation of the City of London are standing on
the corrugated iron plating which lies on top of the girders
of the Farringdon Road bridge. Behind, work on one of the
four corner 'step buildings' is almost finished, and behind
that is the Wren Church of St Andrew, Holborn, which
lost most of its churchyard when the Viaduct was built.
(*National Monuments Record*)

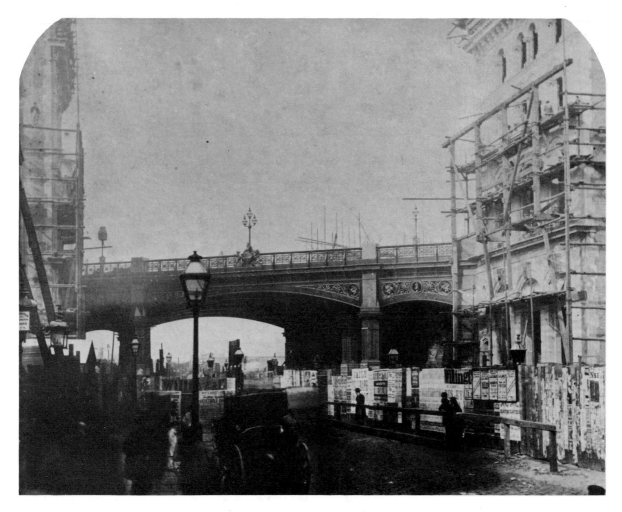

160 HOLBORN VIADUCT AND FARRINGDON STREET FROM THE SOUTH,
22 SEPTEMBER 1869

Anon.

This photograph shows the bridge across Farringdon Street two months before Holborn Viaduct was opened by Queen Victoria. The Viaduct was officially opened (on the same day as the new Blackfriars Bridge) before all the work was complete, as the north-east 'step building' was not nearly finished and the statues symbolizing Commerce, Agriculture, Science and Fine Art had not yet been placed on the piers of the bridge. The void seen through the bridge shows how much property was cleared. Such spaces often remained empty for several years. This site was eventually occupied by the Farringdon Fish Market. The ornamental iron bridge was apparently designed by William Haywood, the engineer of the whole Viaduct, who was Engineer to the Commission of Sewers in the City of London. (*Guildhall Library, City of London*)

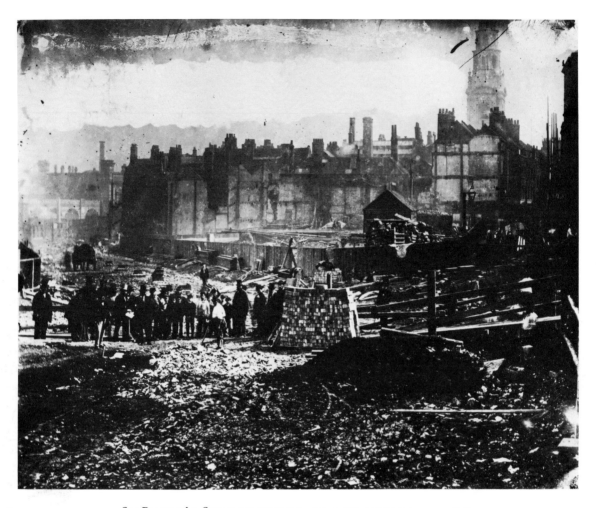

161 ST BRIDE'S STREET UNDER CONSTRUCTION, C. 1869

Anon.

As part of the works connected with building the Holborn Viaduct, a new street, St Bride's Street, was created to run from Shoe Lane down to what became Ludgate Circus. As a result a large area of the old City of London was demolished, as can be seen here. In the distance on the left, at the bottom of the new street, are Ludgate Hill Station and the viaduct of the London, Chatham & Dover Railway – visible because of the destruction of property on the east side of New Bridge Street (see Plate 37). In the background on the right is the steeple of St Bride's church. These works were begun in 1868 and the street opened in 1871. As was often the case with new streets, it was lined with empty sites for a number of years. (See also Plate 39.) (*National Monuments Record*)

THE CRYSTAL PALACE
AND THE ROYAL BOTANIC GARDENS, KEW

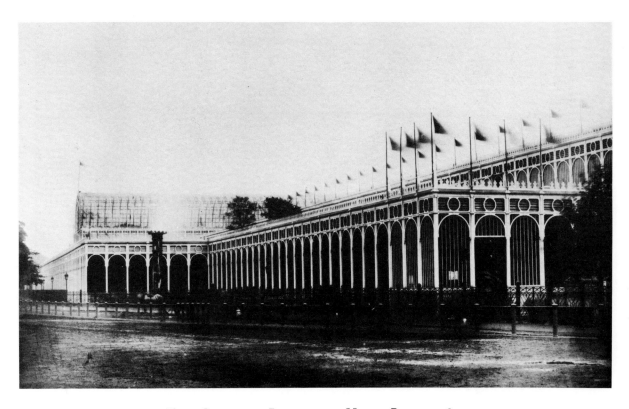

162 THE CRYSTAL PALACE IN HYDE PARK, 1851

Hugh Owen or C.M. Ferrier

(*Calotype*)

Sir Joseph Paxton's prefabricated glass and iron building was erected in Hyde Park to house the Great Exhibition of 1851. The contractors, Fox & Henderson, took possession of the site, between Rotten Row and Prince of Wales Gate, on 30 July 1850 and the building was ready for the opening on 1 May 1851. This view of the completed building was taken from the north-west, with Rotten Row in the foreground.

The Exhibition proved to be a great boost for the new science and art of photography and the building and its contents were recorded by the new medium. Talbot's former assistant, Nikolaas Henneman, who took over the Regent Street studio, made large numbers of prints, many for the Exhibition Commissioners' official *Report*. These were printed from paper negatives made by Hugh Owen and glass negatives made by C.M. Ferrier, a Frenchman. Some of the better photographs were printed in France. (*Victoria & Albert Museum*)

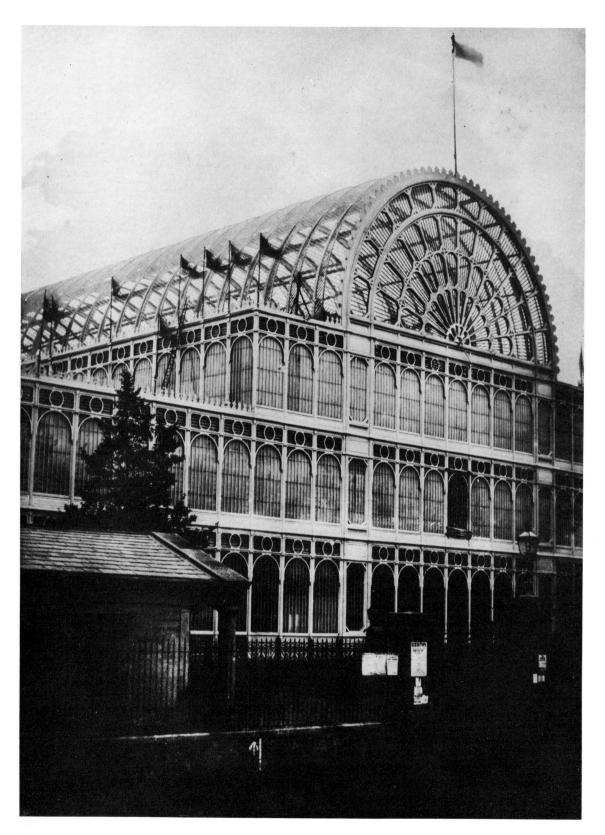

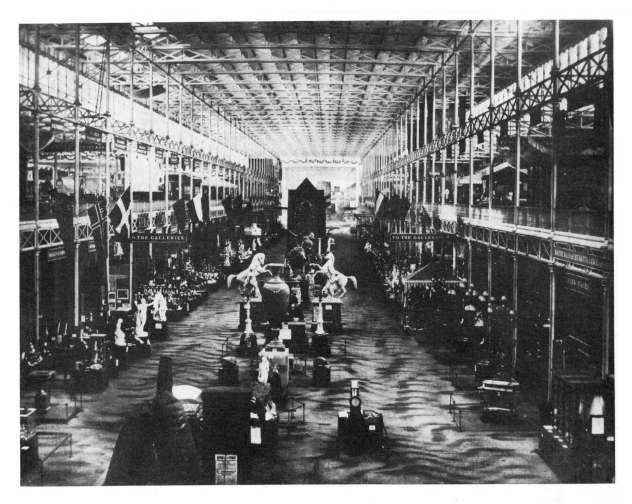

163 THE ENTRANCE TO
THE CRYSTAL PALACE, 1851

Hugh Owen or C.M. Ferrier (*Calotype*)

The most impressive feature of the original Crystal Palace
was the arched transept which ran across its great length.
The south transept was opposite the Prince of Wales Gate
in Kensington Gore; the Doric lodge of 1846, by Decimus
Burton, can be seen on the left. The transept, 104 feet high
and 72 feet wide, which was Paxton's idea, enclosed two
giant elms which opponents of the Exhibition project were
reluctant to have felled. In its architectural treatment, Pax-
ton apparently benefited from the advice of Sir Charles
Barry. The great delicacy of Paxton's patent glazing on the
curved surfaces of a ridge and furrow section, can be seen
in this view. (*Victoria & Albert Museum*)

THE INTERIOR OF 164
THE CRYSTAL PALACE, 1851

Hugh Owen or C.M. Ferrier (*Calotype*)

This view was taken from the gallery at the east end of the
building, looking the whole length of its 'nave', which was
72 feet wide and 64 feet high. The whole building was 1,848
feet long. The exhibits are grouped down the centre of the
nave as well as in the aisles and galleries. Interior photo-
graphs were taken on Sundays when the Exhibition was
closed. (*Victoria & Albert Museum*)

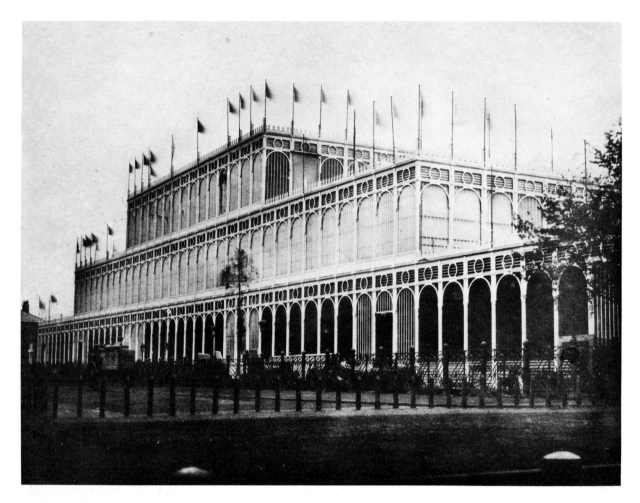

165 THE EAST END OF
THE CRYSTAL PALACE, 1851

Hugh Owen or C.M. Ferrier (*Calotype*)

THE CRYSTAL PALACE 166
BEING TAKEN DOWN, 1852

Philip Henry Delamotte (*Calotype*)

The ends of the Crystal Palace, in the form it took in Hyde Park, were very simple, with three stepped tiers of Paxton's prefabricated iron arched window sections, each eight feet wide. The iron railings surrounding the building were designed by Owen Jones. In the background can be seen buildings in Kensington Gore. (*Victoria & Albert Museum*)

This and Plate 167 are in Volume II of the Prince Consort's collection of calotypes, assembled in 1850–54. The Great Exhibition closed on 11 October 1851, after more than six million people had visited it. When Paxton failed to convince Parliament that the Crystal Palace should stay in Hyde Park, the contractors, Fox & Henderson, began to dismantle the structure in May 1852 and it was removed from the Park by the end of that year. This photograph shows the north transept with one of the great elms which were preserved inside the building. (*Reproduced by Gracious Permission of Her Majesty the Queen*)

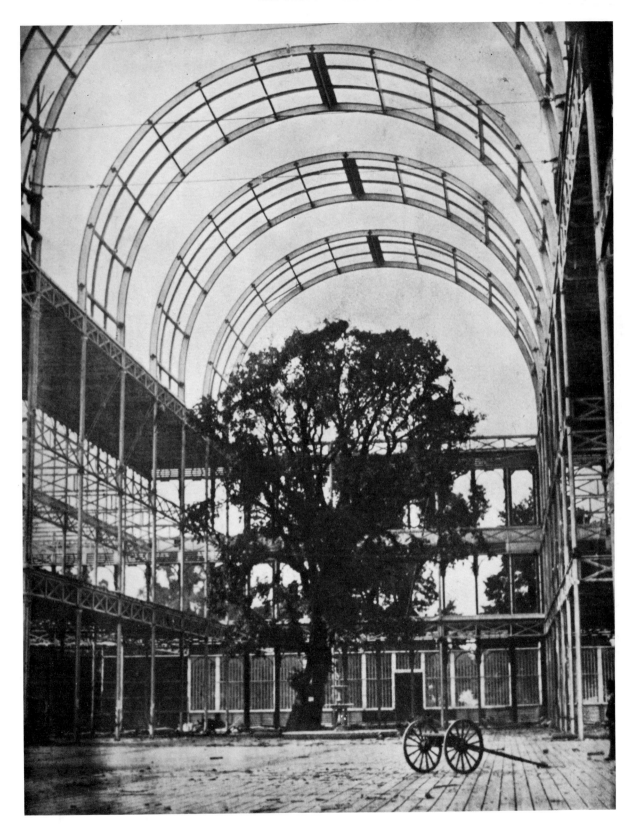

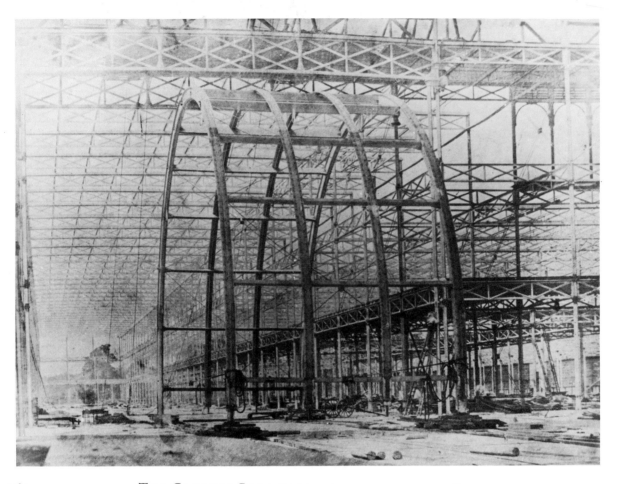

167 THE CRYSTAL PALACE BEING TAKEN DOWN, 1852
Philip Henry Delamotte
(*Calotype*)

This view looks east from the centre of the building down one of the long arms of the nave. Four of the arched ribs of the transept roof have been taken down as they were raised, joined together in one unit. The connecting spars, like much of the construction of the Crystal Palace, were of wood. (*Reproduced by Gracious Permission of Her Majesty the Queen*)

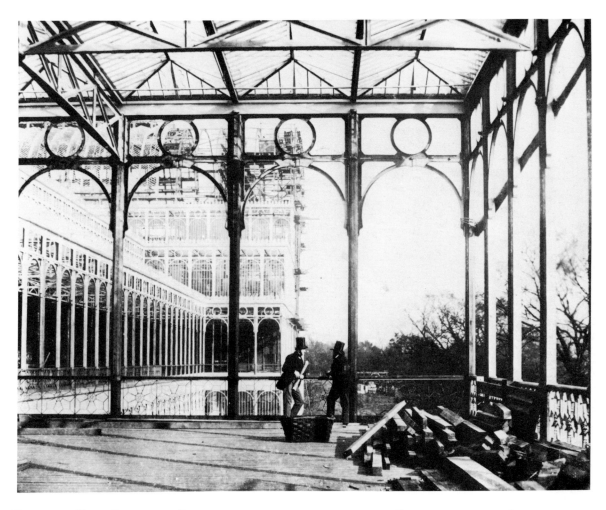

168 THE CRYSTAL PALACE BEING RE-ERECTED AT SYDENHAM, c. 1853
Philip Henry Delamotte

Permission having been refused to keep the Crystal Palace in Hyde Park, Paxton formed a company to buy the building and a new site on which to re-erect it. The site chosen was at the top of Sydenham Hill in south London. Work began on 5 August 1852 and the rebuilt Crystal Palace was reopened by Queen Victoria on 10 June 1854. In its new form the Palace was almost twice as big and twice as high, as more of the standard prefabricated parts had been added to enlarge the building. At Sydenham the longitudinal 'nave' was given an arched roof, while the great transept was enlarged and two additional transepts added at each end of the building. This photograph was taken from the open gallery on the first stage of the main transept looking towards one of the subsidiary transepts, whose arched roof is being glazed. Surrounding the building are the trees of Dulwich Wood.

This is one of a series of photographs taken by Delamotte and published in two volumes as *Photographic Views of the Progress of the Crystal Palace, Sydenham* (1855). (*Greater London Council Photograph Library*)

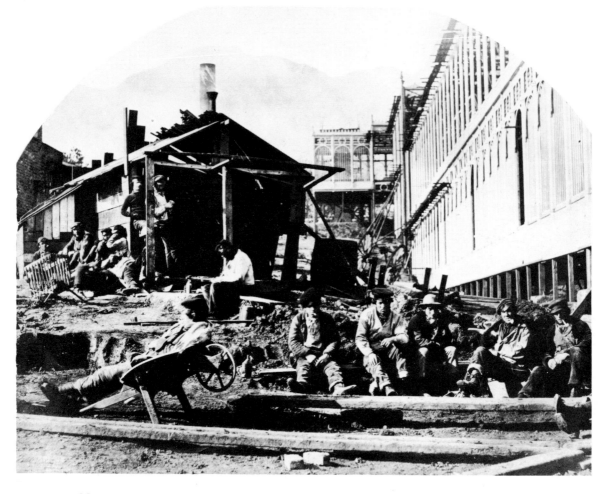

169 NAVVIES BUILDING THE CRYSTAL PALACE AT SYDENHAM, C. 1853
Philip Henry Delamotte

These navvies engaged on re-erecting the Crystal Palace
are presumably taking their dinner break. (*Greater London
Council Photograph Library*)

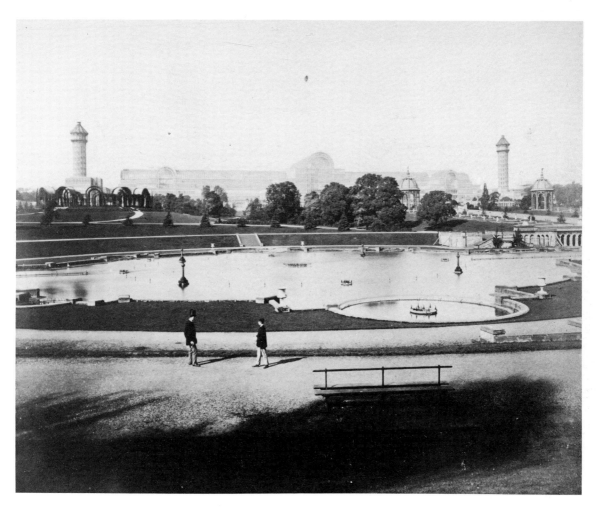

170 THE CRYSTAL PALACE, SYDENHAM, FROM THE EAST, C. 1860

Anon.

The Crystal Palace at Sydenham was opened in 1854, as were the large ornamental grounds, laid out on the side of the hill, which stretched down to Penge. The Palace is seen here across one of two ornamental pools with fountains. The Palace was flanked by two tall water towers, designed by Brunel. In 1866 the eastern transept of the Crystal Palace was destroyed by fire and was not rebuilt. In 1936 the whole building was consumed by fire and today only the park on the lower slopes of Sydenham Hill survives. (*The author*)

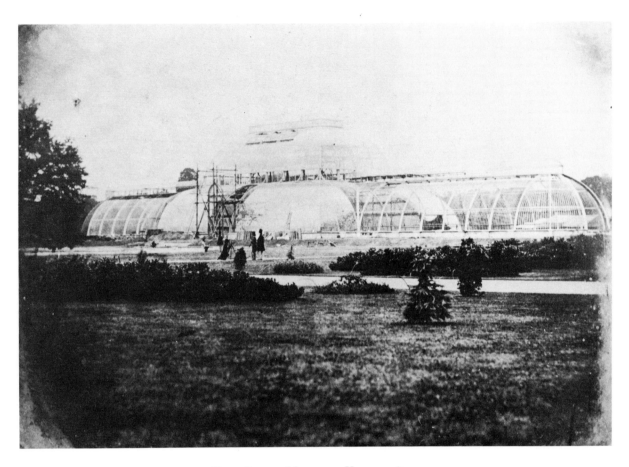

171 THE PALM HOUSE, KEW, 1847
A. F. J. Claudet
(*Daguerreotype*)

The new Palm House in the Royal Botanic Gardens at Kew, one of the most beautiful as well as one of the most innovative iron and glass structures of the nineteenth century, was designed in 1844 and completed in 1848 – two years before Paxton designed the Crystal Palace, technically a much less inventive building. This photograph was taken in 1847, while work was still proceeding on the arched 'transept' and on the clerestory glazing. It is, no doubt, idle conjecture to suppose that the figures in the foreground are the creators of the Palm House: the engineer Richard Turner and the architect Decimus Burton. (*Royal Botanic Gardens, Kew*)

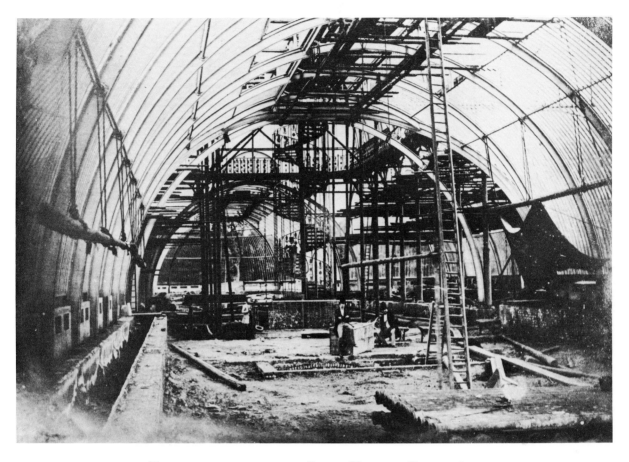

172 THE INTERIOR OF THE PALM HOUSE, KEW, 1847

A. F. J. Claudet

(Daguerreotype)

Interior photographs of the 1840s are very rare, but in the glazed Palm House the intensity of light would have been comparable with that outside the structure. Presumably this photograph was taken at the same time as Plate 171 and records the same top-hatted gentlemen. Not only is work still in progress on the structure of the Palm House, but the foundations are also visible. The floor, of cast-iron gratings, has not yet been fixed at the level of the springing of the curved ribs. The heating pipes, which run under the floor, can be seen in the foreground. On the left is the rain-water storage tank, which runs round the perimeter of the building underneath a bank of heating pipes supporting a plant shelf, an arrangement designed by Richard Turner. *(Royal Botanic Gardens, Kew)*

SOUTH KENSINGTON

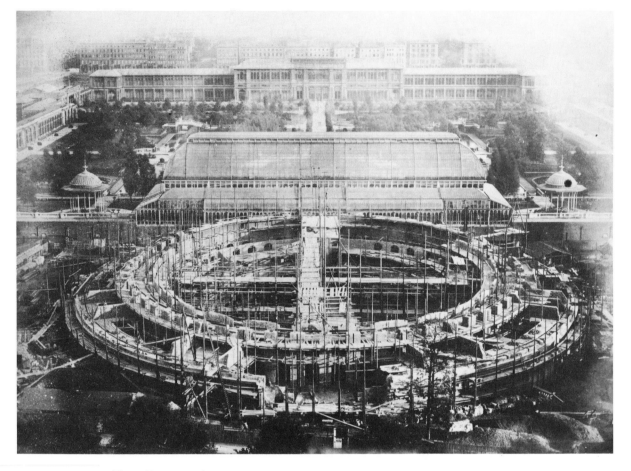

173 THE ROYAL ALBERT HALL UNDER CONSTRUCTION, C. 1868
Anon.

This photograph was taken from the top of the Albert Memorial in Hyde Park, begun in 1864. It shows the circular plan of the Royal Albert Hall of Arts and Sciences which was being built at the same time at the top end of the Royal Horticultural Society's grounds next to Kensington Gore. The Hall was designed by Francis Fowke and Henry Scott, begun in 1867 and opened in 1871. Beyond is the Royal Horticultural Society's Conservatory, designed by Fowke and erected in 1861. In the distance are the terraces lining the south side of Cromwell Road. By the end of the century, these gardens would be covered by institutional buildings – the Natural History Museum, the Imperial Institute and Imperial College. (*Science Museum, London*)

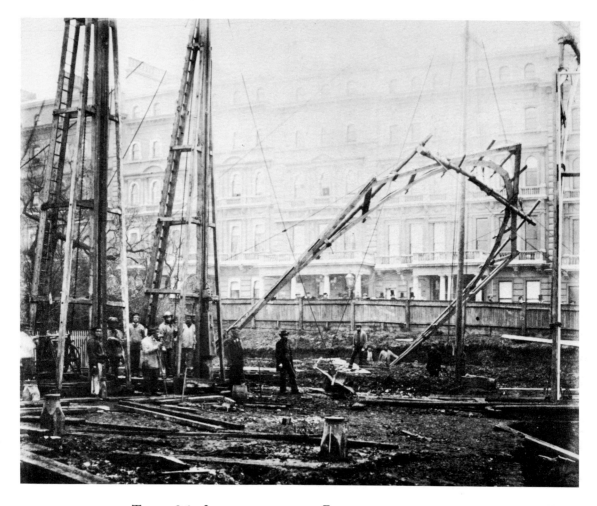

174 THE 1862 INTERNATIONAL EXHIBITION BUILDING
UNDER CONSTRUCTION, 1861
Cundall & Downes

Although less well known today than the 1851 Great Exhibition, the International Exhibition held in South Kensington in 1862 managed to attract about the same number of visitors: over six million. Its building, of brick, iron, timber, glass and stone, was not so straightforward or consistent as Paxton's Crystal Palace and was designed by Captain Francis Fowke of the Royal Engineers, who did so much architectural work in South Kensington. The site of the Exhibition was on the north side of Cromwell Road in the grounds of the Royal Horticultural Society, later occupied by the Natural History and Geological Museums. This photograph shows the raising of a wooden rib for the Eastern Annexe. In the background is Exhibition Road, lined with typical mid-Victorian stuccoed terraces. (*Victoria & Albert Museum*)

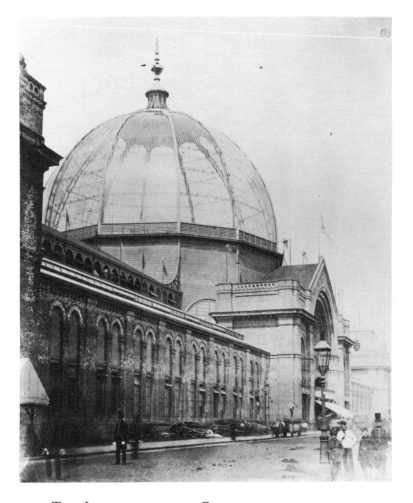

175 THE INTERNATIONAL EXHIBITION BUILDING,
EXHIBITION ROAD, 5 MAY 1862

Charles Thurston Thompson (?)

This photograph shows the Exhibition Road entrance to the Exhibition. When the building was demolished in 1863 it found a new home, as did the Crystal Palace before it. The materials were used to build the Alexandra Palace on Muswell Hill which, although not identical, bore a strong resemblance to the South Kensington building (see Plates 182, 183). (*Victoria & Albert Museum*)

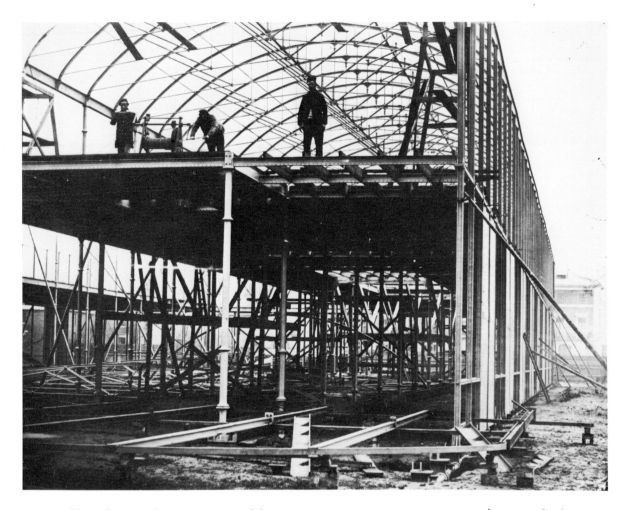

176 The South Kensington Museum under construction, April 1856

Corporal I. Milliken

The first home of the South Kensington Museum – which became the Victoria & Albert Museum – was a prefabricated iron structure made by C.D. Young & Co. of Glasgow. This photograph, which shows it in course of being erected, was photographed by a corporal in the Royal Engineers. From the very beginning, Henry Cole, Secretary of the Museum, encouraged photography and had a resident photographer, Charles Thurston Thompson. In 1856 Thompson trained some of the Sappers stationed in South Kensington to help with the Museum in the practice of photography. That the Museum, and therefore the government, employed a resident photographer and then instructed amateurs to assist in the work particularly incensed Roger Fenton, whose association with the British Museum was not altogether happy. (*Victoria & Albert Museum*)

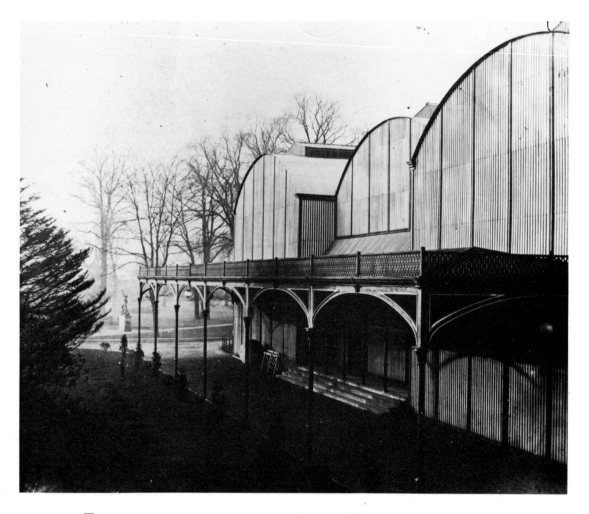

177 THE ENTRANCE FRONT OF THE SOUTH KENSINGTON MUSEUM,
CROMWELL ROAD, 1856

Corporal I. Milliken (?)

For over forty years, the South Kensington Museum presented as its façade to the Cromwell Road the corrugated iron front of the prefabricated iron buildings erected in 1856. Ridiculed by the public, this structure became known as the 'Brompton Boilers'. In 1867 part of the Boilers was taken down and re-erected in East London as the Bethnal Green Museum. (*Victoria & Albert Museum*)

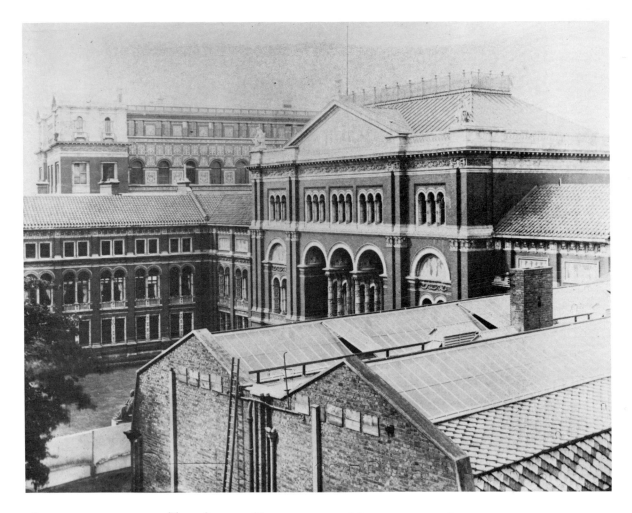

THE SOUTH KENSINGTON MUSEUM, c. 1872
Charles Thurston Thompson (?)

In 1857 the first of the permanent masonry buildings for the South Kensington Museum were commenced. These were the Sheepshanks Galleries, built in 1857-8 and seen in the foreground of this photograph. They later became the east side of the Museum's main quadrangle. All the buildings here were designed by Captain Francis Fowke of the Royal Engineers, who created a distinctive South Kensington style. The north side of the quadrangle, with its pediment and loggia of terra-cotta columns modelled by Godfrey Sykes, was built in 1864-6. The west side was built in 1862-63. The south (library) range was built in 1879-84 and the east side, incomplete here, was finished by Sir Aston Webb in 1901 when he built the new Cromwell Road front to the Museum. In the background is the Huxley Building in Exhibition Road, now the Henry Cole Wing of the Museum. This was built in 1867-71 and designed by Fowke's successor, Henry Scott. (*Victoria & Albert Museum*)

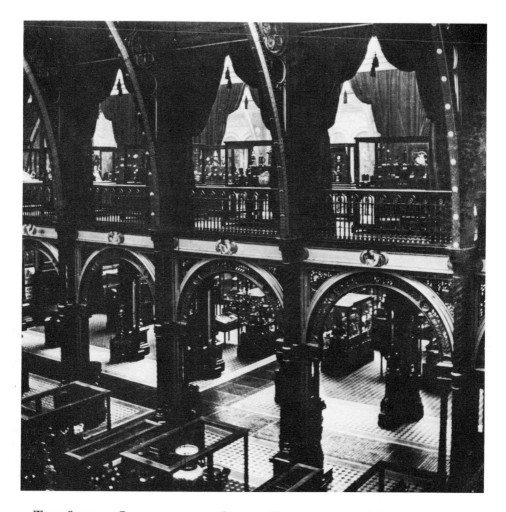

179 THE SOUTH COURT OF THE SOUTH KENSINGTON MUSEUM, 1868
J. Davis Burton

The South Court of the Museum, designed by Fowke and built in 1861-2, is of iron construction but shows how decorative iron could be. The iron arches had decorative mouldings and ornamental spandrils, and the whole was painted by Godfrey Sykes. At either end were frescoes by Leighton, but these are no longer visible as the whole room was boxed in this century and half of the South Court is now the restaurant of the Victoria & Albert. This photograph was taken from the corner of the Cross Gallery and shows the Prince Consort's Gallery. (*Victoria & Albert Museum*)

VICTORIAN IMPROVEMENTS

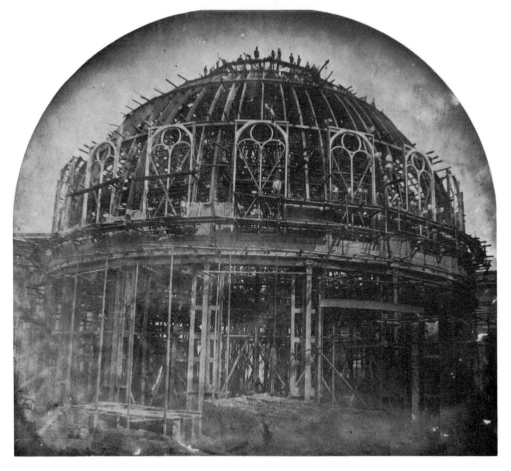

180 THE BRITISH MUSEUM READING ROOM UNDER CONSTRUCTION, 1855
Roger Fenton (?)

Between 1854 and 1858, Roger Fenton undertook photographic work for the British Museum (see Plate 97) so it may have fallen to him to record the construction of one of the most remarkable structures of the age. Between 1854 and 1857 the great courtyard of Sir Robert Smirke's British Museum was filled in by a circular reading room designed by his younger brother Sydney. With a diameter of 140 feet, the library was not only of metal construction but it also had a sophisticated ventilation system which required the dome to have three skins. The photographer must have been in a corner of the courtyard with an unusually wide-angled lens for the period to include the whole structure on one plate. Construction had begun in September 1854 and the erection of the iron skeleton in January 1855. If Fenton himself took this photograph, he must have taken it before 20 February when he set sail for the Crimea, where he was to take his celebrated war photographs, or after his return in July 1855. (*British Museum*)

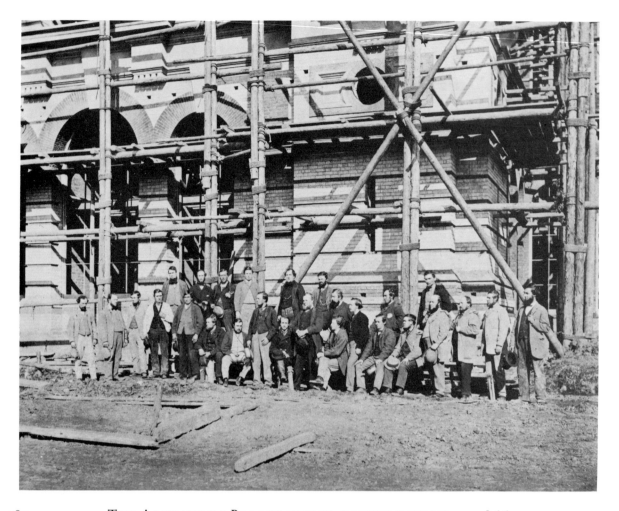

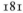 181 THE ALEXANDRA PALACE UNDER CONSTRUCTION, C. 1866
Anon.

The Alexandra Palace on Muswell Hill was to be north London's answer to the Crystal Palace on Sydenham Hill. The building used much of the structure of the 1862 International Exhibition building in South Kensington (see Plate 175). It was built in 1864–6 by Messrs Kelk & Lucas and the architects of the brick exterior were Meeson and Johnson. This appears to be a group of foremen standing in front of part of the end elevation of the building. Scaffolding still consists of long poles lashed together with rope. (*Christie's South Kensington*)

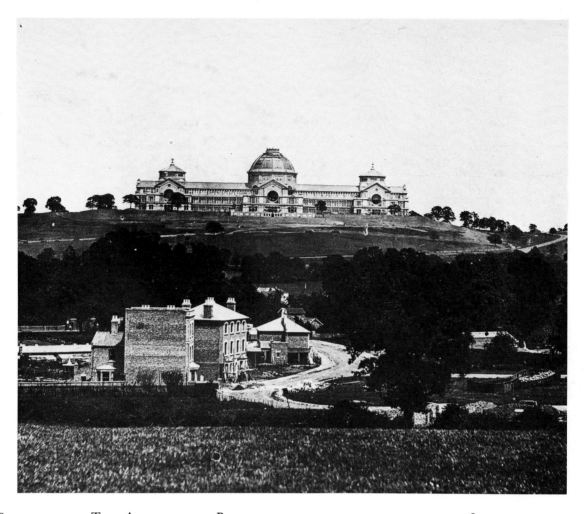

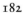 THE ALEXANDRA PALACE FROM THE SOUTH-EAST, C. 1873

Anon.

The completed Alexandra Palace stood in a landscaped park on the top of Muswell Hill. In the foreground is Rectory Road, Hornsey. However, this is not the Alexandra Palace which today stands on the site; in 1873, a fortnight after its eventual opening, the building was largely destroyed by fire (see Plate 183). It was rebuilt to a different design in 1874-5. (*Greater London Council Photograph Library*)

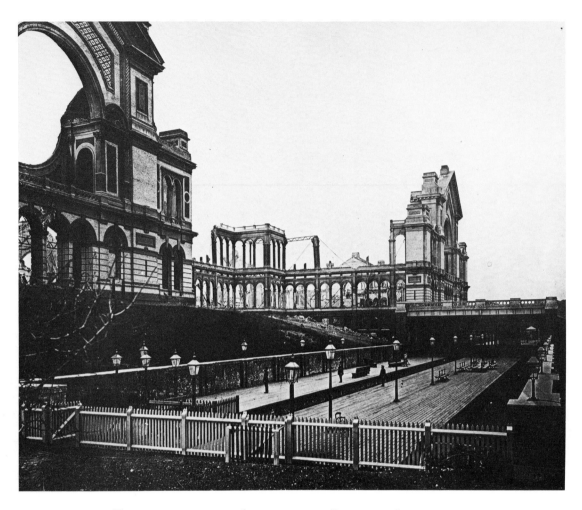

183 THE BURNED-OUT ALEXANDRA PALACE, JUNE 1873

Anon.

The first Alexandra Palace was opened to the public on 24 May 1873. On 9 June the building accidentally caught fire and was largely destroyed. This photograph shows the north side of the ruins with, in the foreground, the terminus of the Muswell Hill Railway, a very steep extension of a branch line of the Great Northern Railway opened in 1873 expressly to bring exhibition crowds to the Palace. It was then closed again until the rebuilt Alexandra Palace reopened in 1875. (*Greater London Council Photograph Library*)

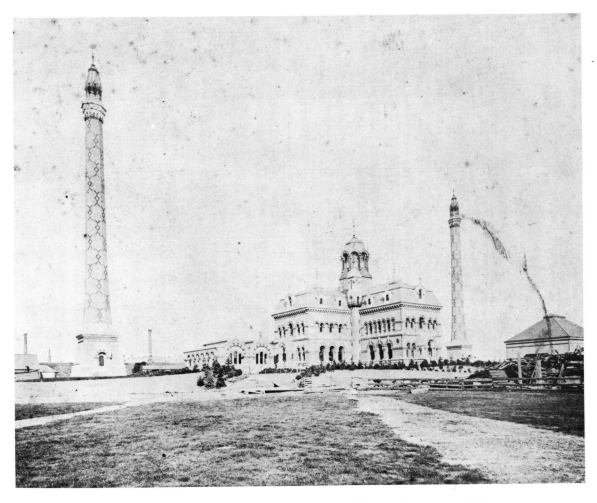

184 ABBEY MILLS PUMPING STATION, WEST HAM, C. 1868

Anon.

Abbey Mills Pumping Station in east London is an integral part of the great system of sewers designed by Bazalgette and built in the 1860s by the Metropolitan Board of Works. The Victoria Embankment is also a part of this system, as it contains the low-level sewer which connects with the Northern Outfall Sewer which runs to Abbey Mills, where it is pumped up to a higher level. This decorative pumping station was designed in a sort of Byzantine style by E. Cooper and built in 1865-8. It survives today but has lost the extraordinary minaret-like chimneys. (*Greater London Council Photograph Library*)

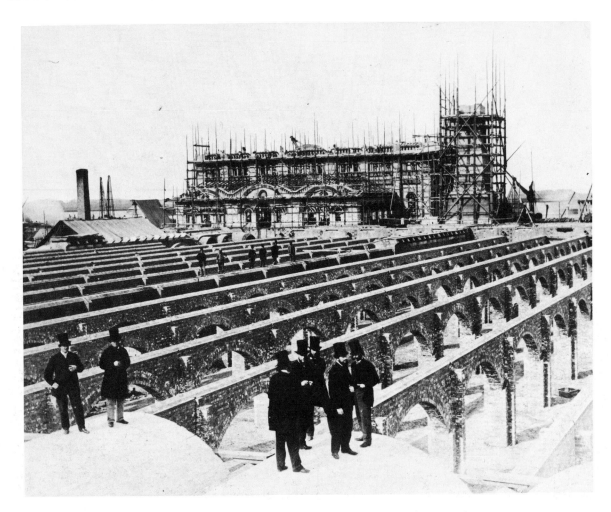

185 CROSSNESS PUMPING STATION UNDER CONSTRUCTION, C. 1864
Anon.

The pumping station at Crossness, near Woolwich, is the south London outlet into the Thames of the Metropolitan Drainage System designed by Bazalgette. It is at the east end of the London Outfall Sewer. In the foreground are the filtration beds; in the background the pumping station and chimney under construction. Beyond, to the left, is the Thames. (*Greater London Council Photograph Library*)

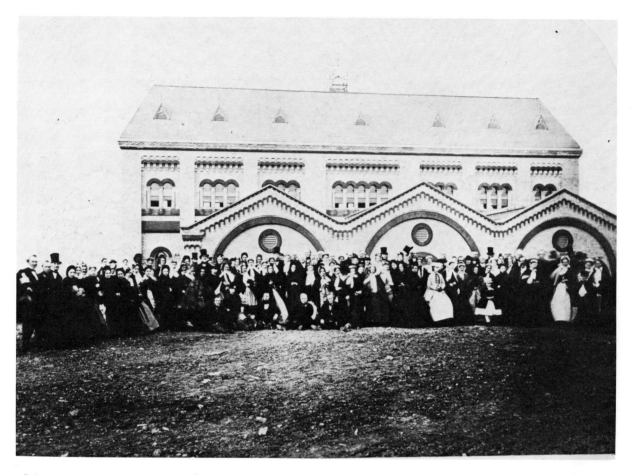

186 CROSSNESS PUMPING STATION, 1865

Anon.

Crossness Pumping Station was opened by the Prince of Wales on 4 April 1865. As no royalty can be detected in this photograph, the event it commemorates is presumably another opening ceremony, possibly with members of the Metropolitan Board of Works and their wives. This build-ing, in a brick Romanesque manner, seems straightforward compared with the exotic style of the Abbey Mills Pumping Station (see Plate 184). (*Greater London Council Photograph Library*)

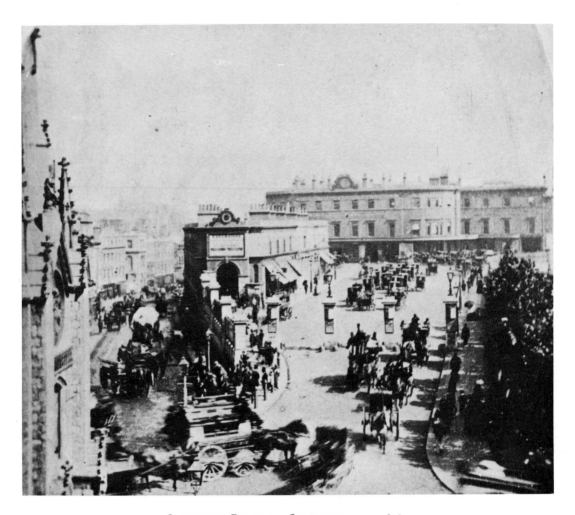

187 LONDON BRIDGE STATION, c. 1860
Anon.

London Bridge was the terminus of London's first railway, the London & Greenwich, opened in 1836. As the railway system expanded, London Bridge Station, a little to the east of Borough High Street and south of Tooley Street, was successively enlarged and was, for a time, the joint terminus of four separate railway companies. Today nothing survives of the station seen in this photograph, apart from the station approach. Only the South Eastern Railway's half of the terminus is shown here; the London, Brighton & South Coast Railway's station was further to the right, behind the grounds of St Thomas's Hospital (the trees surrounding the hospital can be seen in the foreground). The South Eastern Railway portion was rebuilt in 1850–51 by Samuel Beazley. The wing on the left contained a shopping arcade and a restaurant. The four-bay façade to the right of the curved corner appears to be part of Henry Roberts's and Thomas Turner's short-lived Joint Station of 1843–4, but as rebuilt by Beazley. On the far left is Duke Street, connecting with Tooley Street, and the top of the Gothic clock tower seen in Plates 101 and 188. The immensely destructive extension to Charing Cross and Cannon Street, built in 1862–6, replaced half of Beazley's façade and his arcade by a new high-level through station. It also required the removal of the clock tower to Swanage and St Thomas's Hospital to Lambeth. By 1864 a photograph taken from the same position would show little else but a four-track railway viaduct and bridge over the Borough High Street. (*BBC Hulton Picture Library*)

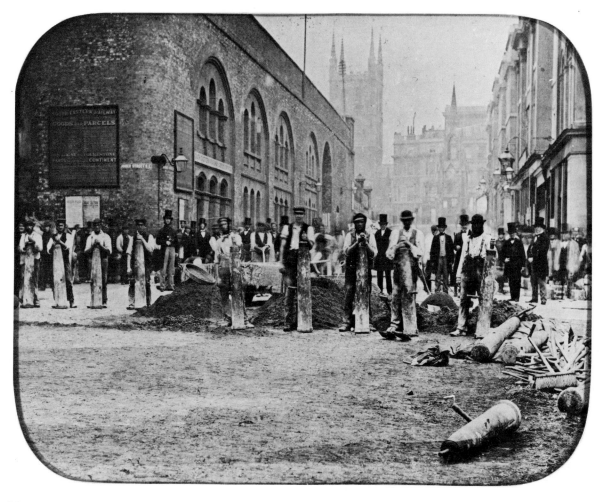

188 ROAD-MENDING IN DUKE STREET, SOUTHWARK, C. 1860

Anon.

(*Ambrotype*)

This view shows Duke Street looking west towards the Gothic clock tower, seen in Plate 101, and the rather older Gothic tower of St Saviour's Church, now Southwark Cathedral. The men are repairing the road by using large wooden rammers to ram down the wood blocks or stone cobbles for the surface. To the right of the picture, out of view, is the junction with Tooley Street and the early eighteenth-century St Olave's Church; to the left is Joiner Street, one of the old streets covered over by London Bridge Station. Lining Duke Street on the left is the substructure of the South Eastern Railway terminus as enlarged in 1851. This served as a goods office, but was partly obliterated when the railway was extended westwards in 1862-4. (*Gernsheim Collection, Humanities Research Center, the University of Texas at Austin*)

BUILDING THE UNDERGROUND

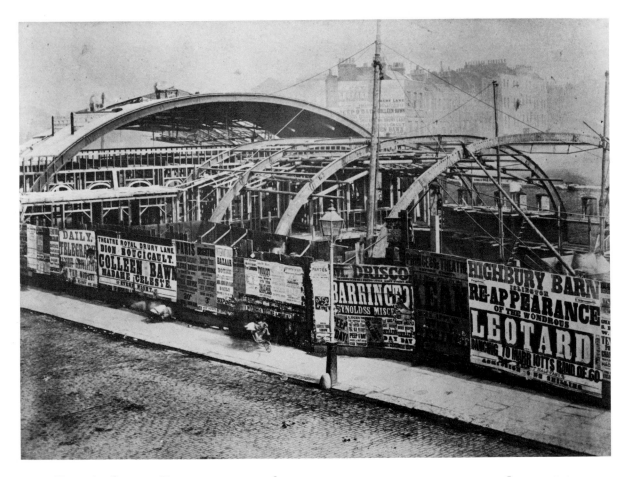

189 KING'S CROSS UNDERGROUND STATION UNDER CONSTRUCTION, JULY 1862
Anon.

This is one of a series of progress photographs taken in July 1862 for John Fowler, Engineer-in-Chief to the Metropolitan Railway. The Metropolitan Railway was the first underground railway in the world when it was opened in 1863. Work had begun on it in 1859. The line ran from Paddington under the New Road to King's Cross, then in open cuttings and tunnels to Farringdon Street (see Plate 152). King's Cross Station was built on a slice of land between Gray's Inn Road and Pentonville Road. This allowed the construction of a glazed, arched iron roof over a brick-lined cutting, a form which became typical of the later stations on what was to become the Circle Line. In this photograph, taken from an upstairs window on the north side of Pentonville Road, Gray's Inn Road can be seen curving away to the right. The brick ticket office, evident here, faced the stretch of the Gray's Inn Road that was then called Chichester Row. (*Guildhall Library, City of London*)

190 KING'S CROSS UNDERGROUND STATION UNDER CONSTRUCTION, JULY 1862
Anon.

This view shows the interior of the Metropolitan Railway Station looking towards King's Cross; the present underground station opened much further west in 1941. This station was made wide enough for four tracks, as connecting tunnels were also built to join up with the Great Northern Railway north of the King's Cross main line terminus. The high, arched roof was taken down in 1910 in connection with the building of a theatre and the short street called King's Cross Bridge, which crosses this railway. (*Guildhall Library, City of London*)

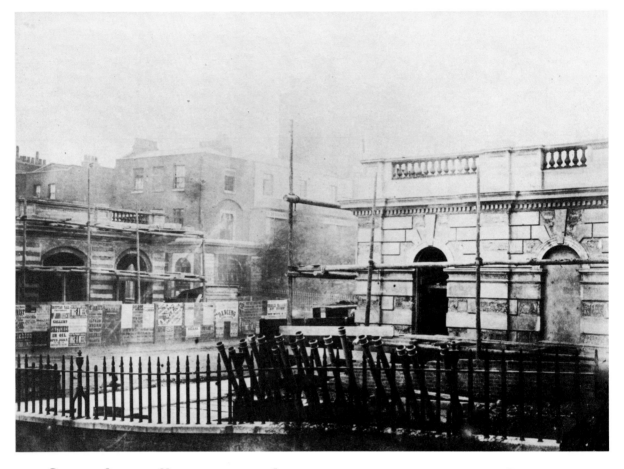

191 GOWER STREET UNDERGROUND STATION UNDER CONSTRUCTION, JULY 1862

Anon.

Gower Street Station, now called Euston Square, is a stop on the Metropolitan Railway where it runs under the Euston Road. This view shows the Euston Road with the two small station buildings erected on some of the long front gardens which the neighbouring houses along the Euston Road still enjoy. The photograph was taken from the south corner of Gower Street. Every building here has since been demolished. The station lodges, apparently designed by Fowler, the engineer, in a Classical style, were of brick faced in Ranson's Patent Stone cement. (*Guildhall Library, City of London*)

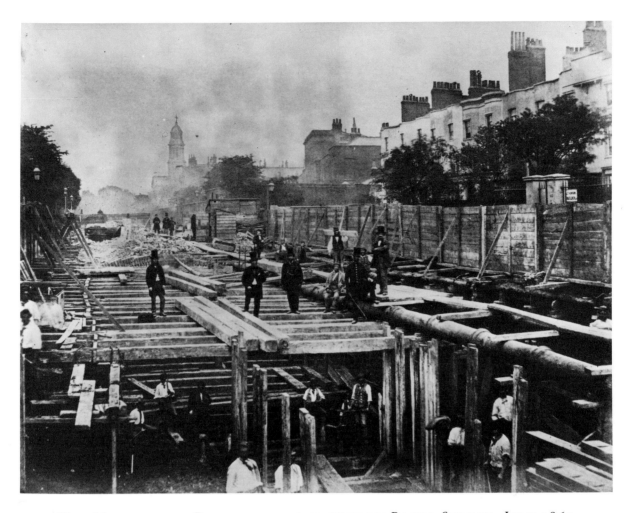

192 THE MARYLEBONE ROAD LOOKING WEST FROM BAKER STREET, JULY 1862
Anon.

This photograph shows the 'cut and cover' method used for constructing the Metropolitan Railway. A trench was dug, lined with brick retaining walls, then covered over again. Here the whole of the Marylebone Road has been dug up. As the line runs right under the whole length of the eighteenth-century New Road (the Marylebone and Euston Roads), considerable chaos must have been caused in the early 1860s. Regency houses still line this part of the road and in the distance is the St Marylebone New Church, designed by Thomas Hardwick and built in 1813-17. Nearer, on the south side at an angle to the street, is the Marylebone Parish Workhouse of 1775, now demolished. (*Guildhall Library, City of London*)

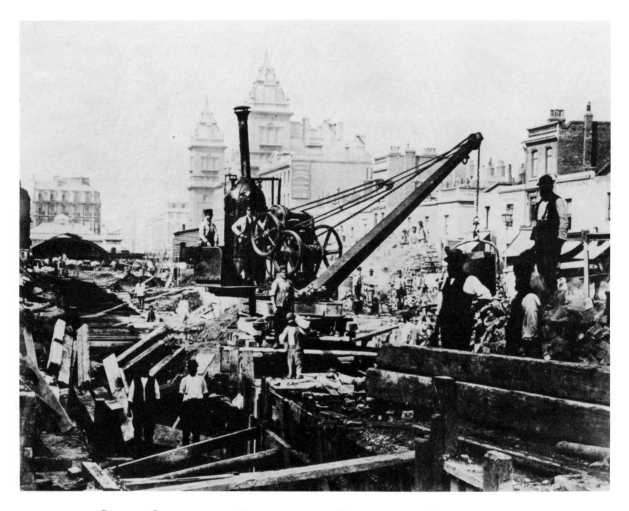

193 P R A E D S T R E E T A N D P A D D I N G T O N S T A T I O N , 24 J A N U A R Y 1866

Anon.

In 1864 the Metropolitan Railway began an extension of its underground line westwards from Paddington through Bayswater and the line was opened to South Kensington in 1868. This photograph showing the works in progress was taken in Praed Street, looking west. The railway works destroyed the buildings on the south side of the street.

Beyond the trench can be seen the arched roof of the underground station and to the right the towers of the Great Western Hotel, designed by P.C. Hardwick and built in 1851–3 in front of the Great Western Railway's new terminus. (*London Transport Executive*)

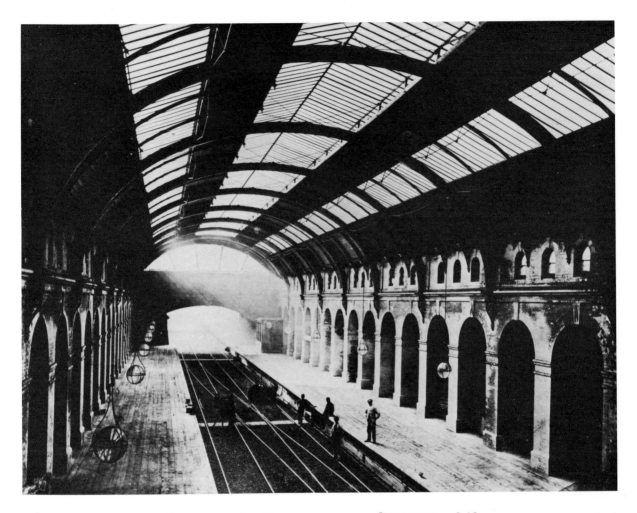

194 PADDINGTON UNDERGROUND STATION, 1868
Anon.

This view of the interior of the Metropolitan Railway Station looking east shows the window, visible in Plate 193, at the end of the arched iron roof. This photograph must have been taken shortly before the line opened on 1 October 1868. The photographer evidently had two cameras, for one is standing on the track and his equipment is on the edge of the platform. (*London Transport Executive*)

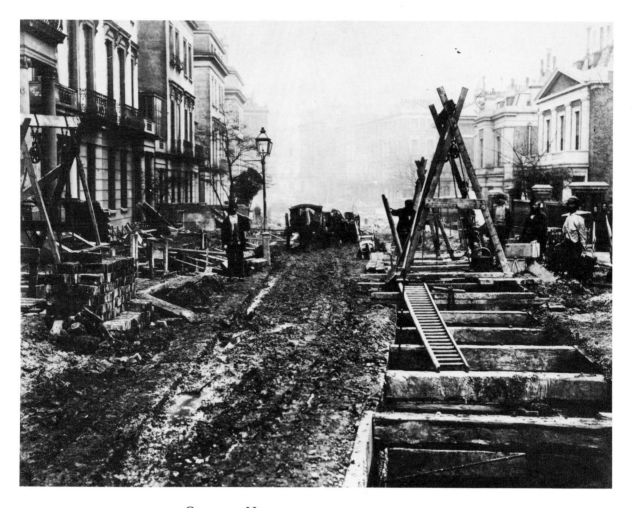

195 CRAVEN HILL LOOKING EAST, C. 1866
Anon.

The building of the Metropolitan Railway caused considerable disruption even in respectable residential streets, though when the works were complete the streets were restored exactly to their original condition. This view shows the construction of the line between Bayswater and Paddington Stations. The photograph was taken in Craven Hill looking east towards Craven Street, which leads to Praed Street. (*London Transport Executive*)

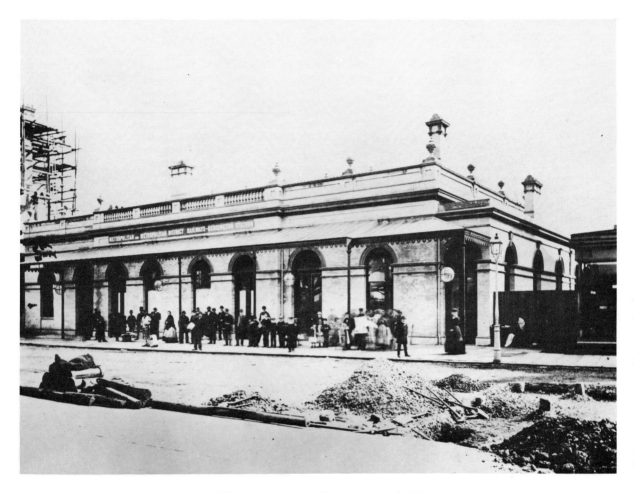

196 KENSINGTON STATION, 1868

Anon.

Kensington Station on the Metropolitan Railway is now High Street Kensington. This simple brick building, which stood on the south side of the High Street, has since been demolished. It seems to have been designed, like the other stations, by Sir John Fowler, Engineer-in-Chief to both the Metropolitan and Metropolitan District Railways. This part of what became the Circle Line was opened in 1868. (*London Transport Executive*)

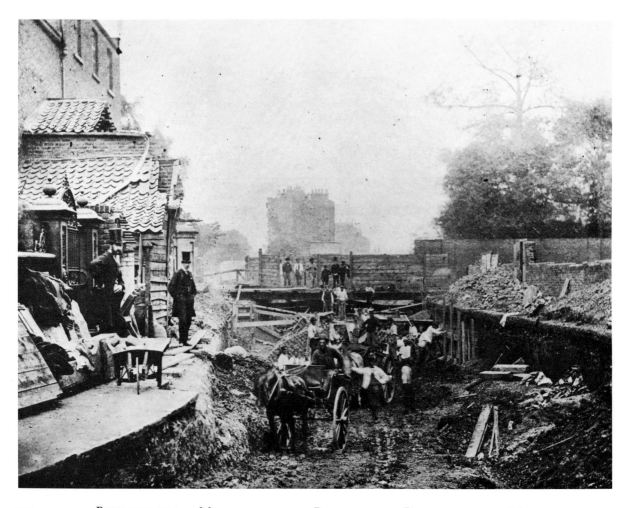

197 BUILDING THE METROPOLITAN RAILWAY IN BAYSWATER, 1867

Anon.

This view appears to show the railway works cutting through behind Pembridge Square and north of Linden Gardens. Great care was taken in conducting the railway through this wealthy area, to the extent of erecting blank false-house façades on either side of the bridge in Leinster Gardens. (*London Transport Executive*)

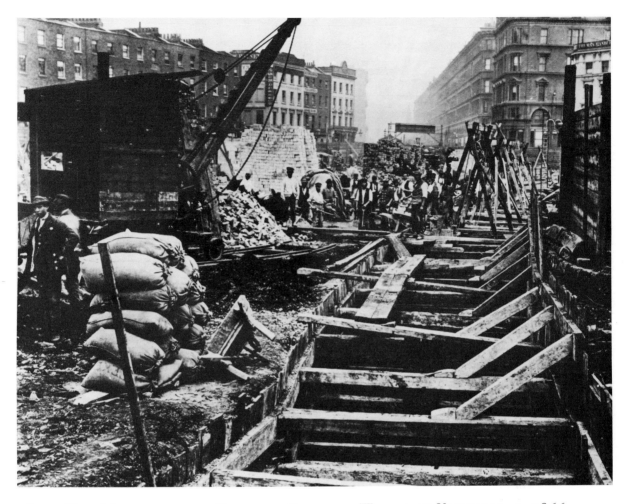

198 THE METROPOLITAN DISTRICT RAILWAY WORKS AT VICTORIA, c. 1866
Anon.

A separate company from the Metropolitan Railway, the Metropolitan District Railway was formed to build the south side of what became the Inner Circle line. Work began in 1865 and the line opened from South Kensington to Westminster Bridge at the end of 1868. The photograph looks towards Victoria Street from the forecourt of Victoria Station. On the left are the late Georgian buildings of Shaftesbury Terrace, today the continuation of Victoria Street. On the far right, on the corner of Wilton Road and the Vauxhall Bridge Road, is the stuccoed Windsor Castle public house. In the distance Victoria Street stretches away, opened from Westminster in 1851 and lined with large and dull blocks of the 1850s. (*London Transport Executive*)

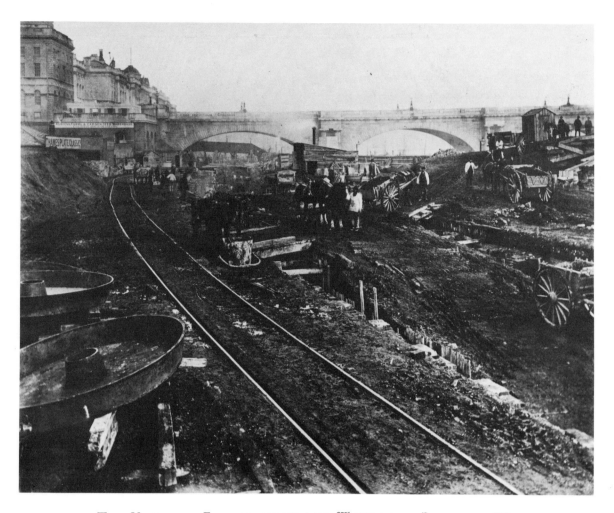

199 THE VICTORIA EMBANKMENT AND WATERLOO BRIDGE, 1869

Anon.

The Victoria Embankment having been completed from Westminster to the Temple, it was promptly dug up again to make the cutting for the Metropolitan District Railway. The company was unable to raise the capital to build this portion of its line until 1869. In this photograph, work is in progress on digging for the railway. It was completed in 1870, when the line to Blackfriars was opened and the Embankment itself was at last opened to traffic. In the background are Waterloo Bridge and Somerset House. The building on the extreme left, on the west side of Lancaster Place (Wellington Street), is the Duchy of Lancaster Office, *c.* 1820, by Smirke. Compare with Plate 134. (*London Transport Executive*)

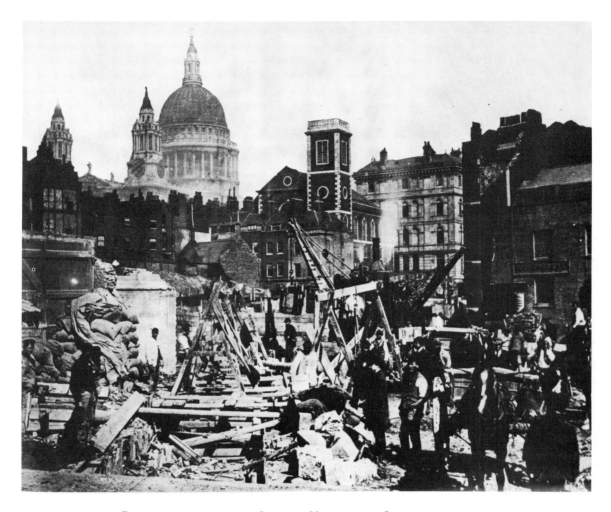

200 BLACKFRIARS AND QUEEN VICTORIA STREET, c. 1869
Anon.

The Metropolitan District Railway was opened from Blackfriars to the Mansion House Station in 1871, when Queen Victoria Street, under which it runs, was also opened. This photograph was taken just east of Blackfriars Station with Queen Victoria Street in the distance. The works in the foreground are for the railway; the empty site on the left, by Printing House Square, is where the new building for *The Times* would shortly rise. In the distance, above the Georgian houses in St Andrew's Hill, is Wren's Church of St Andrew-by-the-Wardrobe. To its right is the building for the British and Foreign Bible Society, designed by Edward l'Anson and rebuilt on the line of the new street in 1866-7. (*Guildhall Library, City of London*)

NEW RAILWAY TERMINI

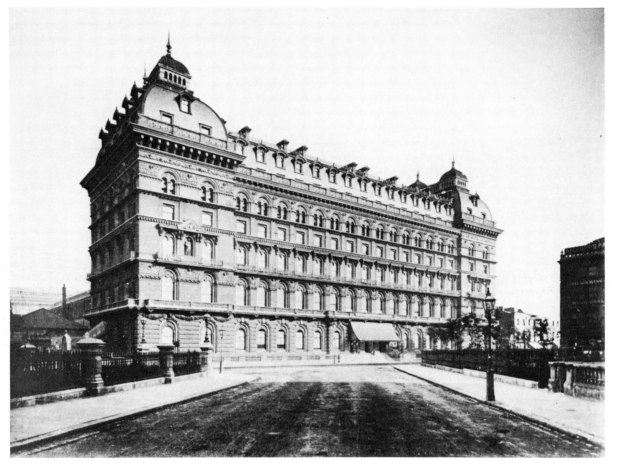

THE GROSVENOR HOTEL, VICTORIA, c. 1868
Anon.

The Grosvenor Hotel was not the first railway hotel in London but it was the first of a new generation of large luxury hotels attached to railway termini. It was built in 1860–62 and designed by J.T. Knowles with assistance from his son, James. This photograph was taken from a new street, Grosvenor Gardens, laid out to connect Victoria Station with Grosvenor Place and Hyde Park Corner.

Late Georgian houses were replaced with a triangular-shaped garden. To the left of the hotel can be seen the temporary railway station erected by the London, Brighton & South Coast Railway in 1860 and, beyond, the tall iron shed of the London, Chatham & Dover Railway's half of the terminus, which survives today. (*Sir Benjamin Stone Collection, City of Birmingham Public Libraries*)

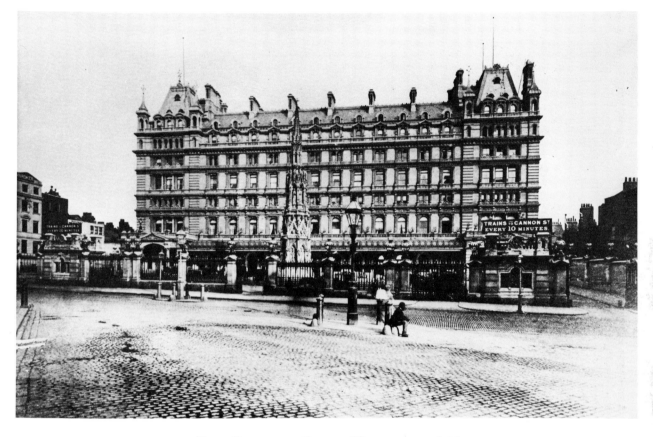

202 THE CHARING CROSS HOTEL, c. 1866
Anon.

The Charing Cross Hotel was designed by E.M. Barry and opened in 1865. Both the hotel and the South Eastern Railway's terminus behind it were erected on the site of the Hungerford Market (see Plates 108, 110). Also by Barry was the re-creation of an Eleanor Cross raised in the station forecourt. In 1951, as a gesture to the Festival of Britain on the South Bank, British Railways lopped off Barry's extravagant skyline of chimneys and pavilion roofs and replaced them by two straight, slab-like storeys. (*Sir Benjamin Stone Collection, City of Birmingham Libraries*)

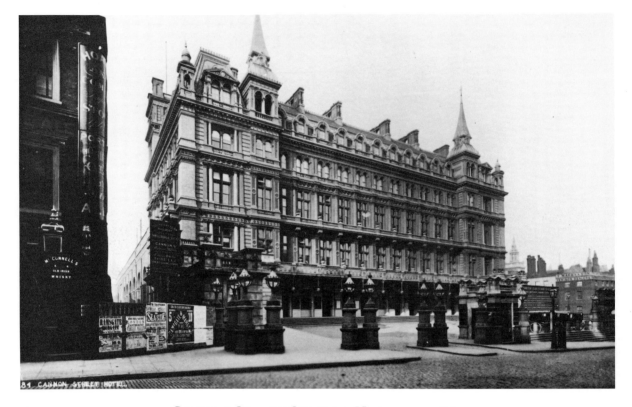

203
CANNON STREET STATION HOTEL, c. 1867
Anon.

Like the South Eastern Railway's station hotel at Charing Cross, the Cannon Street Station Hotel was designed by E.M. Barry. This photograph was taken shortly after its opening in 1867. To its left a notice offers a building lease on the adjacent plot; to the right can be seen the steeple of St James's Garlickhythe, by Wren. (*Sir Benjamin Stone Collection, City of Birmingham Libraries*)

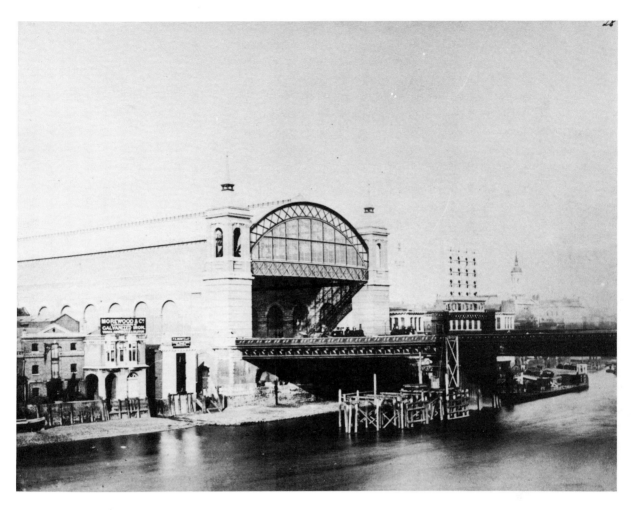

204 CANNON STREET STATION FROM THE THAMES, C. 1866
Anon.

This photograph was taken from Southwark Bridge and shows the river front of the new railway terminus. This City branch of the South Eastern Railway was built in 1864-6. It was designed by Sir John Hawkshaw with Sir John Wolfe Barry, engineers, and had a tall, arched iron and glass roof between massive brick retaining walls. Although the end towers by the river make some attempt to imitate a Wren steeple, this building did great damage to the old City skyline and dwarfed all its neighbours (see

Plate 136). To the right of the obtrusive signal gantry can be seen the steeple of the Church of St Magnus the Martyr and behind it the colonnades of the City of London Brewery, looking more like a building in Calcutta than one in Victorian London. Today the station roof and walls have gone, although the towers survive; quite inexplicably, the ornamental brackets on the railway bridge have been recently removed. (*Victoria & Albert Museum*)

BUILDING ST PANCRAS STATION

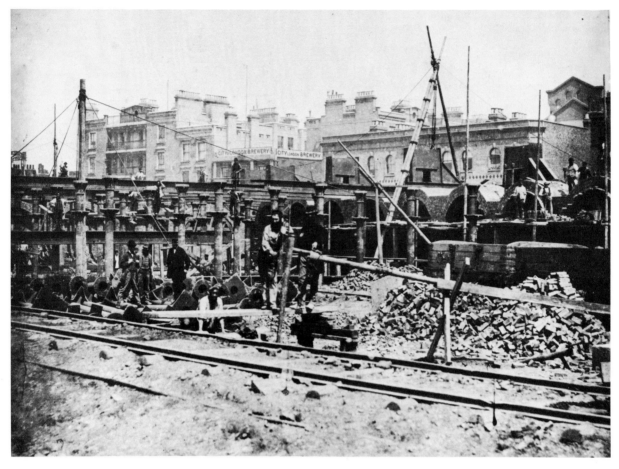

205 ST PANCRAS STATION UNDER CONSTRUCTION, c. 1866–7
Anon.

The orgy of railway building which characterized London in the 1860s ended with the construction of the greatest of the railway stations of that decade: St Pancras. In 1864 the Midland Railway secured permission to build a new main line from Bedford to a site near King's Cross on the Euston Road. Three thousand houses in Agar Town and Somers Town were demolished for the terminus. The contractors, Waring Bros., began work in the spring of 1866 on the station which was designed by the engineer W.H. Barlow and had a single-span arched roof 243 feet in width. Because the railway crossed over the Regent Canal it was above the level of the Euston Road, so the platforms were supported on a basement of cast-iron columns spaced for the storage of beer barrels. These iron columns are evident in this photograph. Behind them are the vaults for the side walls of the station, which were built for shops and workshops. In the background are new buildings erected on the east side of a re-aligned Pancras Road. On the left is a tenement block built by the Improved Industrial Dwellings Company. This has since been demolished but the building on the right with the strange gable still stands. This is the German Gymnasium, designed by Edward A. Grüning and built in 1864–5. (*British Railways Board*)

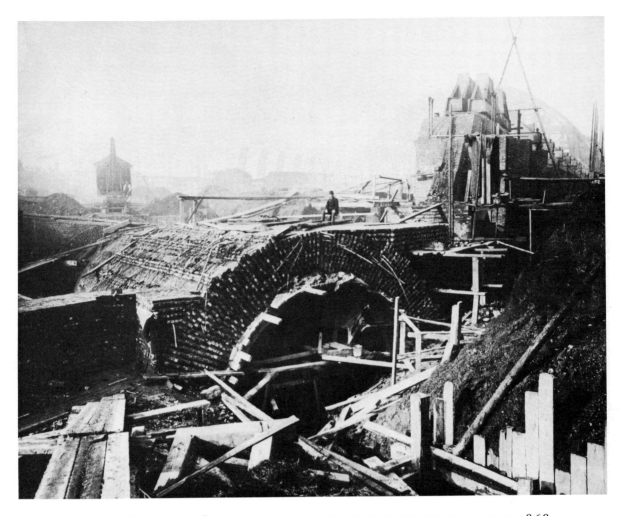

206 THE ST PANCRAS STATION SITE LOOKING NORTH-WEST, EARLY 1868
Anon.

This photograph was taken from near the Euston Road. In the foreground, under construction, is the tunnel which takes two tracks of the Midland Railway beneath the station to connect with the Metropolitan Railway at King's Cross, allowing trains to run through to Moorgate. In the background the great trusses for the station roof are being raised. (*British Railways Board*)

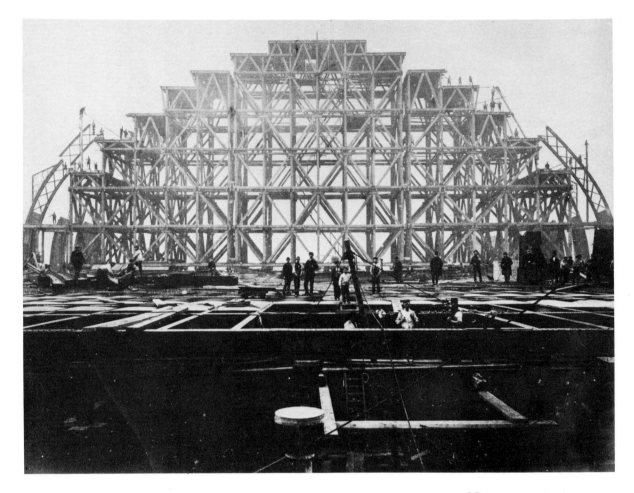

207　ST PANCRAS STATION TRAIN SHED UNDER CONSTRUCTION, NOVEMBER 1867

Anon.

The great ribs of the roof, which had a span of 243 feet, were raised in sections on a huge movable wooden scaffolding. The first rib was erected by the Butterly Company of Derbyshire in November 1867. Four were up by the following February. The Midland Railway complained about the slow progress of the work, partly owing to a harsh winter, and a second scaffolding was erected. The last rib was put in place in September 1868. This photograph shows the first rib being raised at the north end of the station. In the centre foreground is one of the cast-iron columns of the basement which supports the station floor. (*British Railways Board*)

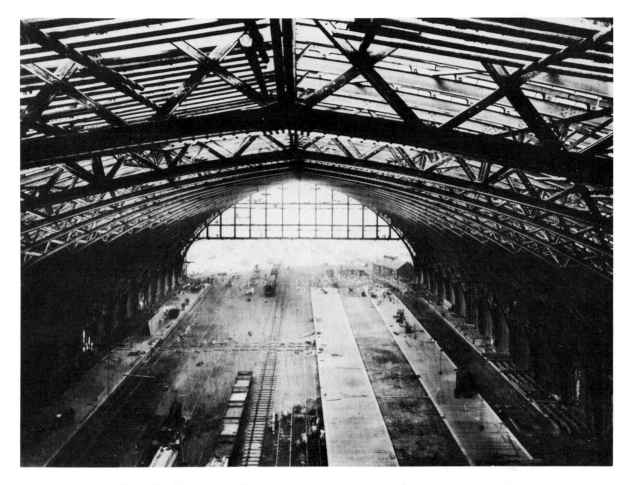

208 THE ST PANCRAS STATION TRAIN SHED, SEPTEMBER 1868

Anon.

This photograph, taken from a terrifying vantage point at the apex of the roof at the south end, shows the station almost ready. It was opened for traffic on 1 October 1868, although the building was by no means finished on that date. (*British Railways Board*)

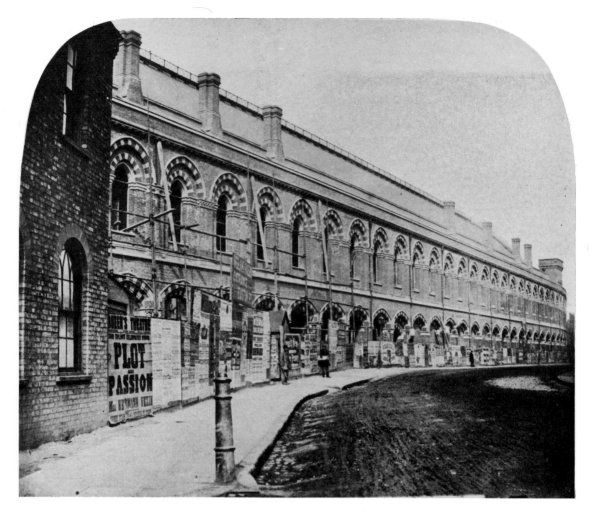

209 PANCRAS ROAD LOOKING NORTH, 1868

Anon.

This shows the Gothic side wall of the new station with the train shed complete. The upper windows, not yet glazed, let light into offices. The lower arches are for shops and for access to the basement. The house on the left, surviving on the corner of the Euston Road, was demolished soon afterwards. (*British Railways Board*)

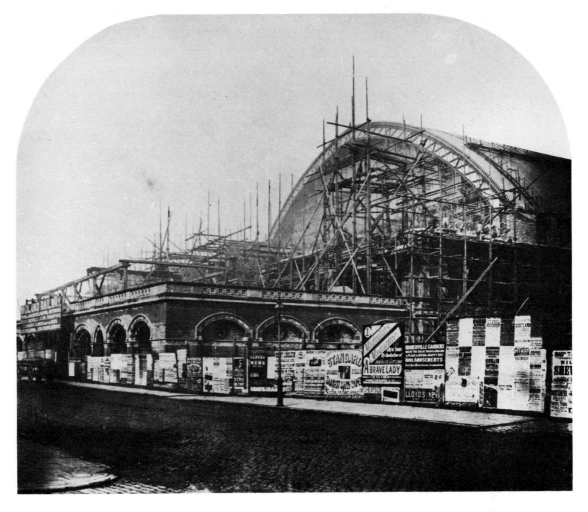

210 ST PANCRAS STATION FROM THE EUSTON ROAD, LATE 1868
Anon.

When this photograph was taken the station was open, but work on the Midland Hotel, in front of the train shed, had only just begun. A competition for the station hotel had been held in 1865 and won by Sir Gilbert Scott with an extravagant Gothic design. Owing to financial difficulties which postponed its construction, the design was modified to reduce the proposed height by the time work began on it in March 1868. In the foreground is the Euston Road, considerably narrower than it is today. Entry to the station was effected through an arch in the basement arcade facing the street – seen below the temporary notice. A tunnel from here leads straight to the platforms. The staircase from Pancras Road, on the right, to the elevated forecourt was not built until later. (*British Railways Board*)

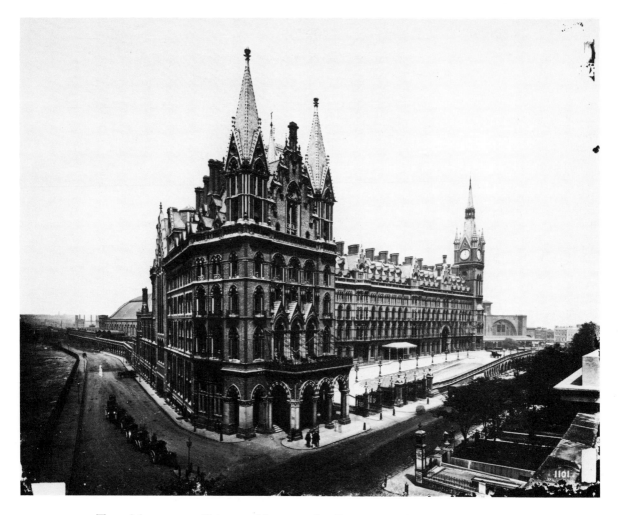

211 THE MIDLAND GRAND HOTEL, ST PANCRAS STATION, C. 1879
Bedford Lemere

The Midland Grand Hotel, when it opened in 1873, was the most luxurious in London. This great Gothic pile, designed by Sir Gilbert Scott, was not finally completed until 1876. To the right of its clock tower can be seen half of the façade of the Great Northern Railway's King's Cross terminus, which the Midland Railway had been determined to outshine. To the left of St Pancras Station is the site of the Somers Town Goods Station. The land was cleared in 1878 and the Midland Railway began work on the building in 1883. Today, a century later, the site is again vacant, this time for the building of the British Library.

This photograph was taken from the top of a house on the south side of the Euston Road, whose front garden had not yet been sacrificed, with those of its neighbours, for road widening. It was taken early in the career of Bedford Lemere, the architectural photographer who recorded so many late Victorian and Edwardian buildings and interiors on his large glass-plate negatives. With its precision and spaciousness, this print both accurately records the complexity of the building and suggests something of the confidence and ruthlessness which enabled the mid-Victorians to transform London and to build such assertive monumental structures. Bedford Lemere here illustrates a very different London from that captured by M. de St Croix's silvered copper plates forty years before. (*National Monuments Record*)

INDEX

(Figures in italics refer to pages on which illustrations appear)